ART IN ANCIENT MEXICO

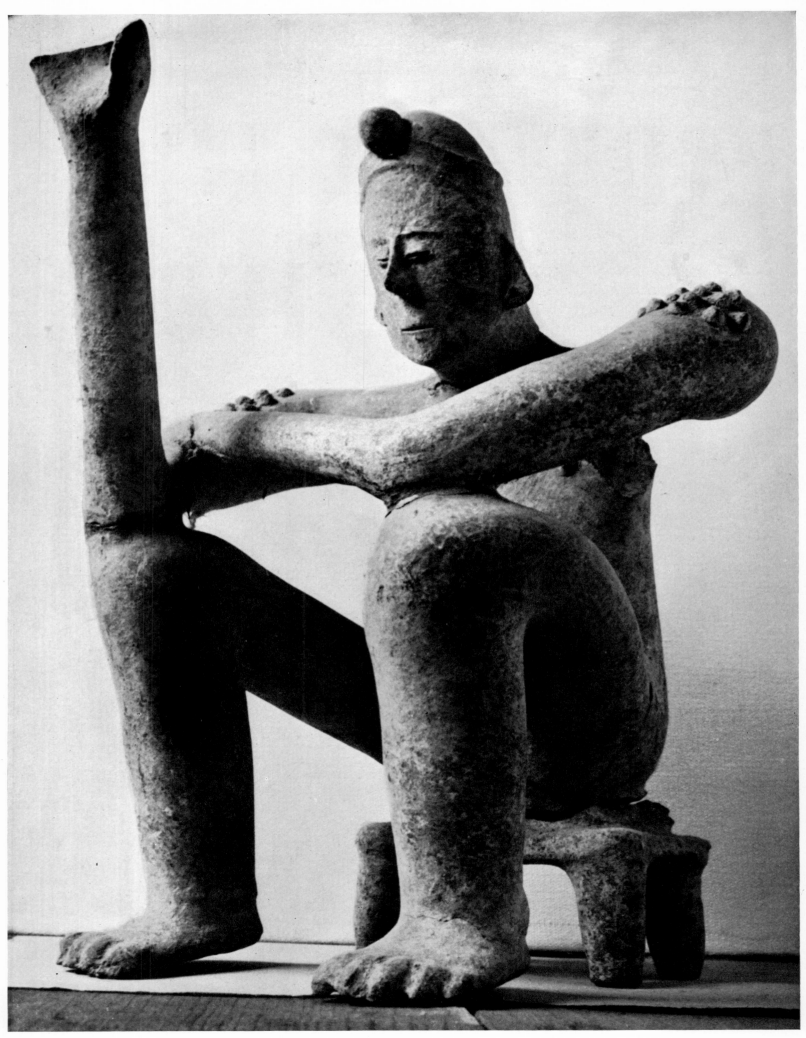

1

ART IN ANCIENT MEXICO

SELECTED AND PHOTOGRAPHED FROM THE

COLLECTION OF DIEGO RIVERA
BY
GILBERT MÉDIONI
AND
MARIE-THÉRÈSE PINTO

OXFORD UNIVERSITY PRESS · NEW YORK

PRINTED IN THE UNITED STATES OF AMERICA

THIS book does not pretend to be a scientific treatise. It is only one side of Mexican Art, in other ways again so rich. I have tried to make this art better known, solely from the plastic point of view.

If I succeed in this, I shall have only feebly expressed the real admiration and the profound feeling of gratitude I have for Mexico.

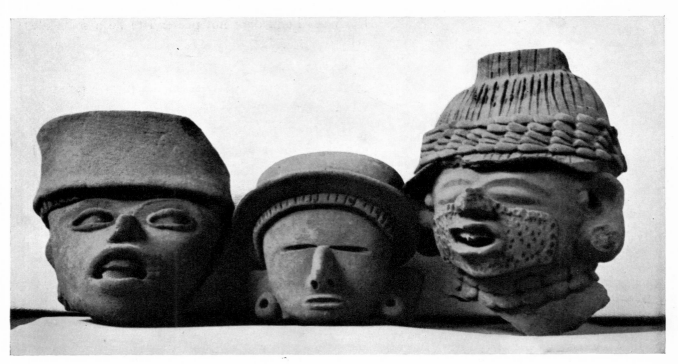

2

VI

INTRODUCTION

Les civilisations commencent par l'épopée, par la théologie et finissent par le roman.
—Henri Focillon, *L'art d'Occident*

THEY worked stone against stone, or with tools of an amazing bronze, in order to realize the wonderful forms they had invented. They built pyramids which they then carefully dissembled, as if they had a foreboding that invasion was going to annihilate their efforts, and that their art, which had reached its highest stage, at one stroke, without groping, was going to disappear as abruptly as a flame.

We know almost nothing of these peoples, and that perhaps is why one of the greatest cycles of art and humanity, the antiquity of Central America, has been longest disregarded. Around these taciturn races, silence; and that also is what is most striking in their country: silence and solitude.

Skies heavy with clouds, of intense colors, ranging sometimes from violet to the deep blue of ultramarine; atmosphere of a surrealist, crystalline, spatial limpidness; snowy volcanoes in circles; and metallic vegetation, origans (cacti) in the form of candelabra, or steely edged magueys: everything here is but a transposition, caused by a tragic fantasy, to the uses of death. For death is everywhere, but without dramatic intensity; and in this singular scenery it is her familiar face one recognizes. It is death that connects us with life and delivers us from the anguish of the cold uplands, or the pervading lassitude of the *tierras calientes*. Amidst this world of forms strange to us, the *calaverite* is reassuring; it sets a term to the destiny of man, the only value common to the Orient and the Occident.

One must not think too much of history here. Our ignorance for once is precious. The fact of Mexico as seen in our age is still the Orient, that is to say, Asia,

in spite of Spain and through it the Moors. For Spain here is a quite different chapter that could be entitled 'painting' in Mexico, a visual debauch, an intoxication of colors. We are concerned only with sculpture; the sculpture of the pre-Cortesian peoples.

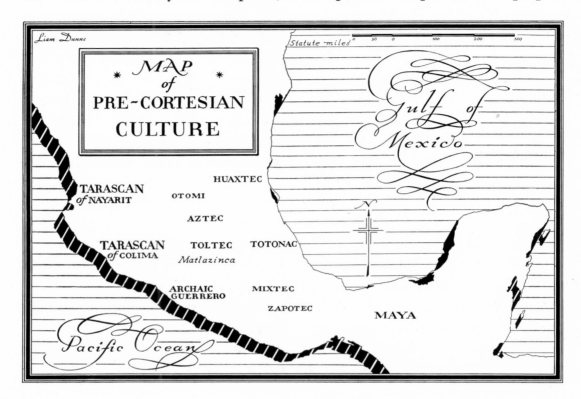

What is the fountain-head of this art? Others will say whether these people had the memory of their distant land of origin: mysterious Asia; whether it is true that man arrived in this country after peopling Oceania, borne by marine currents, or if, resuming the great Ptolemaic dream, 'on this island of Atlantis, kings had founded a great and wonderful Empire.' One could carp at the troubling analogies that exist between Mexican art and that of the old continents, between this Tarascan figure, and that idol of the Greek Cyclades, between this Mayan stele of the Piedras Negras and that Chinese fragment. These coincidences must be admitted. On contact with America, the genius of all peoples expresses itself in a quite different manner, and to the memories of the country of his origin is added the surprise that man must have felt before that exuberance of the tropical earth and the high valleys of the region of Anahuac—strange country, where life as well as art develops, without measure or deliberation, in the heart of astronomical landscapes.

And so it is the land and not history that gives this art its true meaning. All this petrified symbolism joins nothing to anything: not one epoch to another, neither archaism nor decadence, neither rise nor fall. And if one thinks about the peoples who lived in a recent past, it is as if instead of our sixteenth century one evoked prehistoric man. For there is no longer any contact between man and those gods who continue to reign silently, immovably fixed to the land. Alone are the gods with or without plumes, Tlaloc, Mictlantecutli, the Aztec Pluto, and the terrible Huitzilopochtli; and alone is the goddess of the moon, who was hurled from the summit of her pyramid at Teotihuacan; but alone also is man in the face of these idols. There was a clean break, an era ending 13 August 1521, with the capture of Tenochtitlan by Hernán Cortés. Defeat and enslavement saved these peoples from decadence and academicism.

Their testimonials, whether proud monoliths or ornamental steles, statues of fierce gods or humble household pottery made of adobe, have, nevertheless, the trait in common of never being the art of inspired persons, but on the contrary of realists. Warriors accustomed to facing death: that is what they expressed. And so this art means not God but man. To attain symbolism they borrowed elements from the universe which surrounded them. Tlaloc with his round eyes and long teeth, Ehecat himself, are human because they are real before they are abstract.

It is this same desire for a closer communion with nature that one feels at Teotihuacan. The pyramid is nothing but a pedestal to reach the god, a pedestal in the proportions of the mountain whose replica it is. It is not a flame raised towards the clouds, it is not the sky which attracts one at the summit, but the surrounding heights, the soil, the earth; and, beneath the intense light, the marked edges and angles of the rocks make clear-cut designs like architectural plans. This art comes from the earth, diverse as the forms of that rich tropical nature, vital as life itself.

A more important place has voluntarily been made for the Tarascans. Unity, and the search for balanced combinations of line and mass, as well as the development of certain accents, confer style upon the sculpture of this people. But it is perhaps the freest art we know, through its infinite variations on the human figure, always purely plastic. This seated figure may be reduced to a play of curves and straight lines, an X-grille; whereas in another the limbs, through a play of proportions, are immoderately lengthened, or are shortened, stunted like fins. In every case, the contours, of a quite extraordinary sensibility and foreshortening of lines, define a rare arabesque.

These good fellows, full of rather disturbing joviality, whose faces express by the most simple means a sort of fierce candor, are indeed only vases, recipients intended to contain water or the drink drawn from the maguey. Standing or seated, with arms uplifted or brought back towards the chest, their legs well perpendicular, they are amazing in their vitality and expressive intensity. The style is the same in them all, but each one is a different person.

There is no cruelty among the Tarascans. They apparently wished to ignore war, bloody sacrifices, and even death; in any case nothing of this sort appears in their art. They are the Greeks of America, if, as has been said, the Mayas represent the flamboyant style. With a tender, never wicked humor, they banter the big-bellied bourgeois, personages occupying important public positions, all swollen with their dignity and functions, judges with toques, or others. Hunchbacks, fat people, the deformed, large or misshapen women constitute a gallery of grotesques remarkable for their gentleness. All their love goes out to children, dogs, the young of animals, familiar scenes; while the warriors, all adorned with plumes and entangled with their weapons, over their shields throw to their enemies looks that are more sly than frightening. Without in any way impairing the effect of fullness and plasticity, a few markings close to nature confer life upon them.

It is easy with a little practice not only to tell these *monos,* as they are called in Mexico, from the sculpture of the other peoples of America, but also to recognize their origin, that is to say, the regions where they were found, which constitute so many sources of civilization. Among the Huicholes of the State of Nayarit, the dark red earth with metallic glints, adorned with a few geometric designs, has acquired a precious savor.

The Tarascans of Colima seem more realistic, compared with the Huicholes, especially if one considers certain pieces that are perhaps contemporaneous with the Spanish invasion; but there exists also an entire abstract era, which produced rare and strange forms, probably anterior to it.

This art is collective, popular, certainly anonymous—as are still anonymous in our day the maker of *juguetes,* the little peasant of Metepec or of Texcoco, and the potter of Patzcuaro, who in the course of centuries have not lost the sense of grandeur, the innate taste for plastic art, humor, and poetry.

Gilbert Médioni

THE RELIGION AND THE GODS

OF ANAHUAC

THE ancient inhabitants of Mexico, primitive Toltecs, Olmecs, Zapotecs, Toto-
nacs, Aztecs, Tarascans, were like the Mayas polytheistic. They worshipped the
deified powers of nature, such as water, air, fire, clouds, lightning, and the sun. Most
of the stars as well as the circumstances of life depended upon a god who bore the
image and likeness of man.

But a strange bargain rapidly transpired between man and his gods. Men recog-
nized that they owed their existence to the gods, but the gods, in turn, in order to
subsist, needed a mysterious power, *chalchiuatl*, or breath-of-life, to be found only
in the heart and blood of man: whence the necessity for continually repeated human
sacrifices. Certain gods, like the sun, Huitzilopochtli, required numerous victims.
Others, like Xipe Totec, the god of spring, or Tlaloc, god of water, demanded them
only at the times of the year that they had need of them.

The most ancient gods, apart from Tlaloc, seem to have been Ometeuctli (or
Tonacatecuti) and his wife Omecihuatl, whom the Toltecs transplanted to Mexico.
They were at the same time the creators of the universe and of the other gods. From
the primordial waters they caused a monster to arise, whose back, called Cipactli,
was the earth, and it is this same name that they used to designate the first day.

According to the legend, Omecihuatl had four sons: Tlatlauhquiztecatl, Yaya-
quitlecatlipuca, Quetzalcoat, and Huitzilopochtli. But subsequently the goddess-
mother gave birth to—a flint knife! The indignation of her sons was such that one
of them seized it and threw it to the ground. The instant the knife touched the soil,
six hundred gods sprang up out of it, who without further hesitation decided to
assemble in council. They complained of lacking everything, and especially men for
serving them. They addressed themselves, quite naturally, to Omecihuatl, their

mother, and she answered them severely that to be worthy of living eternally in heaven, at her side, they would have to have more noble and elevated thoughts. She bade them address themselves to Mictlantecutli, ruler of hell, at the same time advising them not to trust him.

The gods followed the counsel given them. It has been claimed that it was Quetzalcoat who was dispatched to Mictlantecutli, but it seems rather that it was Xolotl, the god with a dog's head, who was charged with this mission, for we know that in his flight to escape the subterranean god, Xolotl dropped a bone that had been entrusted to him. This bone having broken into numerous pieces, he picked them up and delivered them to his brothers. The latter hastened to gather all the fragments into a vase, which they filled with their blood. On the fourth day a male child was formed and three days later a little girl. It was again Xolotl who was charged with their upbringing. Since then one knows that the difference in the stature of men can be explained by the inequality of the fragments from which they have issued.

<p style="text-align:center">❦ ❦ ❦</p>

Among the oldest gods a special place must be made for Tlaloc, the most popular of them all. He is the god of water and of mountains, and commands the rains and the springs, the snow, hail, and thunder.

In the massive side of Ixtaccihuatl and Popocatepetl, at the foot of the volcanoes, in a place called 'Tlalocan,' the god Tlaloc had his abode. It was there that were formed the clouds from which comes earth's fecundity. There too went all those who could not be cremated after death, warriors fallen in battle, women who died in their first childbirth, and many more still, as, for example, those who had suffered from dropsy or other diseases during their lifetime.

There existed besides upon almost all the mountains subordinate Tlalocs, always four in number: the chief Tlaloc and three other gods who were content with reigning over the cardinal points. They had at their disposal four jars, filled respectively with good rain, evil rain, that which keeps the harvest from drying, and hail.

Tlaloc is always represented with circles round his eyes, and with long teeth as defenses. This mask is in reality nothing but the abstract design of two intertwined serpents who join their fangs upon the mouth of the god, as may be verified from certain more ancient depictions, particularly the manuscripts. When he is presented standing, he holds in his hands a spiralled and pointed ingot of gold: lightning. His colors are green and blue, like those of the water he represents.

XII

There is a story that at the time of their first king, Xolotl, the Chichimecs found upon the Tlalocan an idol of white stone with a vase full of offerings in front of it. Nazahualpilli, king of Acolhuacan, had the idea of changing this idol for another more beautiful one made of very hard black stone. This was done, but as soon as the new one had been installed, it was immediately destroyed by lightning, and he was obliged to replace it with the old one.

Tlaloc upon certain occasions required the sacrifice of children whose tears were flowing, in order to promote the rains. In the courtyard of the great temple of Mexico, on certain days of the year, the shades of the sacrificed children were supposed to look on at the ceremonies.

<div align="center">🐾 🐾 🐾</div>

Tlaloc was the consort of the water goddess, Chalchihuitlicueye, 'She who has a jade skirt.' She was also called Matlacueye, 'She who has a blue dress,' by the Tlaxcaltecs, and this same word was used to designate the highest mountain of the region of Tlaxcala. Torquemada has called her Xochiquetzal, and Boturini Mecuixochiquetzal.

<div align="center">🐾 🐾 🐾</div>

We have seen that among the sons of Omecihuatl there were two called Quetzalcoat and Huitzilopochtli. These with Tlaloc and Tezcatlipoca are the four great Mexican gods.

Quetzalcoat (the feathered serpent), or Ehecatl, is the god of wind, of life, of the morning, and of the planet Venus. He is also the god of twins and monsters, and is called by turns, according to his role: Ehecatl, Quetzalcoat, Tlahuizcalpantecutli, Ce Acatl.

His history is confounded with that of the greatest of the Toltec chiefs, who bore the same name and who had been the high priest of Tula. The god and the chief were probably one and the same. The most logical but perhaps not the most likely explanation is that after his mysterious disappearance Quetzalcoat, the chief, was revered as a god.

Quetzalcoat is familiar to us. He has been described as being of the white race, tall, corpulent, with black hair over a narrow forehead sheltering great eyes. He had a copious beard, and was always dressed in a long robe. He is reputed to have been a sage, not only because he was opposed to human sacrifices, but also because he taught the Anahuac peoples the art of fusing metals and carving stone. The laws that governed them through many centuries are his work. His life seems to have

been austere, exemplary, and at the same time luxurious, for he lived in palaces of silver and precious stones.

The peoples under his government likewise lived in abundance and happiness. An ear of maize was enough for the custody of one man, and the gourds reached a colossal size. Cotton grew naturally in all colors. The countryside was full of birds of dazzling plumage.

Why did it have to happen that Quetzalcoat was unable to resist the cup of sparkling pulque tendered him by the god Tezcatlipoca, the invisible omnipotent one? He drank, and in his drunkenness forgot his most sacred obligations. He went so far as to inebriate his sister Quetzal-Petl-Atl, and spent the night with her to amuse himself. In the morning Quetzalcoat wept, groaned, and deeming himself unworthy, decided to leave for Tlapallan, the land of his ancestors. He then burned his most treasured possessions, his houses of shell-work and silver; he ordered the birds Quetzaltototl and Tlauhquechol to precede him on the road of exile.

Accompanied by musicians playing the flute, Quetzalcoat left Tula and arrived at the place called Quauhtitlan, where stood a gigantic tree. There he asked for a mirror, looked at himself in it, and said, 'I am old,' and he called this spot Ueue-Quauhtitlan. He then threw stones at the tree and they buried themselves in the bark.

Then Quetzalcoat resumed his journey and arrived at another place, where he rested. He pressed his hands on a stone: the impressions remained printed there. Then turning his eyes backwards in the direction of Tula, he began to weep and his tears pierced the stone on which he was sitting.

At Coapan the necromancers came to meet him.

'Where are you going?' they said to him. 'Why have you left your capital? To whom have you entrusted it?'

But Quetzalcoat said to them: 'You cannot keep me from going. It is absolutely necessary for me to leave.'

The necromancers asked him again: 'Where are you going?'

And Quetzalcoat answered them: 'I am going away to Tlapallan.'

'Why are you going there?' asked the necromancers.

'I was called, and the sun reclaims me.'

Then they said: 'Go away, if it is your wish, but leave to us the art of melting silver, of working stones and wood, of painting and of doing work in feathers as well as in many other materials.'

Quetzalcoat stayed more than twenty years at Cholula, which he ruled wisely. After that he went on his way, accompanied only by four young people who were the noblest among the Chichimecs. Having reached Coatzocualco, he sent them back, telling them he was going back in the same direction whence he came, and he added that in the year Ce-Acatl he would return.

Quetzalcoat then entered the sea and disappeared.

The cult of Quetzalcoat, after originating in Cholula and Tula, spread all over Mexico. The Yucatecs boasted of having one of his descendants as chief. At Cholula some green stones that were said to have belonged to him were preserved with veneration. It is in this town, moreover, that his festivals were especially famous during the divine year or Teoxihuitl.

Quetzalcoat, whom barren women invoked in order to have children, was opposed to Tlaloc, the god of rain, whose way he tried to bar by blowing.

*** *** ***

Huitzilopochtli was the god of war, and was more particularly charged with the protection of the people of Mexico. It was he, indeed, who designated the place where they should erect their city Tenochtitlan; and on the very spot where the Aztecs had their vision of the Nopal on which stood the eagle with outspread wings, there was raised to him his first sanctuary, a humble hut of boards covered over with straw. It was around this temple, which was to become the most important religious center, that Mexico City was born. At the time of the Conquest, according to the accounts left us by the Spaniards, companions of Cortés, the temple of Huitzilopochtli had become an imposing edifice. The summit was reached by a staircase of one hundred and twenty steps. Balustrades composed of stone serpents ran from the base to the upper part of the building, where the sacrificial stone was to be found.

The image of the god was colossal. He was shown seated on a bench of blue, surrounded by four serpents. He was wearing a golden mask and had as headgear a handsome panache in the shape of birds' beaks. About his neck was a necklace composed of ten human hearts, on which he nourished himself. His waist was girt with a large golden serpent. In his right hand he held a spiralled wand, and in his left an escutcheon on which there were five feather balls arranged in the shape of a cross, and a banderole with four arrows that had been sent him from heaven to accomplish glorious deeds.

According to the legend, his birth was miraculous.

XV

The historian Sahagun, from whom we borrow the following passage, tells us that on the sierra of Coatepec, near the valley of Tula, there lived a woman by the name of Coatlicue, the mother of four hundred Indians called Centzonuitznaua, and of a daughter named Coyolxauhqui:

Now, one day as she was sweeping the temple, a little ball of feathers, resembling a ball of thread, fell upon her. Catching it, she placed it in her bosom, near her belly, underneath her skirts. But when she wanted to take it up again, she couldn't find it. Some time later, Coatlicue found herself pregnant.

The brothers did not believe in this miraculous conception, and cried: 'Who has covered us with shame and infamy?'

Their sister Coyolxauhqui on her part said to them: 'Brothers, let us kill our mother, because she has disgraced us by becoming pregnant without our knowledge.'

Coatlicue felt sorely grieved, until she heard a voice that came out of her breast: 'Fear nothing, Mother, I will save your honor and my fame.'

The brothers then prepared as if for a battle, arranging their hair in twists which they fastened in the manner of the most valiant warriors. But one of them called Quautlicac, on whom the role of traitor has devolved, went to report everything that his Indian brothers the Centzonuitznaua said, to Huitzilopochtli, who was still in his mother's belly, and who answered: 'Oh, Uncle, watch carefully everything they do, listen to what they say, so that I may know what I should do.'

The Indians left to go to the place where their mother was. Their sister Coyolxauhqui marched at their head. They were armed with all sorts of weapons and adorned with papers, little bells, and darts, as was suitable. Quautlicac went up the sierra to tell Huitzilopochtli that the Indians Centzonuitznaua were coming with the intention of killing him.

Huitzilopochtli said to him: 'See where they are this minute.'

Quautlicac answered that they were arriving at the place called Tzompantitlan. Huitzilopochtli then asked, 'Where are they now?' and Quautlicac told him they were getting to Coaxalco. Huitzilopochtli asked again, 'Where have they arrived?' and the answer was that they were arriving at Petlac; and Huitzilopochtli asked Quautlicac again, 'And right now, where are they?' He answered that they were in the middle of the sierra, and again Huitzilopochtli asked, 'And where are they now?' and the answer was that they were near him and that Coyolxauhqui was marching in front of them.

But at the moment that the Indians Centzonuitznaua arrived, Huitzilopochtli was born, his face painted and his head surmounted with ornaments of feathers stuck to it. His left leg was frail and covered with feathers, his thighs and arms were painted blue. Huitzilopochtli commanded one named Tochoncalqui to set fire to a serpent made of pine wood, called Xiuhcoatl, and it was with that that Coyolxauhqui was wounded and died, broken into pieces. Her head remained on that sierra of Coatepec. Huitzilopochtli then arose, took up his weapons, and set in pursuit of his brothers, whom he chased from the sierra, fighting all the while and going around the mountain four times.

This legend symbolizes the birth of the Sun, the young and valiant warrior who is reborn each morning from the belly of Coatlicue, the ancient goddess of earth. Coyolxauhqui is the goddess Moon. The Four Hundred Brothers are the stars, which are extinguished upon the appearance of the Sun, personified by Huitzilopochtli, who was born armed with the Fire Serpent or solar rays for killing the Moon and the Stars. Each day the Sun must wage this battle so that men may live, but he disappears every evening to go into the kingdom of the dead.

She is a winning figure, Coatlicue, mother of Huitzilopochtli, goddess of the Earth and of Death, but she is also known by the names of Cihuatcoatl, and of Tlazolteotl, goddess of impurity, Woman-Serpent, and 'She who has a skirt of serpents.' She suckles gods and men, for she is 'Mother' to them all: Tonantzin. Without ever satisfying her hunger she must feed on the corpses of men, whence her name of eater of filth.

In her other aspect of Cihuatcoatl, she is the god of women who have died in childbirth. She is seen at nightfall at crossroads and the intersections of ways, uttering terrible cries, and carrying a little cadaver. Woe to children who meet her.

🐾 🐾 🐾

Another of the most important of the gods is Tezcatlipoca, or Brilliant Mirror. He was alternately called 'The young man' or 'Telpochtli,' in order to have it understood that he did not grow older and that his strength did not diminish with the years; and 'He whose slaves we are,' for he was the omnipotent, invisible, ubiquitous god, the soul of the world, the creator of heaven and earth, the ruler of all things. He was also designated by the name of 'Obsidian,' for he always carried a mirror made of that substance, which was useful to him, it was said, for seeing everything that was going on in the world.

XVII

The only thing known about him is that he came down from heaven on a rope made of spider webs. His history, his birth are as unknown to us as the reasons that impelled him to persecute Quetzalcoat, as we have seen. He was nevertheless a god of justice who rewarded the virtuous and sent diseases to the wicked as punishment.

His image was carved in *teotetl*, a black lava-stone, as brilliant as marble—but some say in obsidian. He wore gold and crystal pendants in his ears. His hair was bound with a golden cord from which hung a plaque of the same metal on which were symbolized the sufferings of the afflicted. His chest was covered with massive gold. He had gold bracelets on both arms, his navel was encrusted with an emerald, and in his left hand he held the famous mirror.

At other times he was shown seated, his body entirely black, girt with a red cloth on which were painted human skulls and bones, to express his omnipotence over life and death, and holding in his left hand a shield and four arrows.

There were stone benches reserved for him at street corners so that he might rest if he chanced to be tired. He was the patron of military colleges.

❦ ❦ ❦

Among the Mexican divinities there are others of lesser importance.

Mictlantecutli, god of hell, and his wife Mictlancihuatl resided in the bowels of the earth. He had black hair, curled and studded, with eyes like stars, which helped him see in the most complete darkness. At the time of the festival of these deities, which was celebrated during the seventeenth month in Mexico, the priest consecrated Tlitantlenamacac to their cult, and stained his body and face black in order to perform his functions.

Xoalteuctli was the god of night, and Xoalticitl the goddess of cradles, to whom children were entrusted at night, that she might protect them and send them sleep.

❦ ❦ ❦

Among the agrarian divinities, less important, are:

Centeocihuatl, or Chicomecoatl ('Seven Serpents' and 'Seven Ears of Maize'), female goddess of the ripening maize, sister of Tlaloc, most often pictured with her hair cut in a fringe beneath the sumptuous *Amacalli*, or 'House of paper,' with which her head is covered, and which forms superposed bands and roses. In her hands she holds a pair of *mazorcas*, or ears of maize.

Centeotl, the goddess of earth and of maize, known by the name of Tonaca-yohua, which means 'She who nourishes.' She is supposed to be the daughter of Tlazolteotl, the goddess of earth and voluptuousness, and sister of Xochiquetzal

('Feather-flower of Quetzal'), the goddess of flowers and fertility. She was especially adored by the Totonacs, who believed that she did not like human sacrifices, and hoped that it would be she who would deliver them from this custom.

❧ ❧ ❧

Xochipilli, although his effigy is sinister, is a very interesting deity. He is the prince of flowers, the god of the dance of love, of spring, and of all games in general. He is clad in a tunic bedecked with flowers and butterflies, and he holds in his hand a staff planted in a heart, the *Yolotopilli*.

❧ ❧ ❧

Xiuhteuctli is the god of fire. He was also given the name of Izcozauhqui, to convey the color of flame, and he was offered the first swallow of every drink and the first mouthful of every dish, for he was very much revered.

❧ ❧ ❧

The gods of pulque or Olctli, that is to say, of intoxication, numbered four hundred, whence the name by which they were called, 'Four hundred rabbits,' for the rabbit was the symbol of drunkenness.

Their mother was Mayahuel, a goddess whose chest was adorned with four hundred breasts with which to nourish her four hundred sons: the Centzontotochin.

As the moon was supposed to be inhabited by a rabbit, these gods quite naturally became associated with the moon. Patecatl, Tepoztecatl, and Macuiltochtli, recognizable through the crescent they wear beneath the nose and the bell-shaped stopper in their ears, are among the best known of the gods of the Octli.

Metztli, the Moon, has a shellfish as symbol.

❧ ❧ ❧

Among the other gods of war are:

Tlacahuepan-Cuexcotzin, younger brother and companion of Huitzilopochtli.

Tonatiuh, sun god and protector of warriors.

Finally, Xipe-Totec, the god of spring and of jewels, but also 'Our lord, the flayed-one,' for the earth in the spring seems to change its skin by covering itself with a new vegetation. The priest consecrated to Xipe performed his functions clad in the skin of the victim he had just sacrificed.

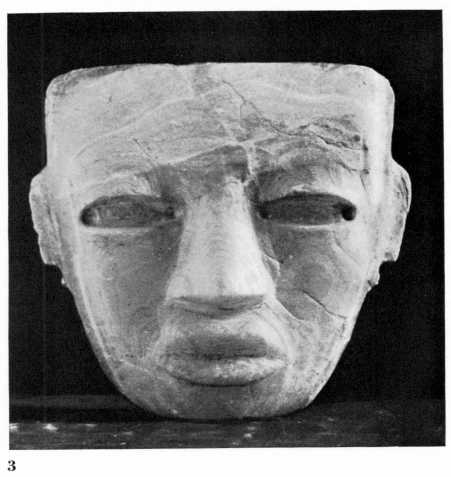

3

PLATES

[*Dimensions are given in centimeters*]

(*Cover*) Original composition: serpent in wood. Origin: Coyoacan. 40x42

1. (*Frontispiece*) Man seated. Tarascan from the state of Colima, *clay* 36x30

2. Totonac heads, State of Veracruz, *clay* Respective dimensions from left to right, 14x12, 12x12, 17x14

3. Toltec(?) mask, *jade* 17x18

ARCHAIC SCULPTURE OF GUERRERO

All these pieces have been found in the state of Guerrero. They seem to correspond to a civilization which probably developed in this region.

The pieces 4, 5, 6, 12, 13, 15, and 16 probably represent tools, hatchets or hammers. The surfaces show signs of wear, the limbs are crudely indicated, and the schematism exaggerated, but one has only to handle one of these idols to realize its purpose, for one's hand and fingers fit perfectly into the hollows contrived for them, which make the pieces well-adapted tools.

4. Figure, *stone* 19x8

5. Rudimentary figure, *jade* 15x6

6. Figure, with one arm hanging, the other on the chest, *stone* 18x6

7. Abstract figure, *stone* 8.5x6.5

8. Mask, giving a different image when placed on either end, *stone* 7x2

9. Same

10. Same

11. Mask, *marble* 20x17.5

12. Rudimentary figure, *stone* 17x6

13. Rudimentary figure, *stone* 18x6

14. Elongated figure, *stone* 20.5x5

15. Effigy of Mictlantecutli, *stone* 15x7.5

16. Figure, *stone* 10x5.6

17. Figure, *stone* 23x10

18. Geometric figure, *stone* 29x15

19. Mask. Guerrero, *marble* 10.5x11.5

20. Mask, *lava stone* 9x7

21. Flat figure, *jade* 17.5x6 (cf. Toltec sculpture, Plate 209)

22. Flat figure in a long dress with little cape hiding the arms, the head and forehead covered with a cap, *jade* 17x6 (cf. Toltec sculpture, Plate 209)

23. Mask, *petrified wood* 21x18

24. Head, *stone* 5x2

25. Mask, *stone* 15.5x17.5

26. Figure of a man with arms crossed, the eyes, nose, and mouth bearing traces of incrustations, *serpentine* 54x17

27. Mask, *diorite* 20x12.5

28. Mask, *diorite* 18x14.5

29. Figure. Olmec of Guerrero, *diorite* 17.5x9

30. Mask. Olmec of Guerrero, *obsidian* 9x8.5

31. Mask. Olmec of Guerrero, *jade* 20x17

32. Mask, *stone* 16x15

TARASCAN
FROM THE STATE OF NAYARIT

All the pieces presented here are in baked clay, most of them painted and decorated in lively colors. The pieces 75, 76, 77, and 78 come from the border of the states of Nayarit and Sinaloa. They do not in any way resemble the other Tarascans of Nayarit or Colima.

33. Detail of Plate 34

34. Male figure. 61x30

35. People eating, assembled in a house resembling those still used by the Huicholes. 31x17

36. Same

37. Female figure. 30x11

38. Same

39. Crouching figure. 21x11

40. Same

41. Man sitting, playing the drum. 45x28

42. Same

43. Detail of preceding figure

44. Same

45. Figure of a woman seated, with a cup on her shoulder. 39x28

46. Figure of a man seated, with a ball in his hands. 25x16

47. Same

48. Child seated. 24x17

49. Figure of a man standing. 55x23

50. Same

51. Anthropomorphic flute. 31x11

52. Couple clasped together. 40x32

53. Figure of a woman standing. 47x25

54. Same

55. Old man crouching. 28x14

56. Same

57. Figure of a woman standing. 51x25

58. Figure of a woman standing. 41x23

59. Same

60. Figure of a woman standing. 50x19

61. Same

62. Figure with body enclosed in a sort of breastplate (perhaps a ball player). 37x16

63. Figure with body enclosed in a sort of breastplate (perhaps a ball player). 47x18.5

64. Same

65. Woman crouching. 44x20

66. Woman crouching, with uplifted arms. 37.5x21

67. Ball player(?). 57x18

68. Same

69. Woman seated. 46x23

70. Same

71. Man crouching. 39x16

72. Same

73. Woman and child. 23x14

74. Woman with her arms crossed. Origin: Guanajuato. 31x17

75. Abstract figure, *clay* 24x11

76. Same

77. Flat figure, *clay* 28x17.5

78. Figure, *clay* 29x17

MIXE (STATE OF OAXACA)

79. Standing figure, *clay* 33x16

80. Same

TARASCAN
FROM THE STATE OF COLIMA

With the exception of Plates 203 and 204, all the Colima pieces are in baked clay.

81. Figure. 25x17

82. Figurine. 14x10

83. Figurine. 14x10

154. Standing figure. 36x16

155. Seated geometric figure. 36x30

156. Figure carrying a vase. 23x12

157. Hunchback. 37.5x31.5

158. Same as Plate 156

159. Same as Plate 157

160. Dog. 25x24

161. Crouching dog. 20x11

162. Seated figure. 25x14

163. Seated figure. 50x27

164. Same

165. Two ducks. 18x18

166. Duck. 30x18

167. Standing figure. 42x19

168. Same

169. Standing figure. 34x14

170. Same

171. Seated figure. 33.5x18

172. Same

173. Same

174. Hunchback. 27x19

175. Parrot. 20x30

176. Vase with figures. 24x30

177. Vase with human heads. 17.5x17.5

178. Man carrying a load. 31x21

179. Same

180. Seated figure. 34x27

181. Man standing. 34x26

182. Male geometric figure. 36x25

183. Same

184. Same

185. Figure with arm raised. 33x22

186. Seated figure. 36x29

187. Anthropomorphic vase. 30x26

188. Fantastic animal. 26x20

189. Same

190. Figure drinking. 34x22.5

191. Standing figure. 48.5x23

192. Woman seated. 49.5x21

193. Same

194. Seated figure. 44x28

195. Vase with figures. 24x30

196. Figure standing, holding a vase. 43x24

197. Man holding a vase. Tarascan of Jalisco. 32x20

198. Man carrying a burden. 43x22

199. Figure carrying a pitcher. 24x19

200. Dog. 34x18.5

201. Dog. 29x26

202. Seated figure. 28x18

203. Bear. Origin: Chupicuaro, *stone* 41x15

204. Crouching figure. Tarascan of Jalisco, *stone* 19x13

205. Vase in the shape of a fish. Tarascan of Michoacan, *clay* 36x18.5

206. Ball player (?). Tarascan of Colima, *clay* 36x19

207. Tarascan figure. Origin: Chupicuaro, *clay* 9x4.5

CASAS GRANDES

208. Anthropomorphic vase, adorned with geometric decorations. Origin: Casas Grandes, *baked clay* 27x21

TOLTEC

Toltec is used as a generic term for the undefined plastic stages prior to the coming of the Aztecs.

209. Idol wearing pendants in its ears. It has hollow eyes, mouth partly open, and a green stone (probably representing the heart) is placed in a hole in the chest, *calcified light-green jade* (cf. Guerrero Plates 21-22) 17x8.5

210. Head. Origin: Valley of Mexico. Attributed to the Toltec civilization because of the characteristic shape, in spite of the conical headdress or 'copilli,' which is typically Huastec. 40x23

211. Same, profile

212. Mask, *stone* 22x17

213. Rudimentary standing figure, with loin cloth; perhaps an effigy of Patecatl (because of the crescent under the nose). Aztec(?), *lava stone* 100x50

214. Man with crossed arms. Aztec(?), *lava stone* 84x39

215. Left: Effigy of Tezcatlipoca, holding a mirror in his hand. Aztec(?), *lava stone* 76x24

 Right: Banner bearer. Aztec, *lava stone* 81x25

216. Head of man. Origin: Tula, *stone* 27x17

217. Seated figure. Origin: Teotihuacan 6x3

218. Mask, *jade* 19x18

219. Mask, *diorite* 15x13

ZAPOTEC

220. Man seated. Zapotec, *clay* 29x15

221. Same

MIXTEC

222. Mask of Tlaloc. Mixtec, *jade in process of decomposition* 13x13

AZTEC

223. Tlaloc, *clay* 43x42

224. Tlaloc, *clay* 22x12

225. Tlaloc, *clay* 17x12.5

226. Tlaloc, *clay* 17x11

227. Tlaloc, profile of figure 224, *clay*

228. Tlaloc, *clay* 31x25

229. Tlaloc, *clay* 37x23

230. Chalchihuitlicue, the goddess of water, recognizable through her cloak whose corners fall in a point in front and in back. She is kneeling, in the manner of the Mexican women, both her hands placed on her knees. She wears a turban with two large pendants falling on each side of her face, hiding her ears; mouth partly open, hollow eyes, *basalt* 46x22

231. Same

232. Effigy of Ehecatl or Quetzalcoat, god of wind, recognizable by the mouth which juts out like a beak, *stone* 105x 32

233. Effigy of Centeocihuatl, goddess of maize, always represented with the 'Amacalli' or house of paper on her head, which is one of her attributes; shown kneeling, *lava stone* 28x21

234. Chalchihuitlicue, *lava stone* 35x19

235. Dog or coyote (Itzcuintla), *stone* 37x18

236. Figure of a man, perhaps a ball player, with a sash. Origin: Tlaxco viejo, *basalt* 48.5x19

237. Head of a man, *meteorite* 24x20

238. Centeocihuatl; besides the 'Amacalli' she holds ears of maize in her hands, *lava stone* 42x24

239. Male figure. Latest Aztec era, *granite* 59x28

240. Male figure, *lava stone* 23x28

241. Figure of a man standing, *baked clay* 68x32

242. Centeocihuatl, *lava stone* 42x28

243. Centeocihuatl, *lava stone* 36x16.5

244. Same

245. Woman seated, *stone* 42x23

246. Man with his knees bent back on his chest, *stone* 42x18

247. Man with his legs crossed, *stone* 35x 18.5

248. Cascabel serpent, or serpent with little bells, *stone* 19x22

249. Possibly the figure of a woman deified after her death. The eyes and ears are represented by concentric circles. She wears rings in her ears, *stone* 54x0.38

TOTONAC

250. Relief. Origin: Tajin, *stone* 49x49

251. Male torso with a head carved on the

chest. Origin: Sierra de Puebla, *jadeite* 30x20

252. Male head, *stone* 19x8.5

253. Figure with crossed arms. Note the headdress, earrings, and necklace, *clay* 35x22

254. Head adorned with earrings and necklace, *clay* 20x13

255. Decorated Huastec vase, *clay* 23x25

256. Male figure. Origin: Veracruz, *clay* 36x19

MATLAZINCAN

257. Figure. Matlazincan. Origin: Calixtlahuaca, *sandstone* 95x21

258. Man seated, with arms crossed. Matlazincan. Origin: Calixtlahuaca, *lava stone* 60x15

259. Serpent shaped from a mandragora root. Origin: Coyoacan. 40x42

ARCHAIC SCULPTURE OF
GUERRERO

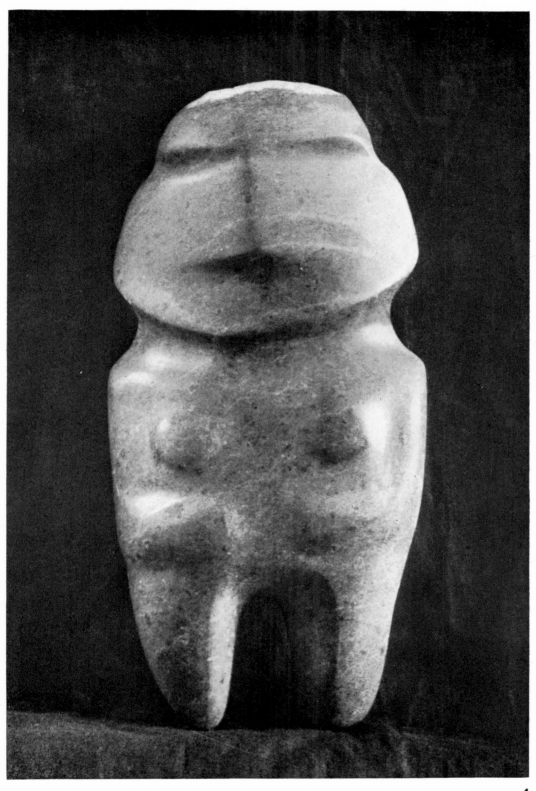

4

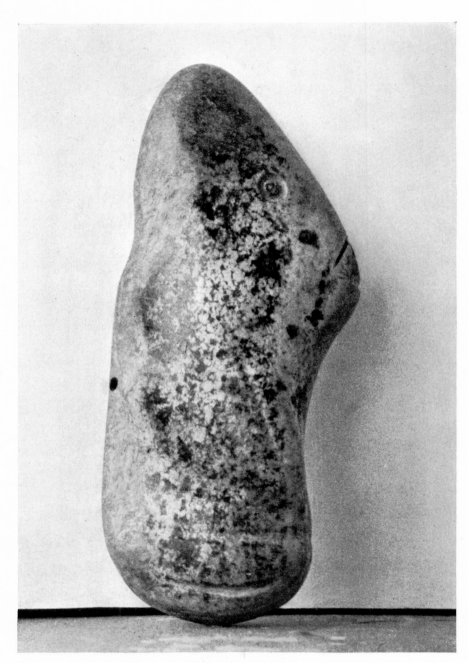

5

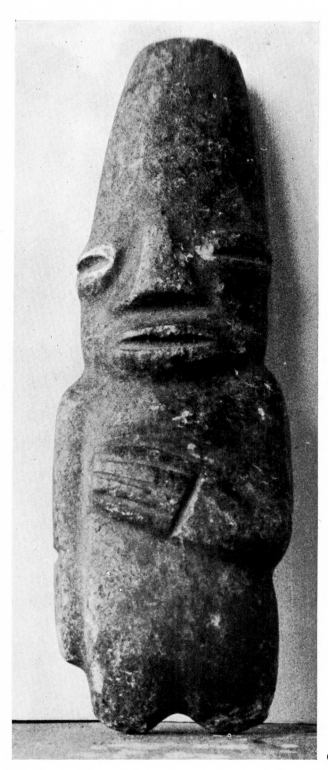

6

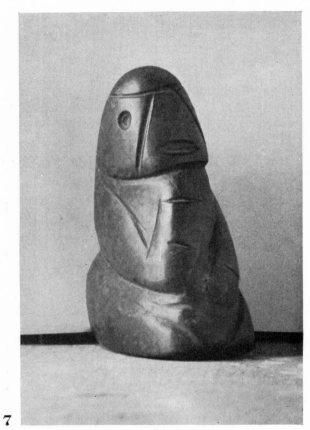

7

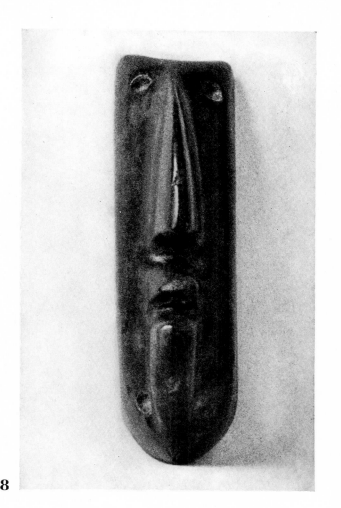

8

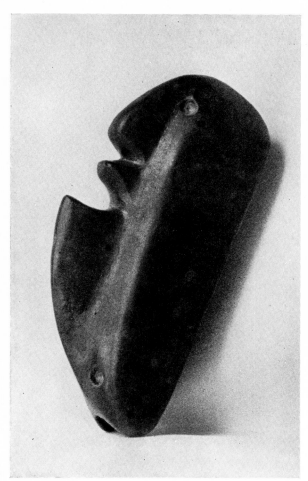

9

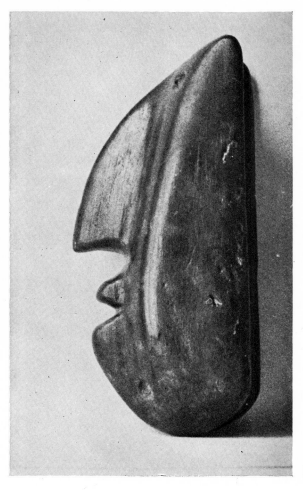

10

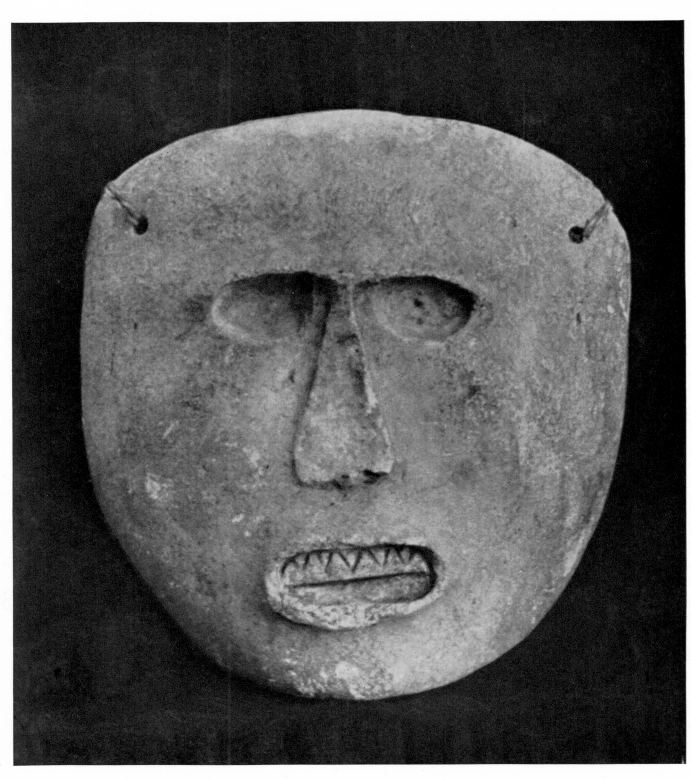

11

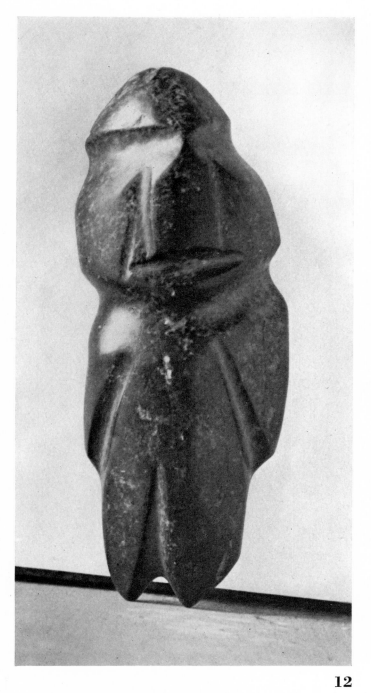

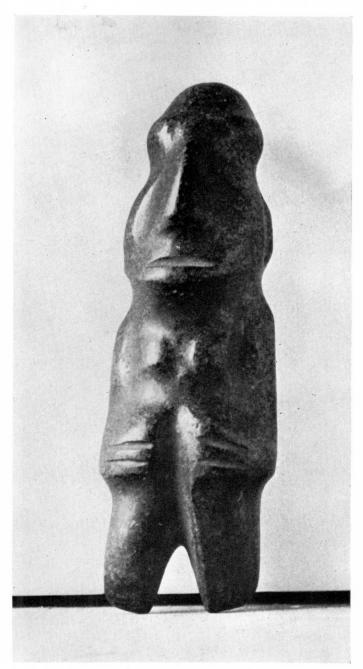

12

13

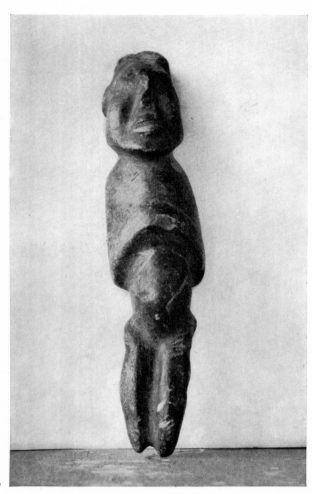

14

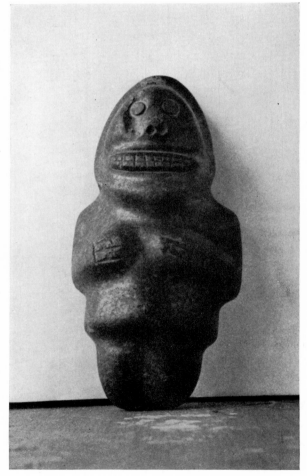

15

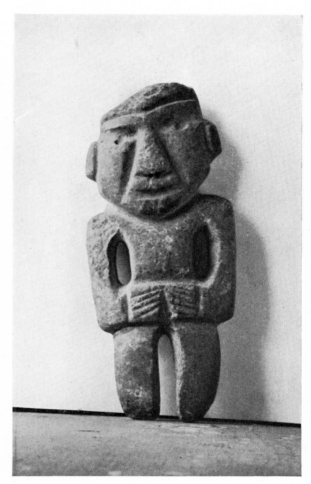

17

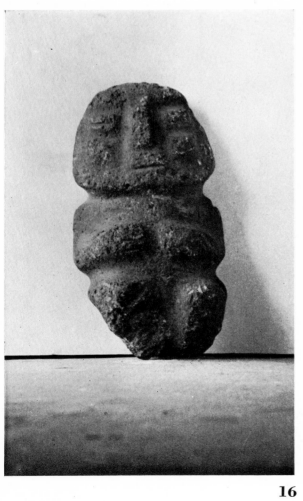

16

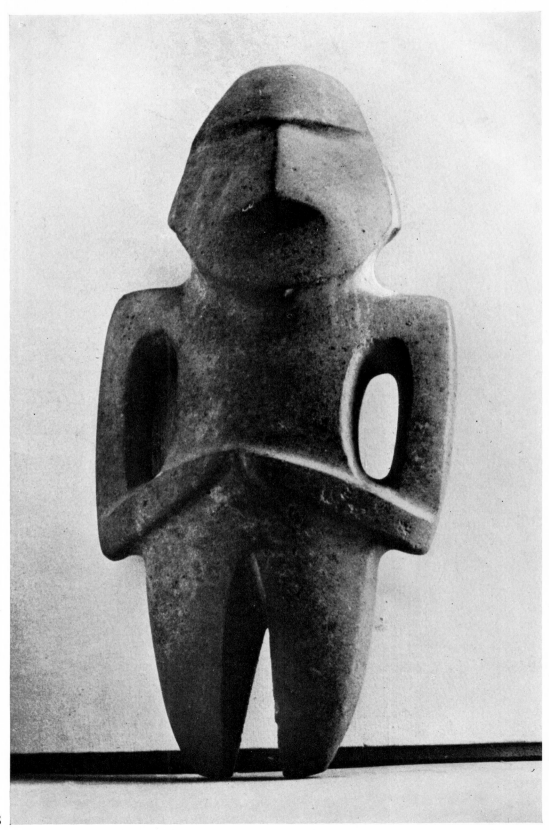

18

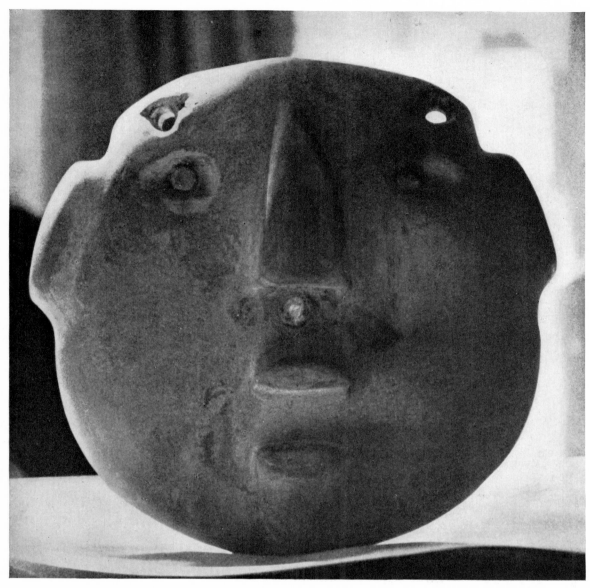

19

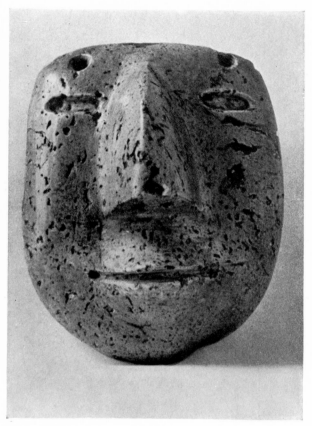

20

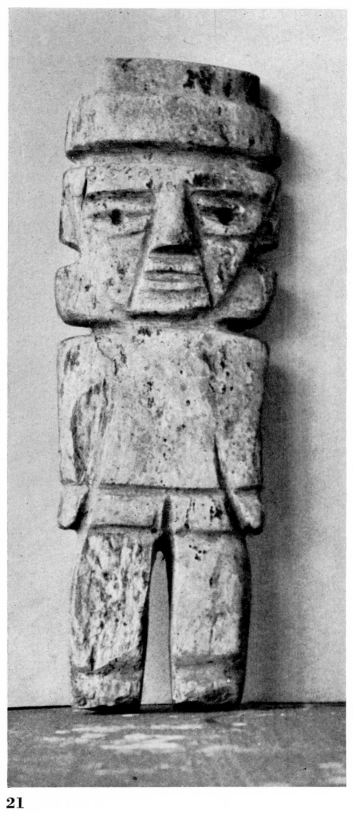

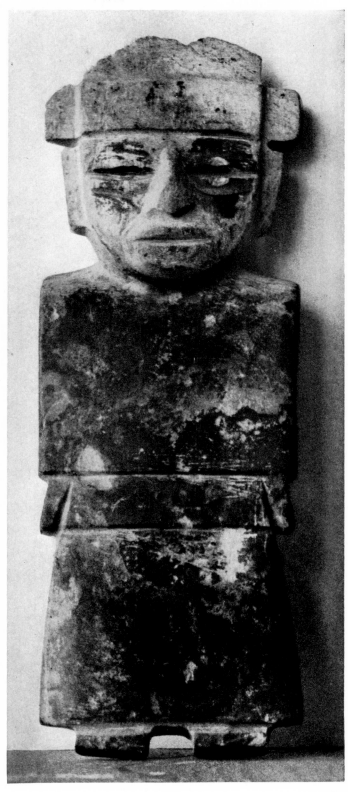

21

22

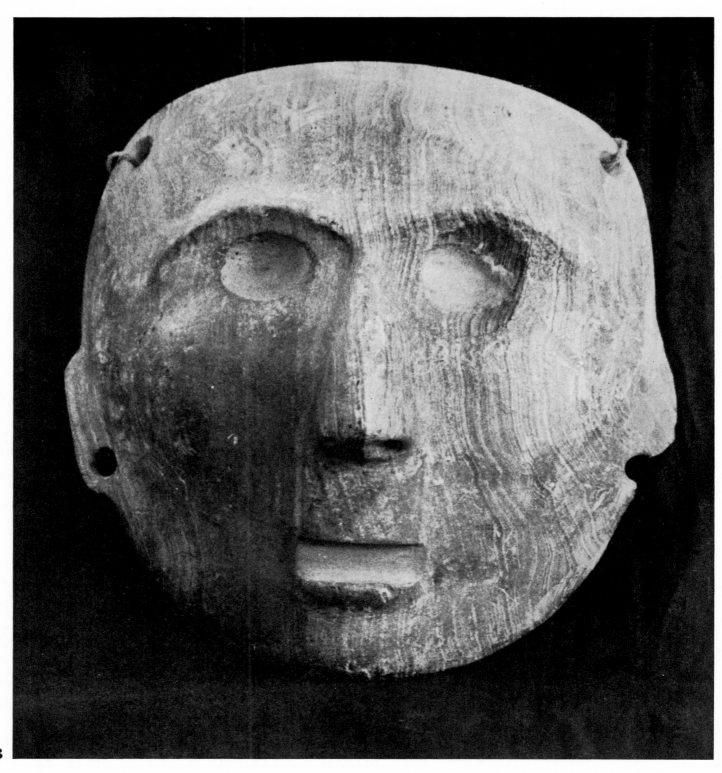

23

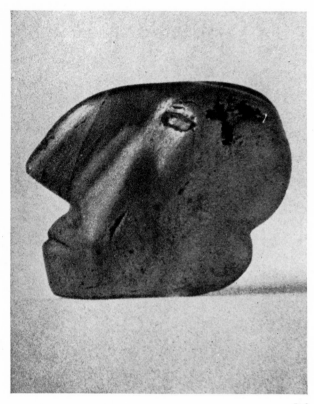

24

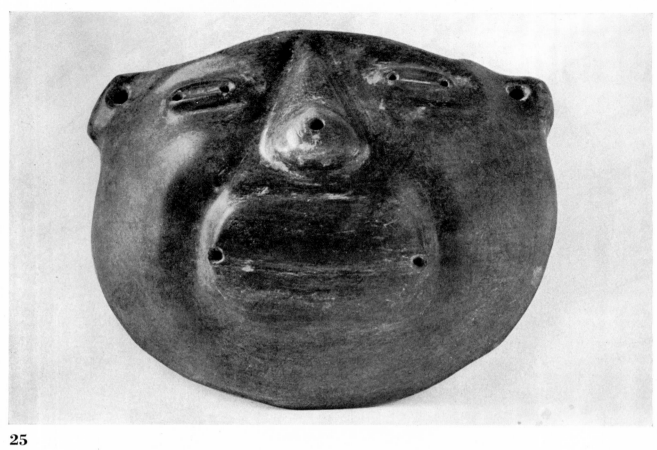

25

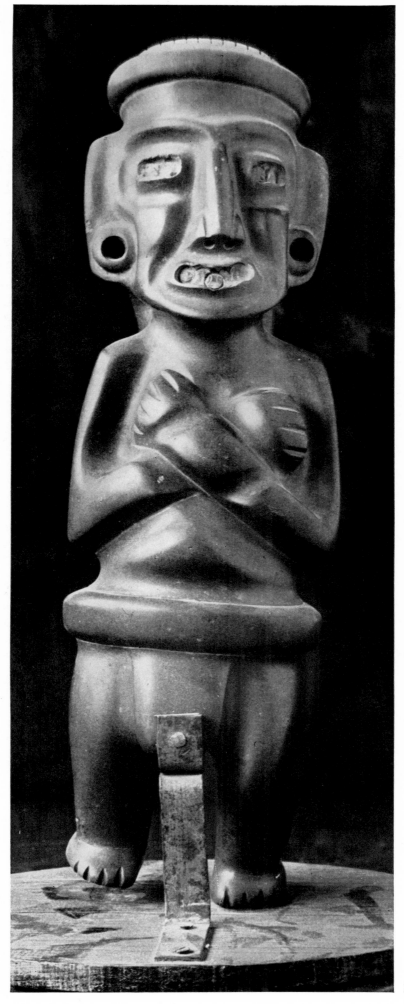

26

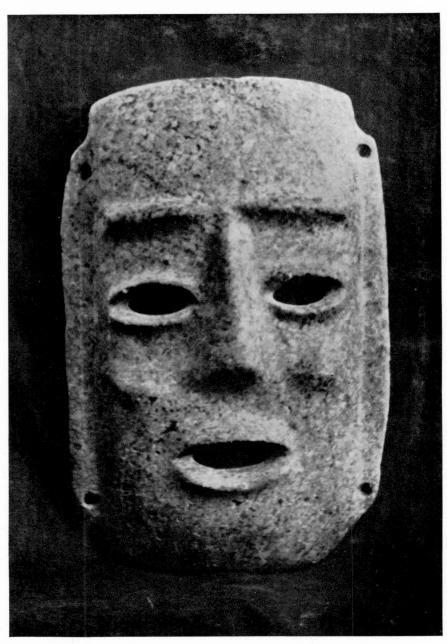

27

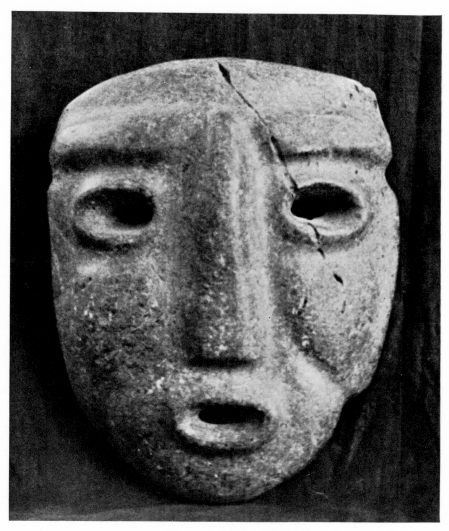

28

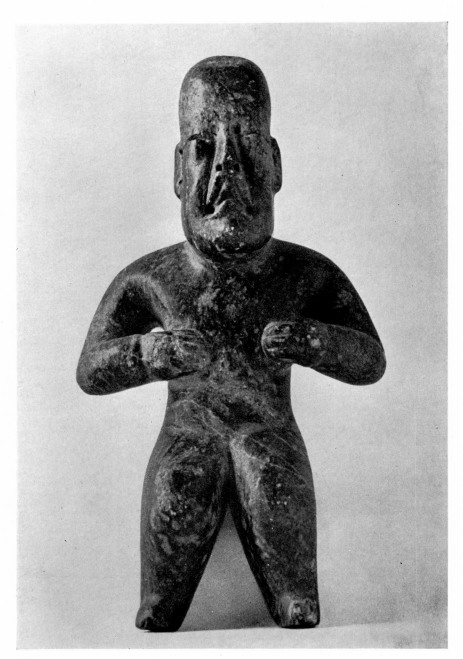

29

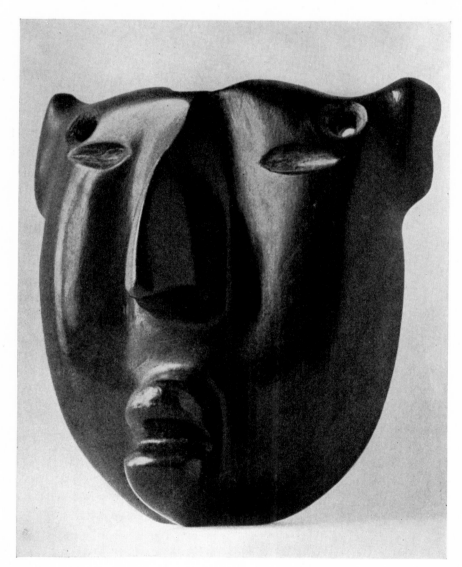

30

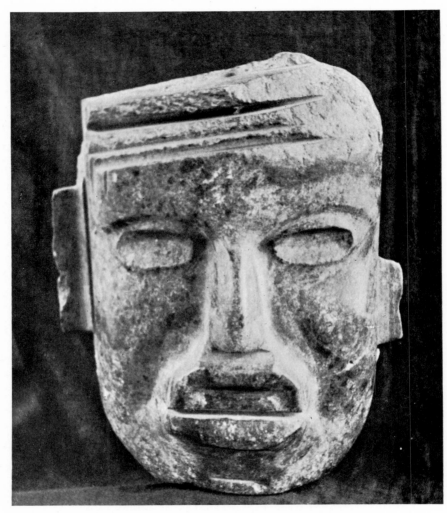

31

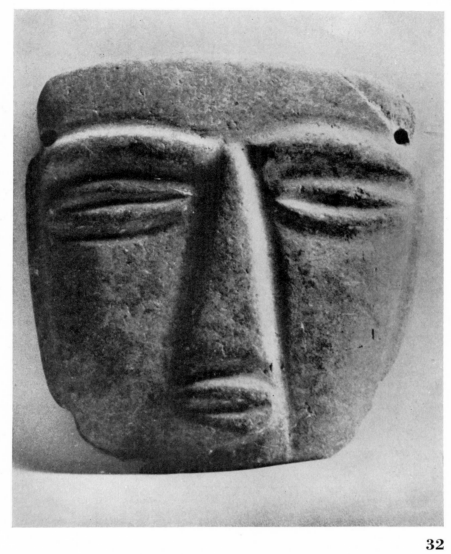

32

TARASCAN

FROM THE STATE OF NAYARIT

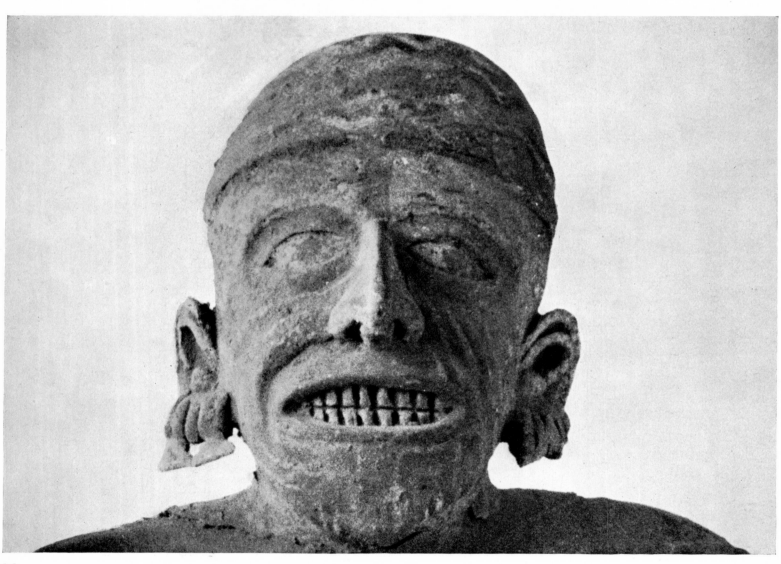

33

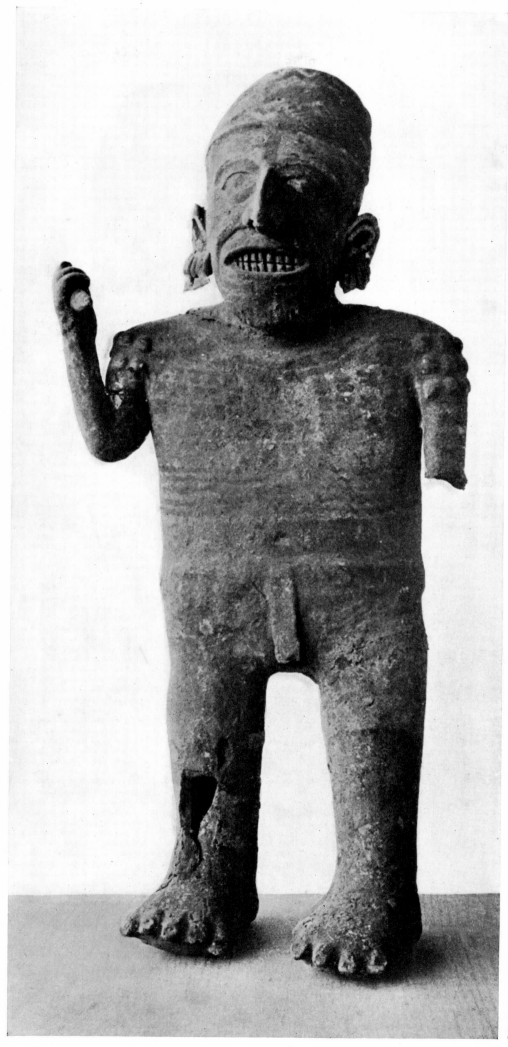

34

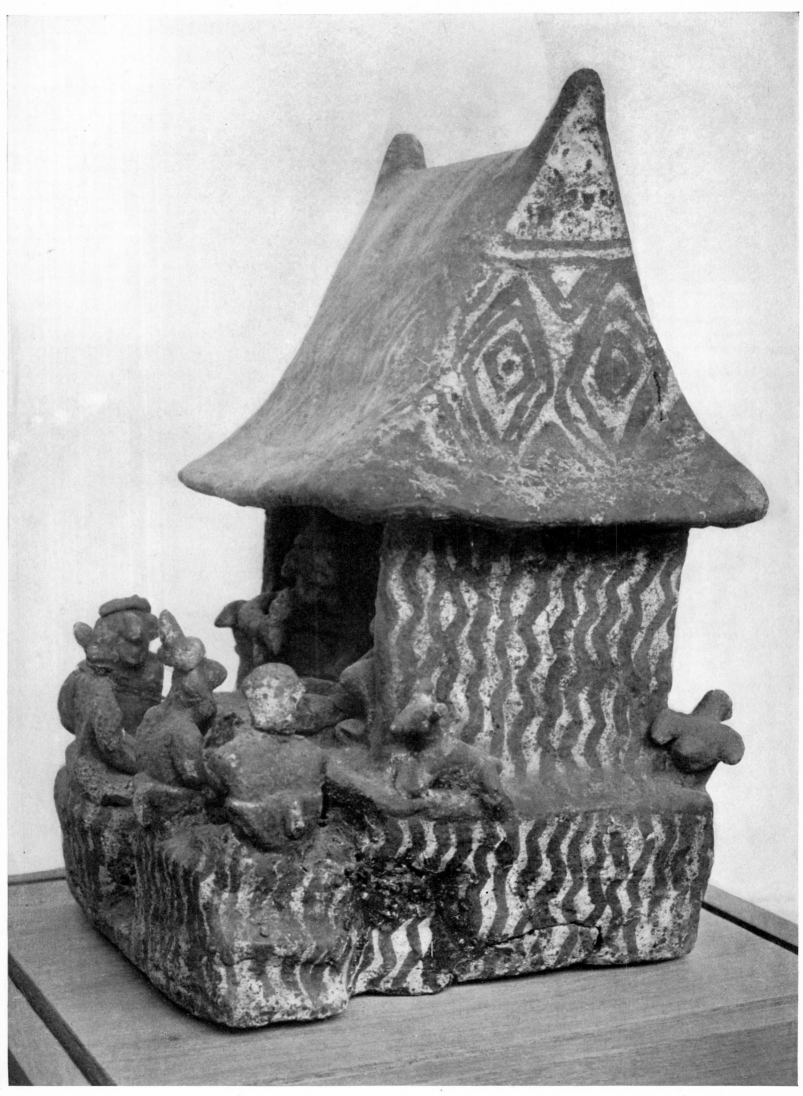

35

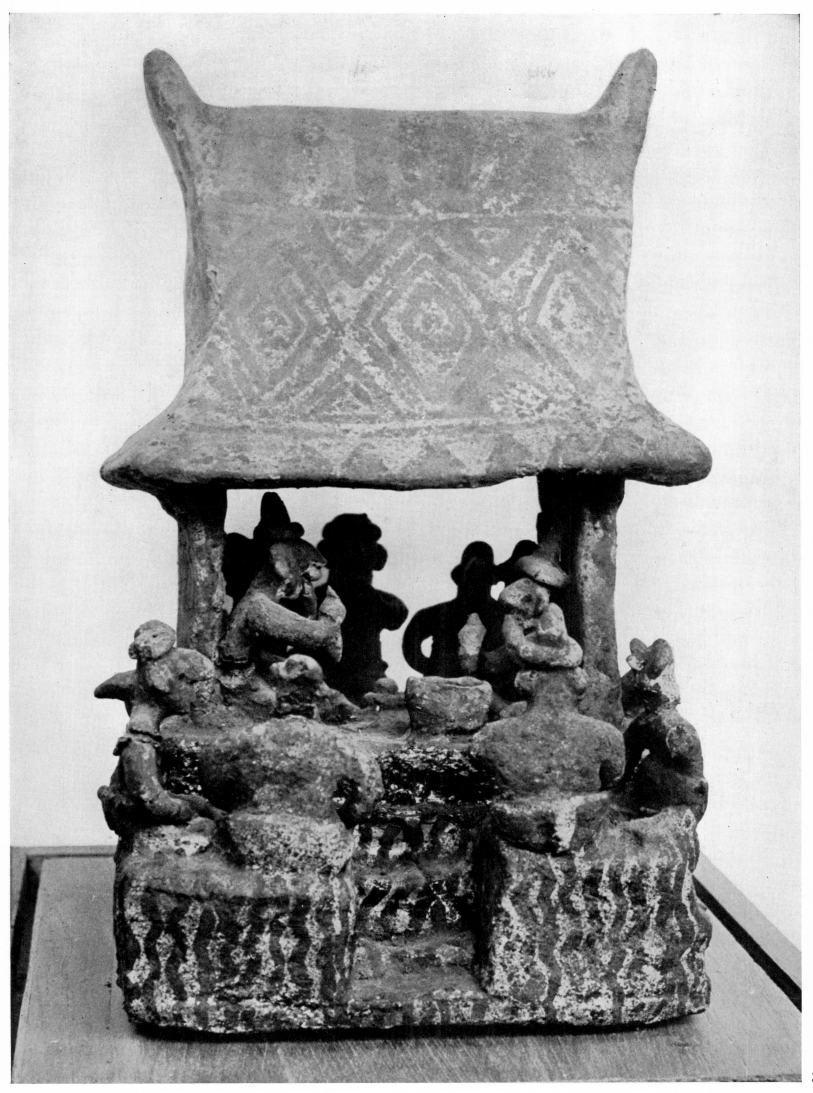

36

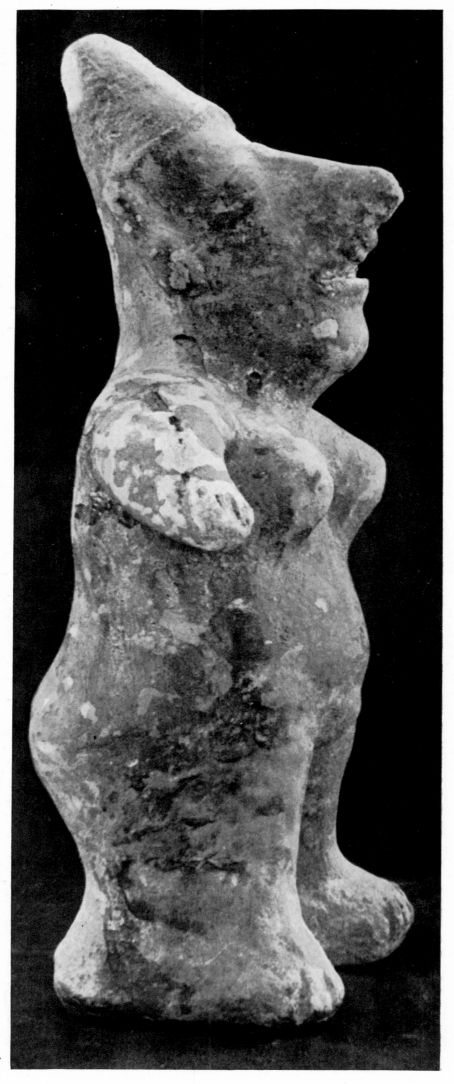

37

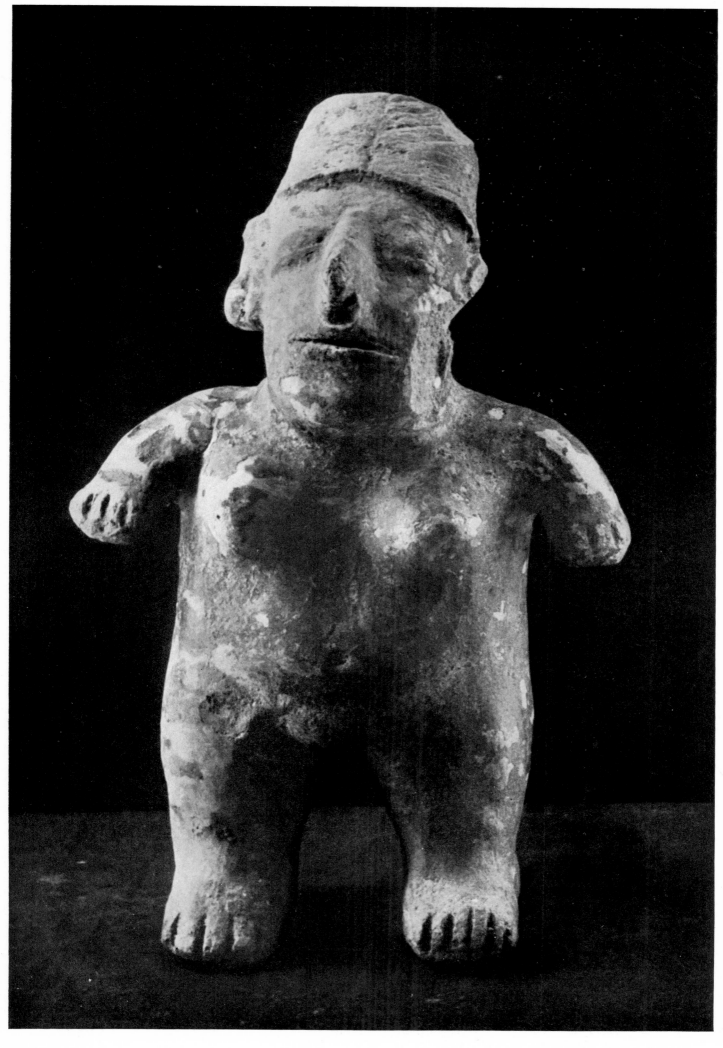

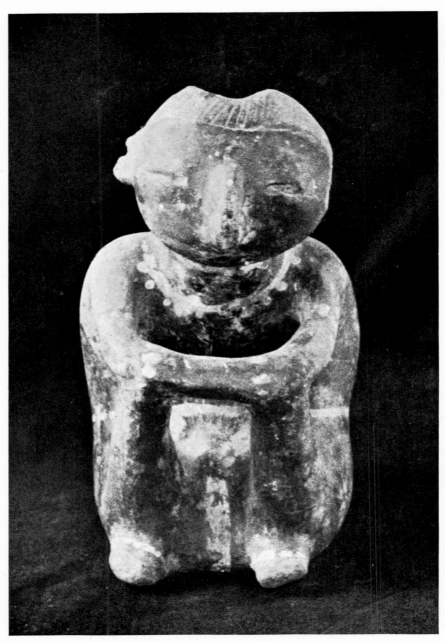

39

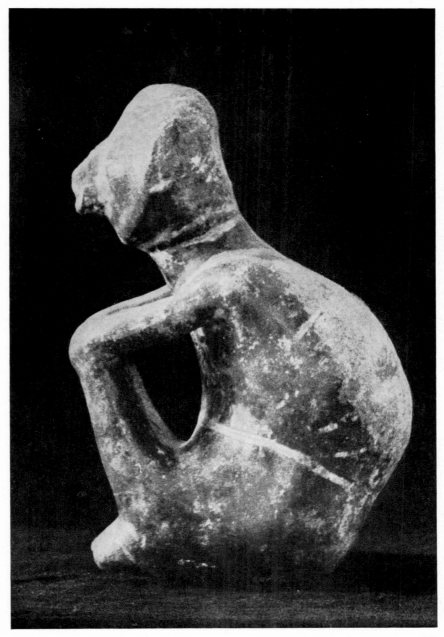

40

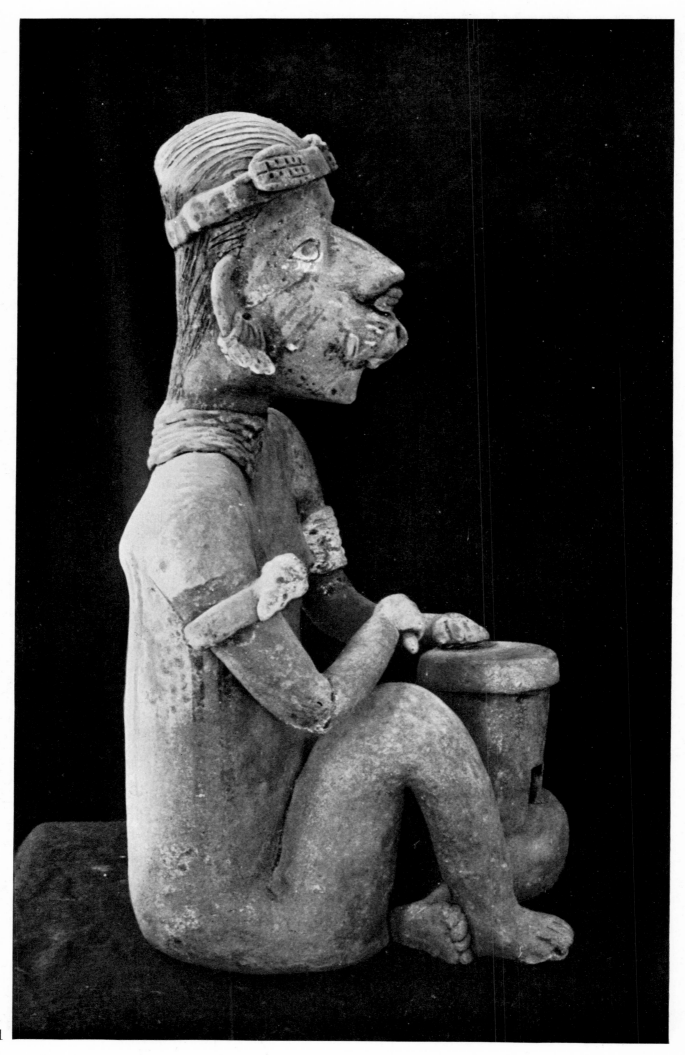

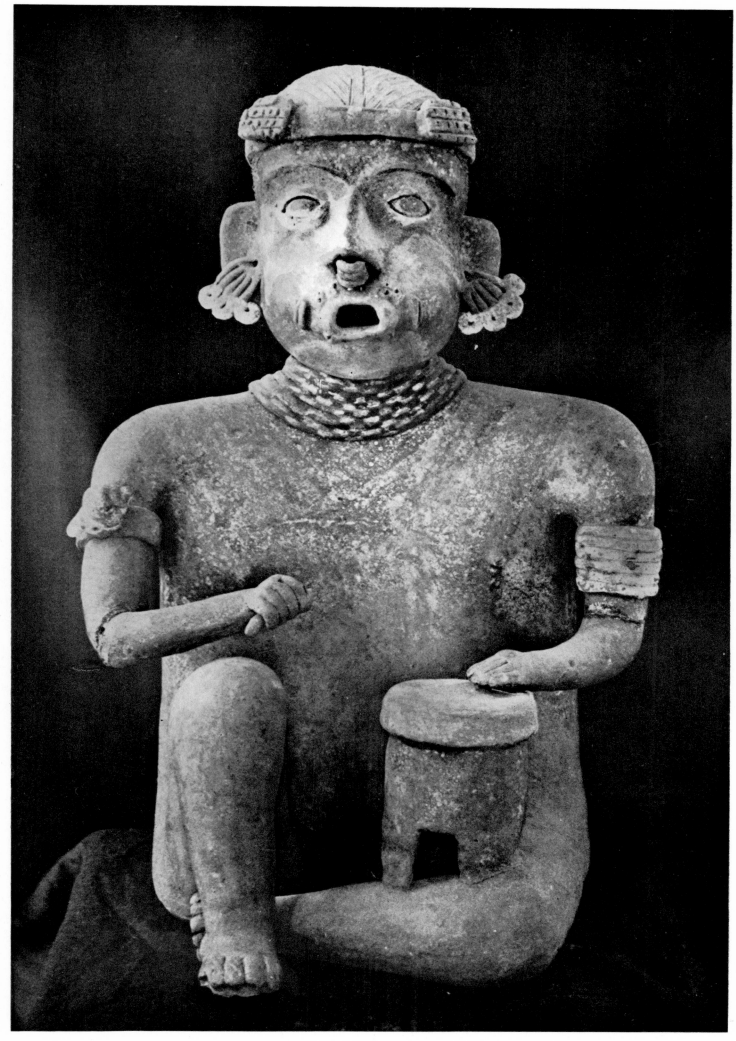

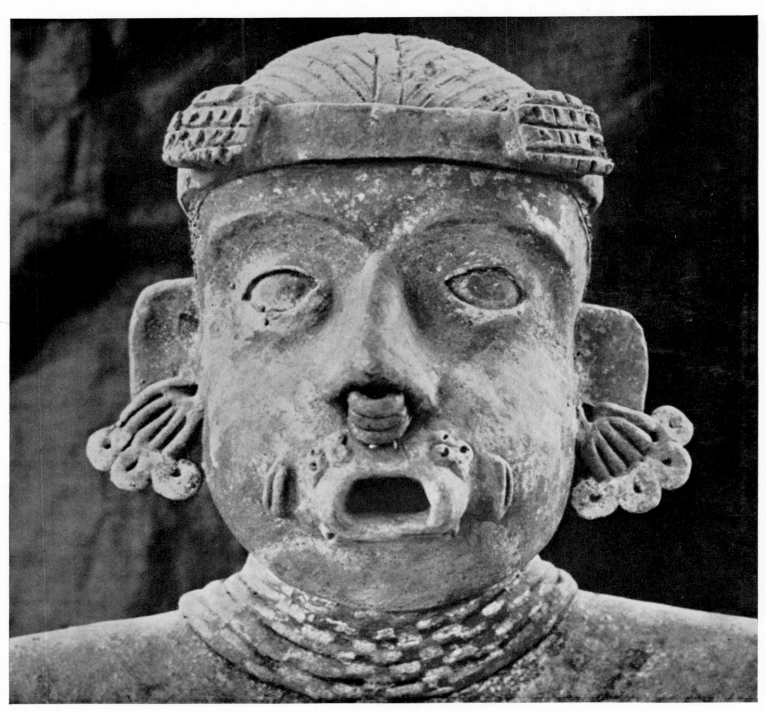

43

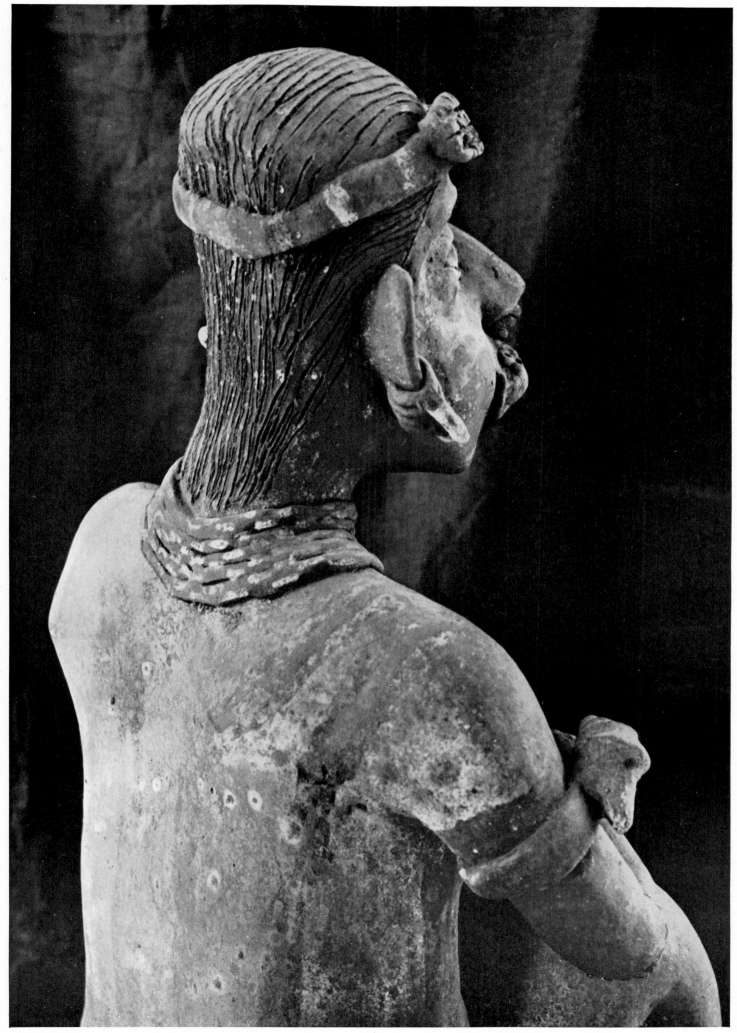

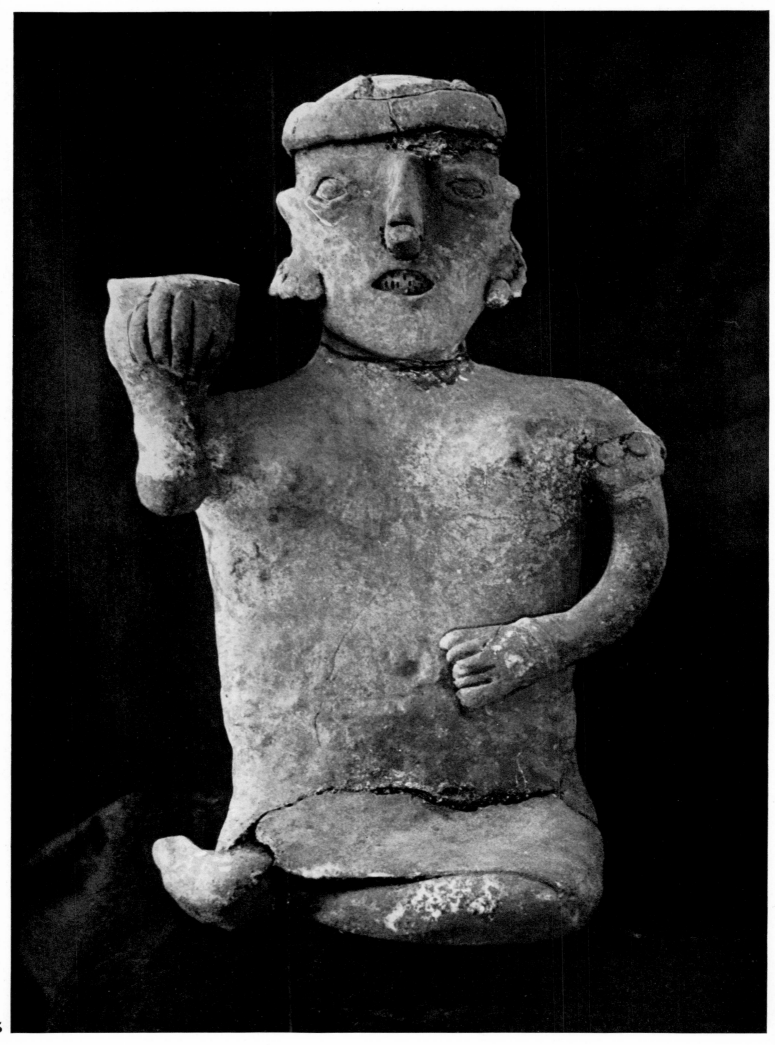

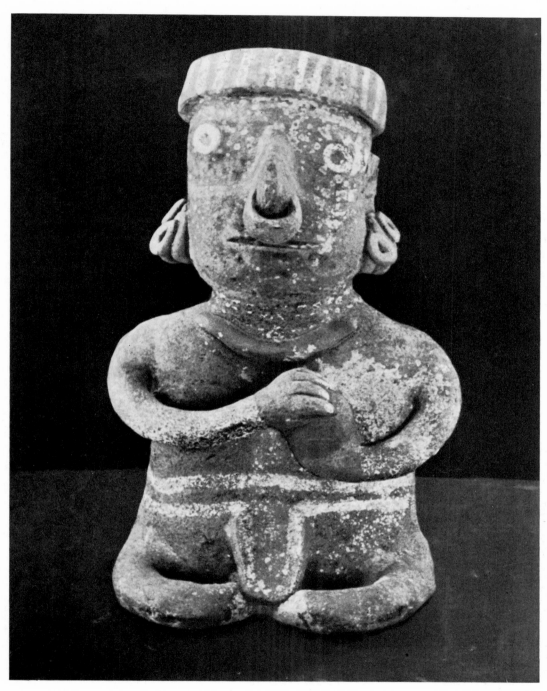

46

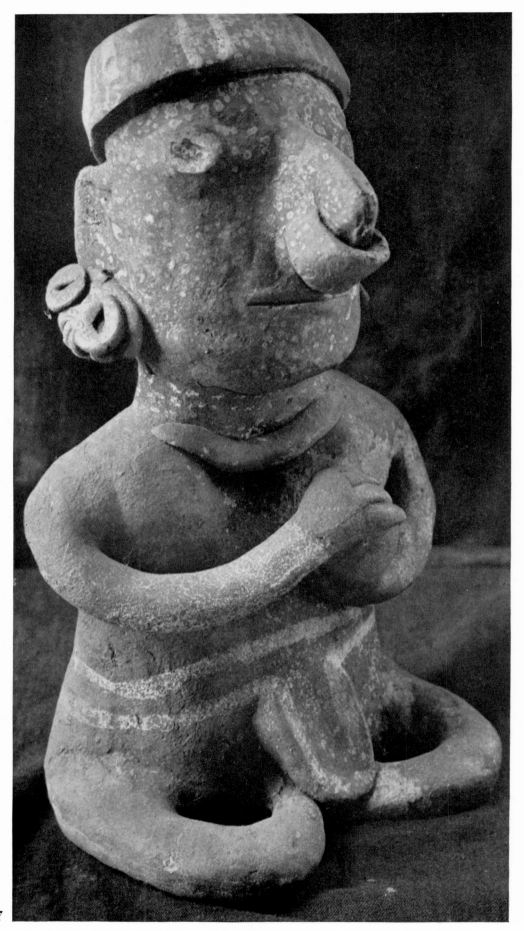

47

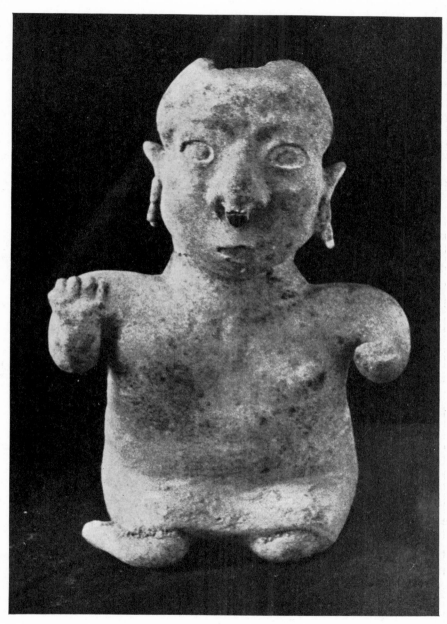

48

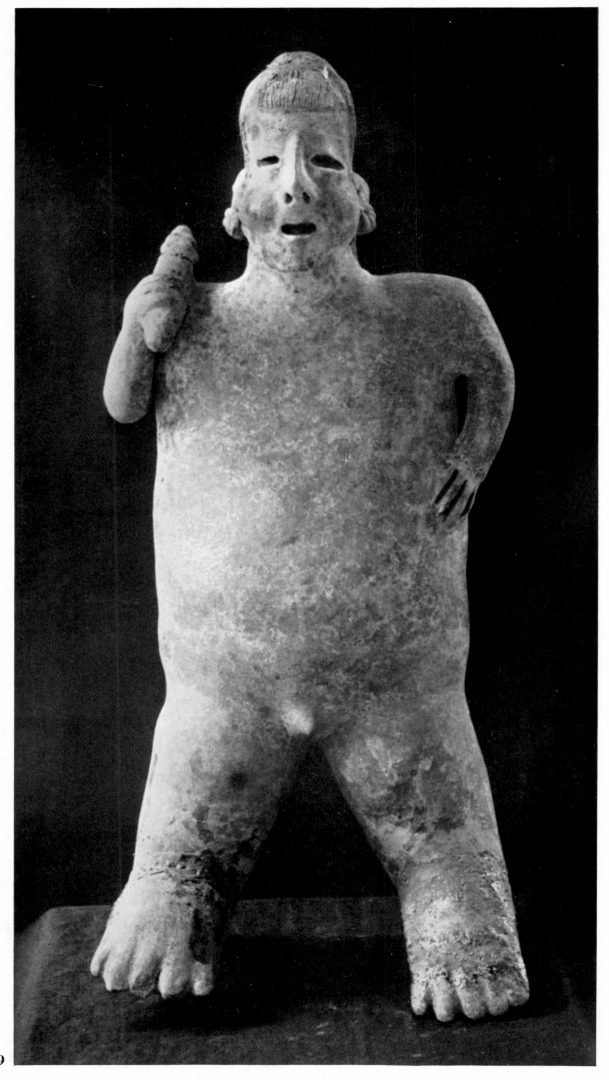

49

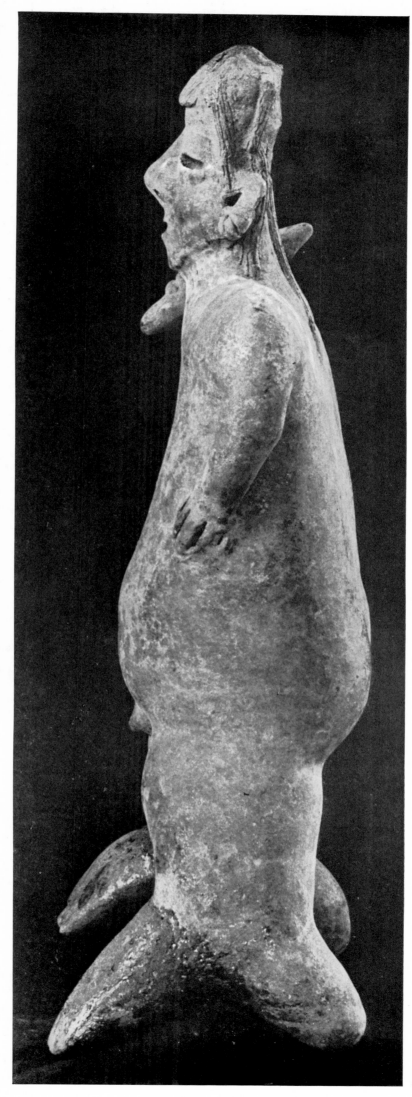

50

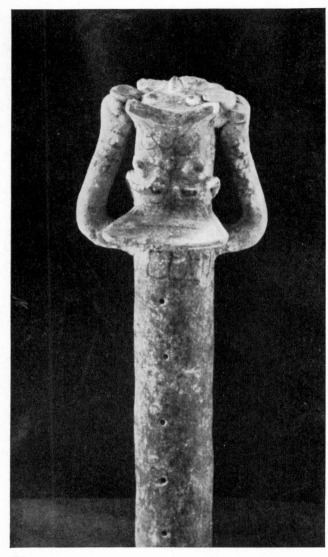

51

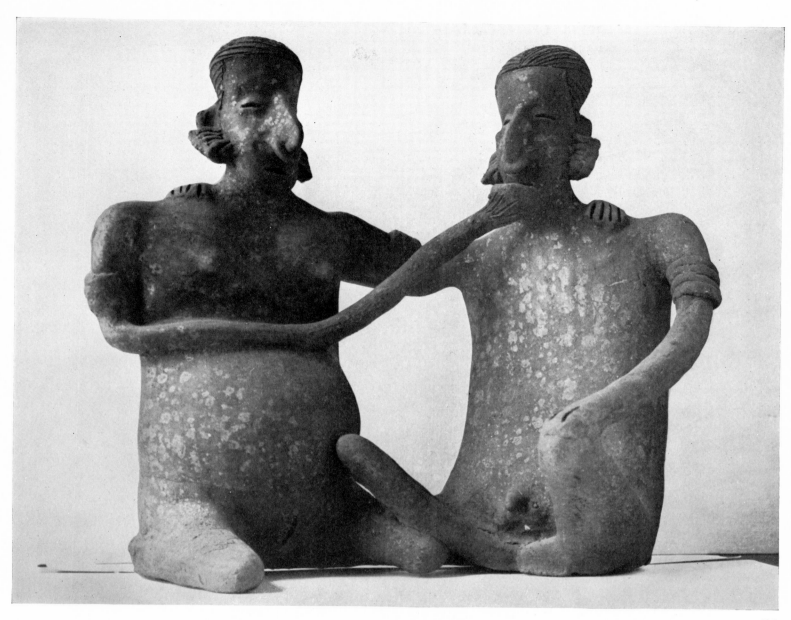

52

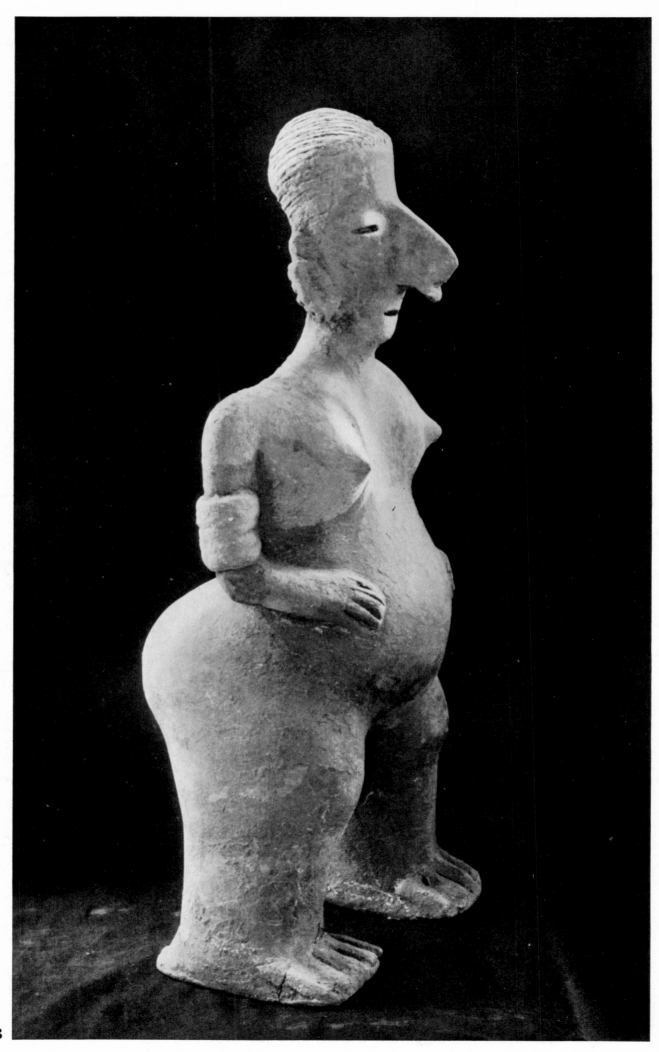

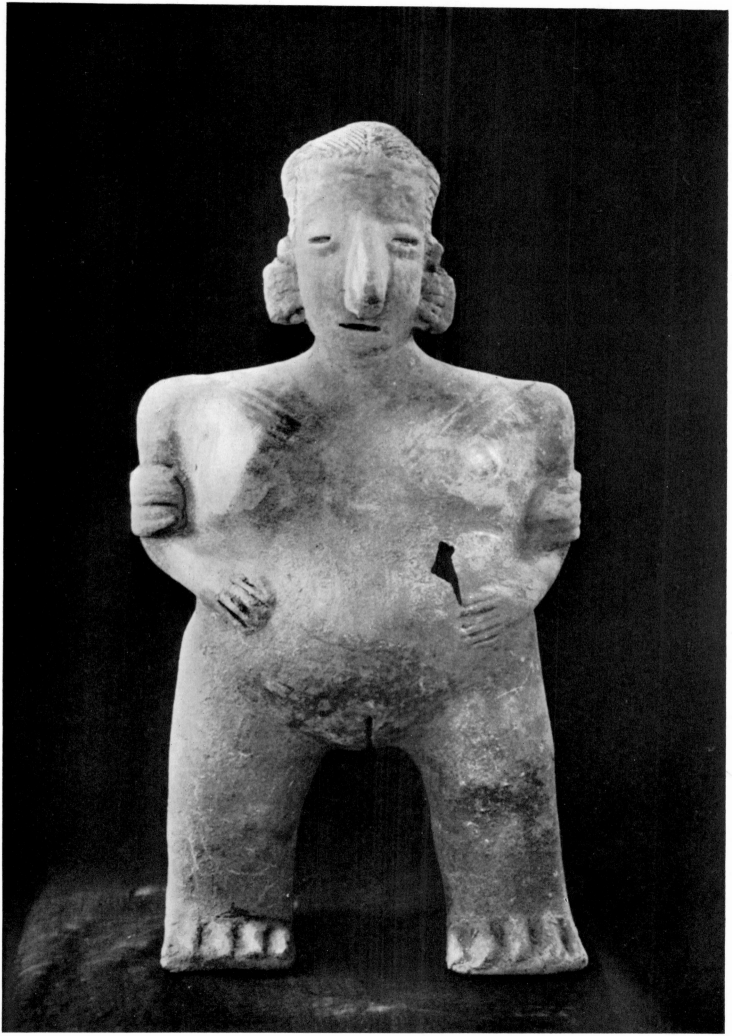

54

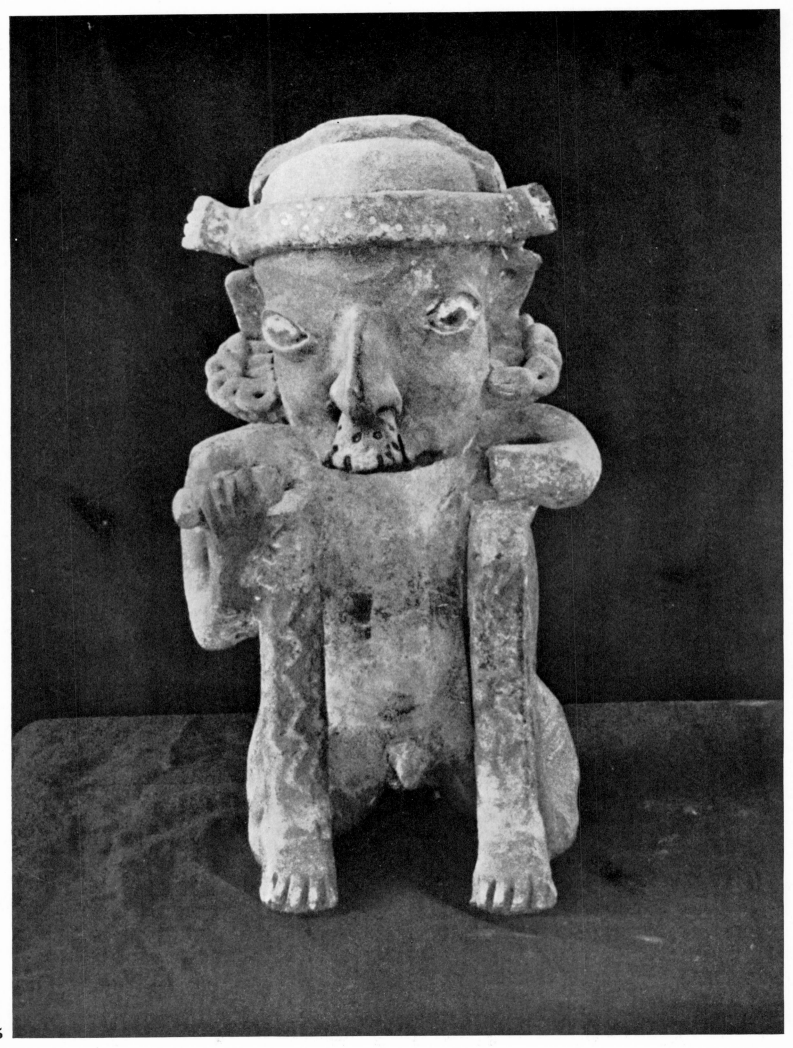

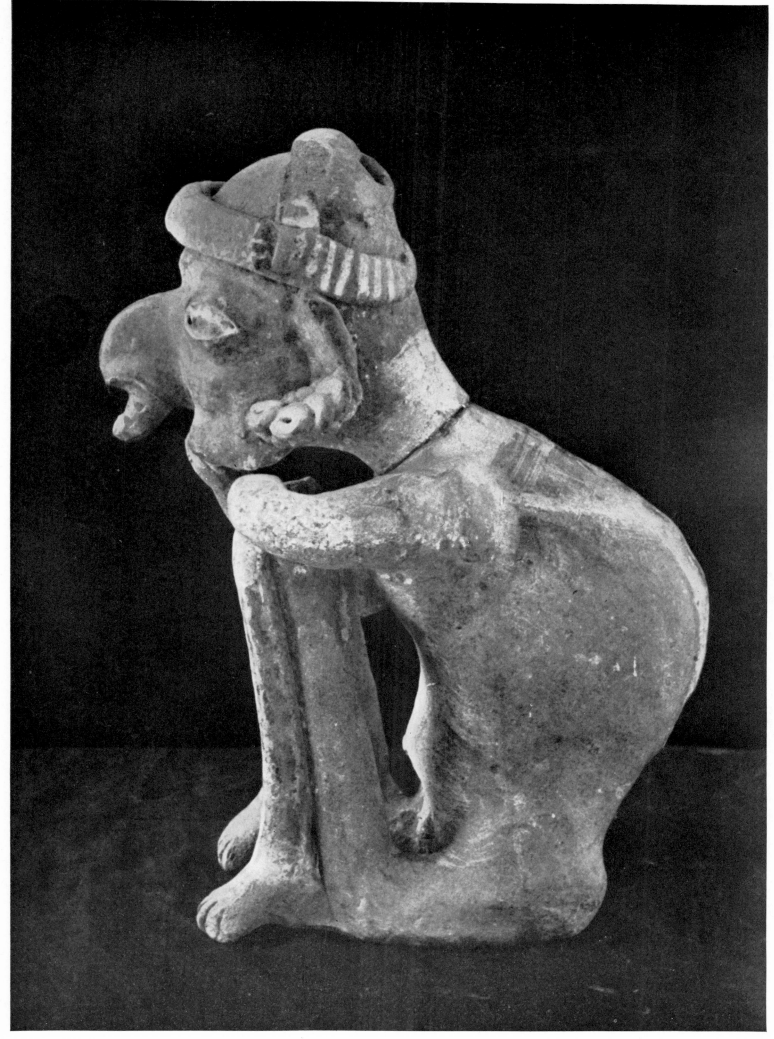

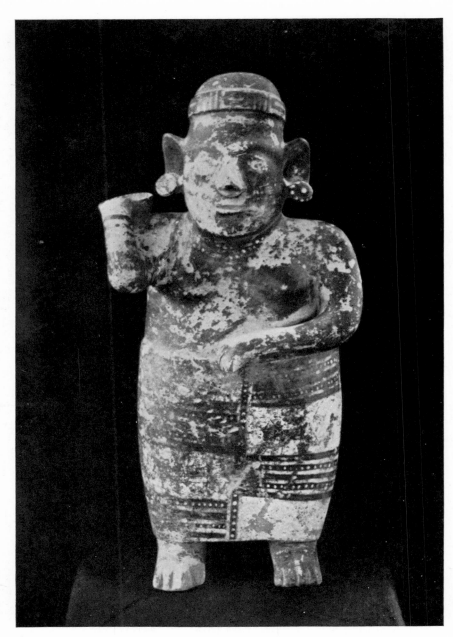

57

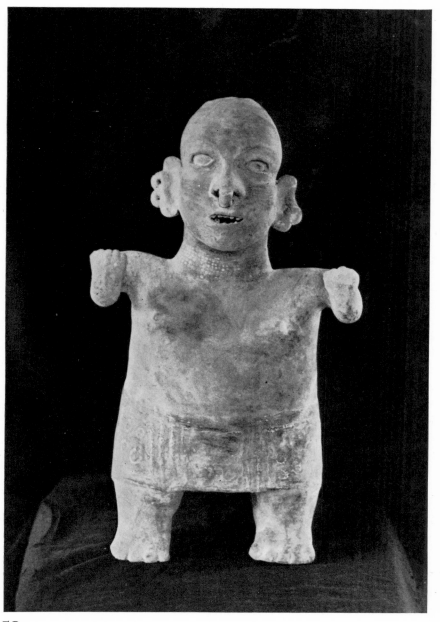

58

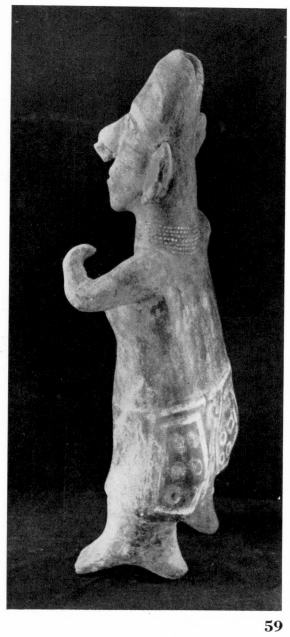

59

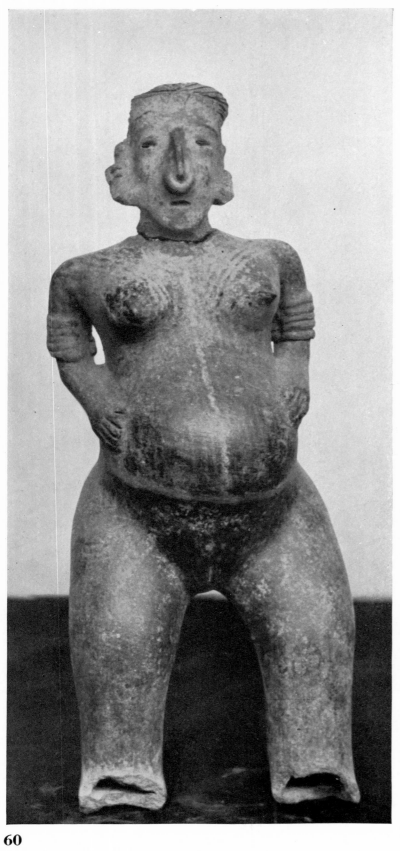

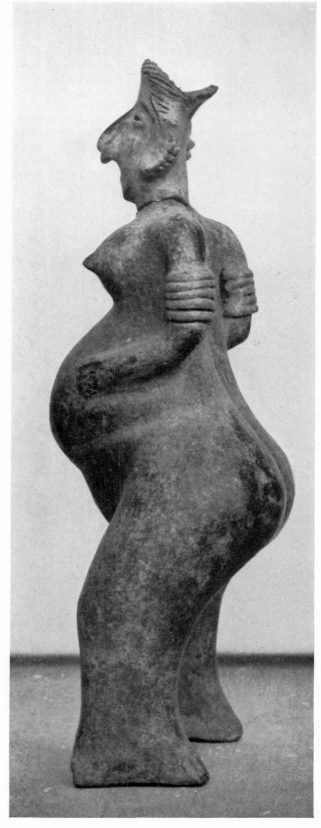

60

61

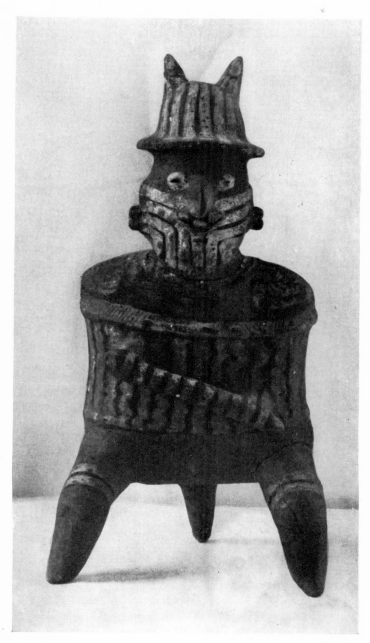

62

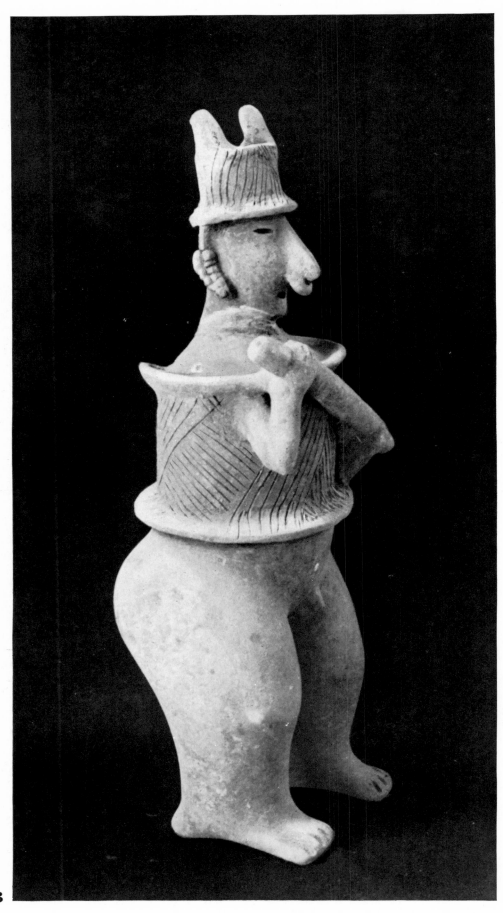

63

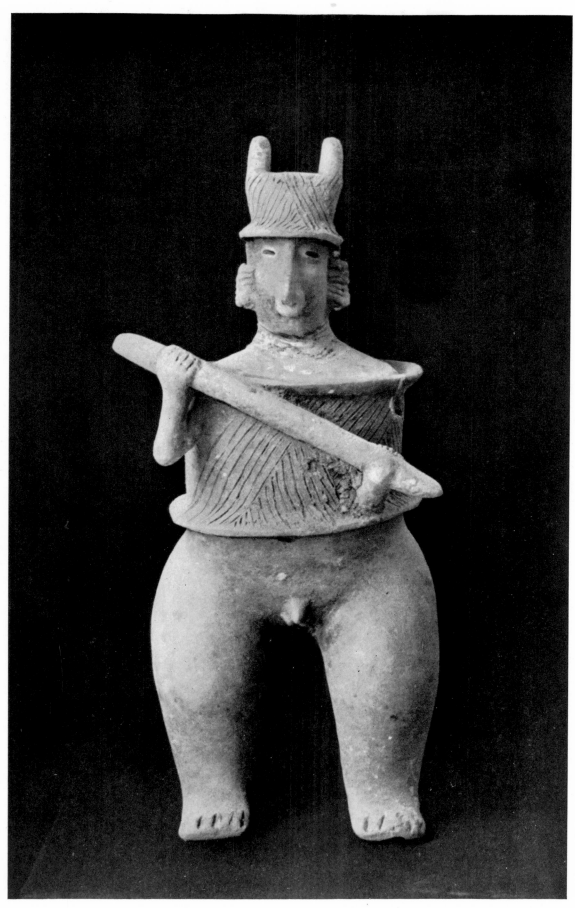

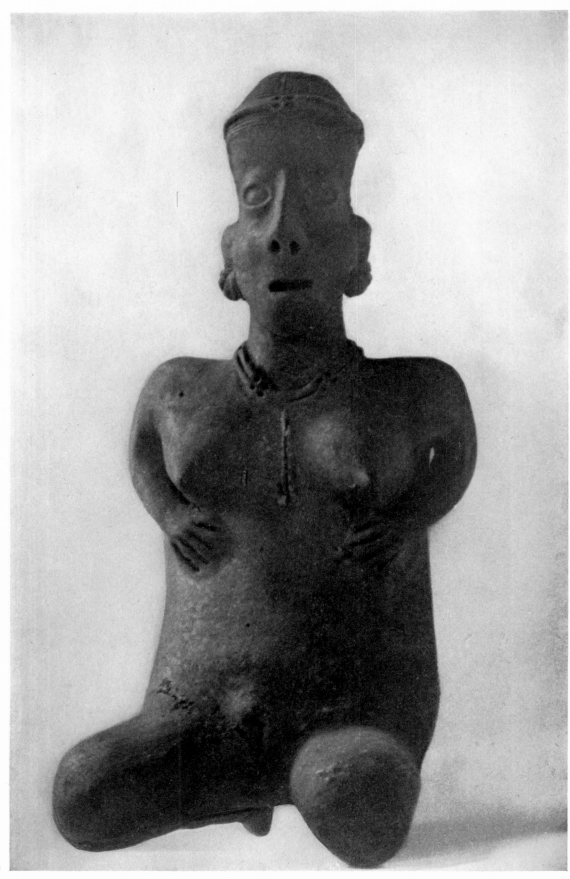

65

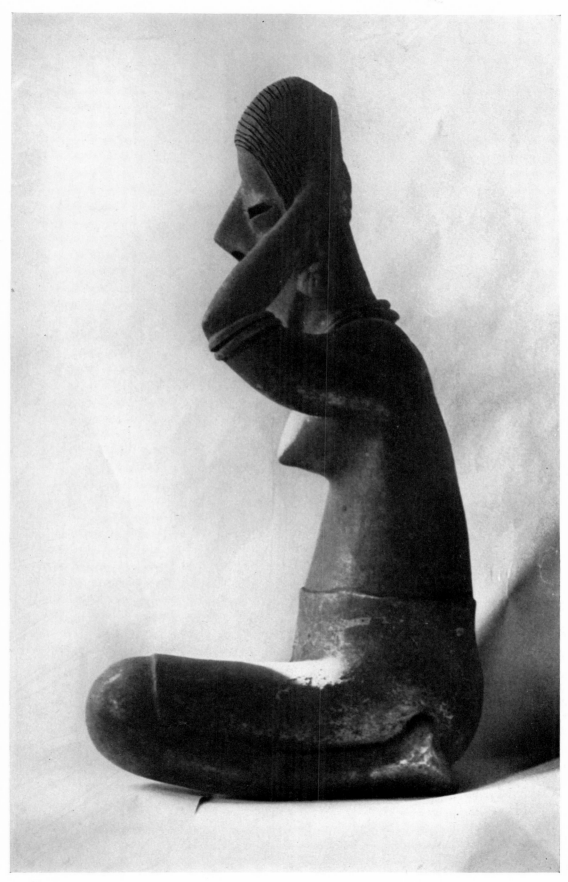

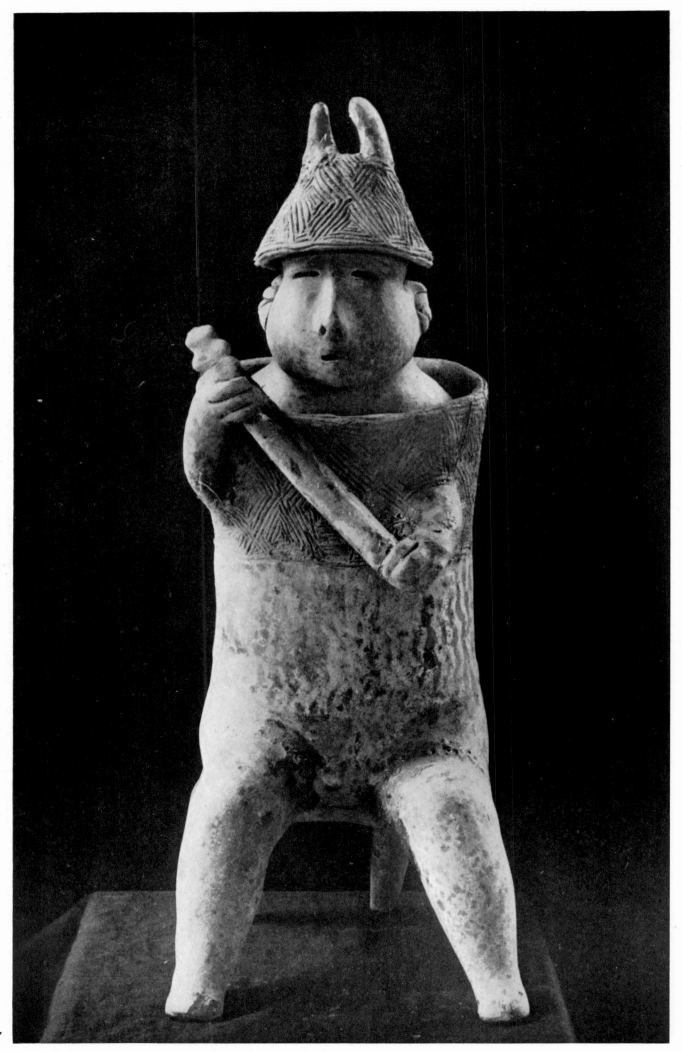

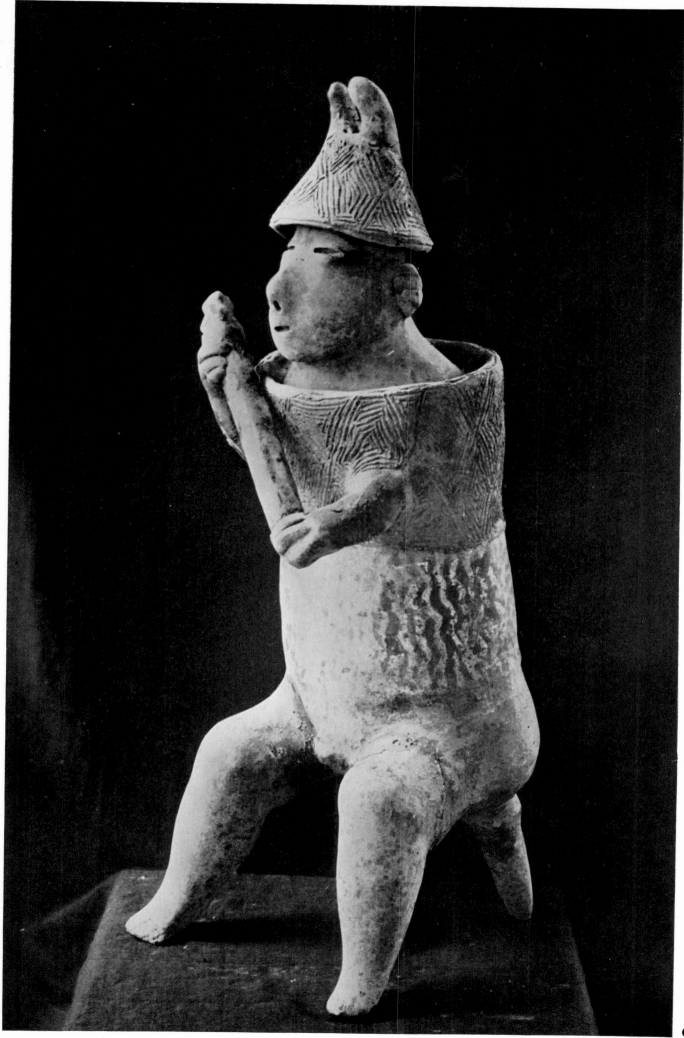

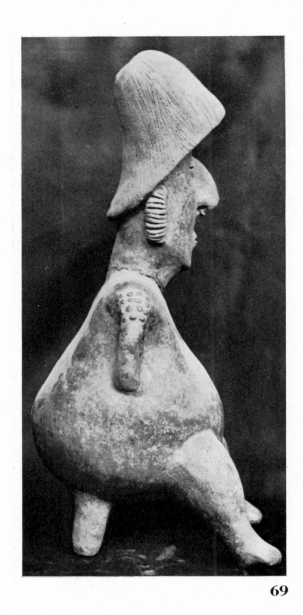

69

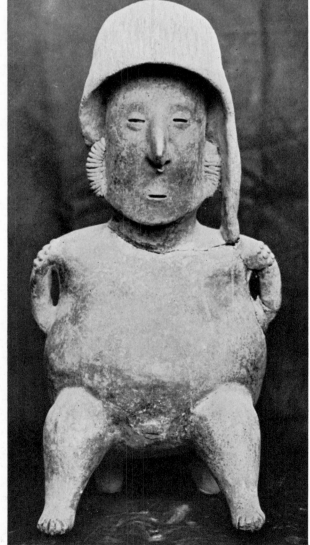

70

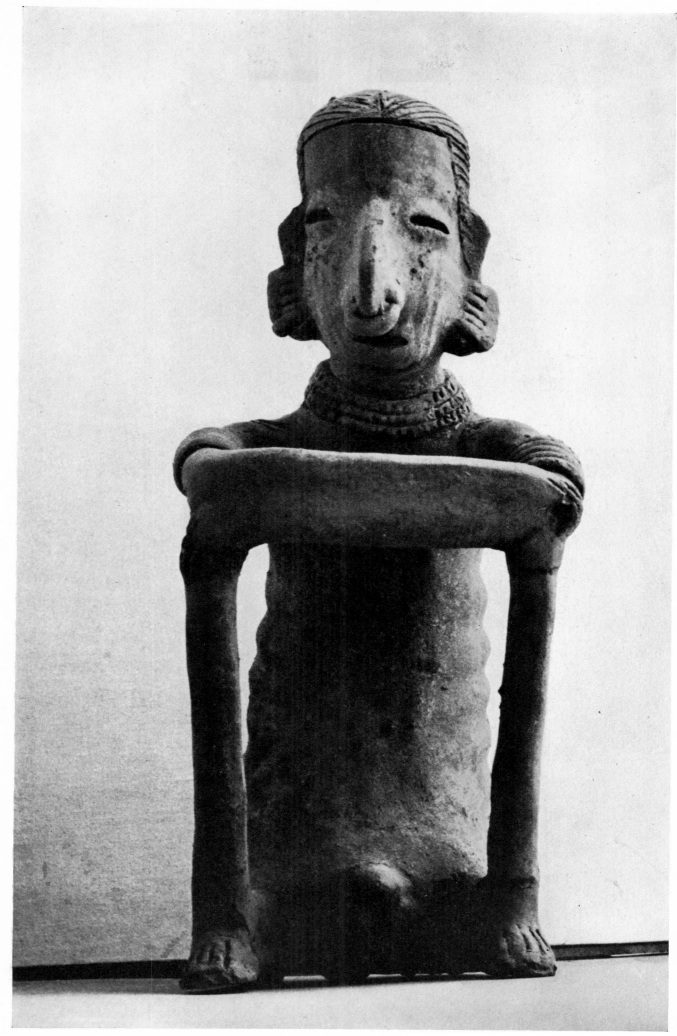

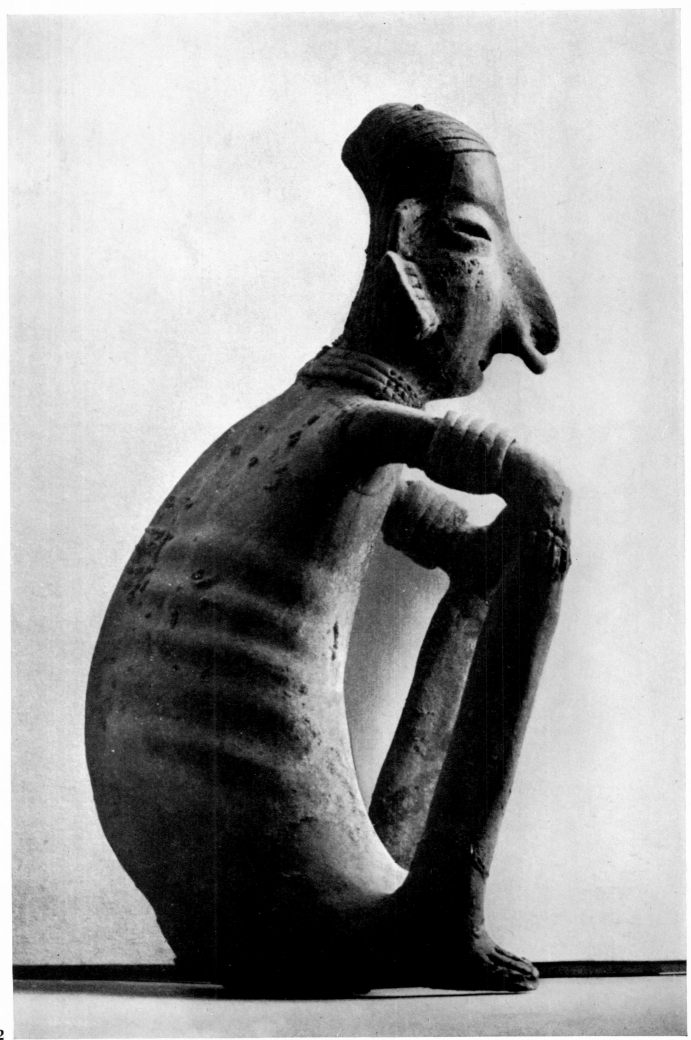

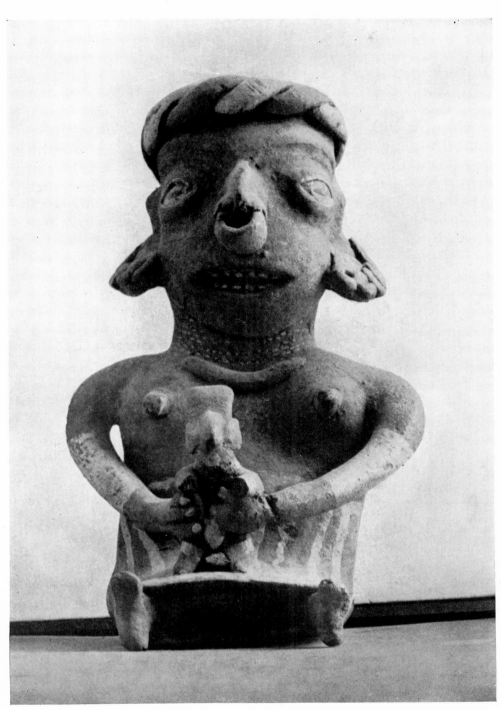

73

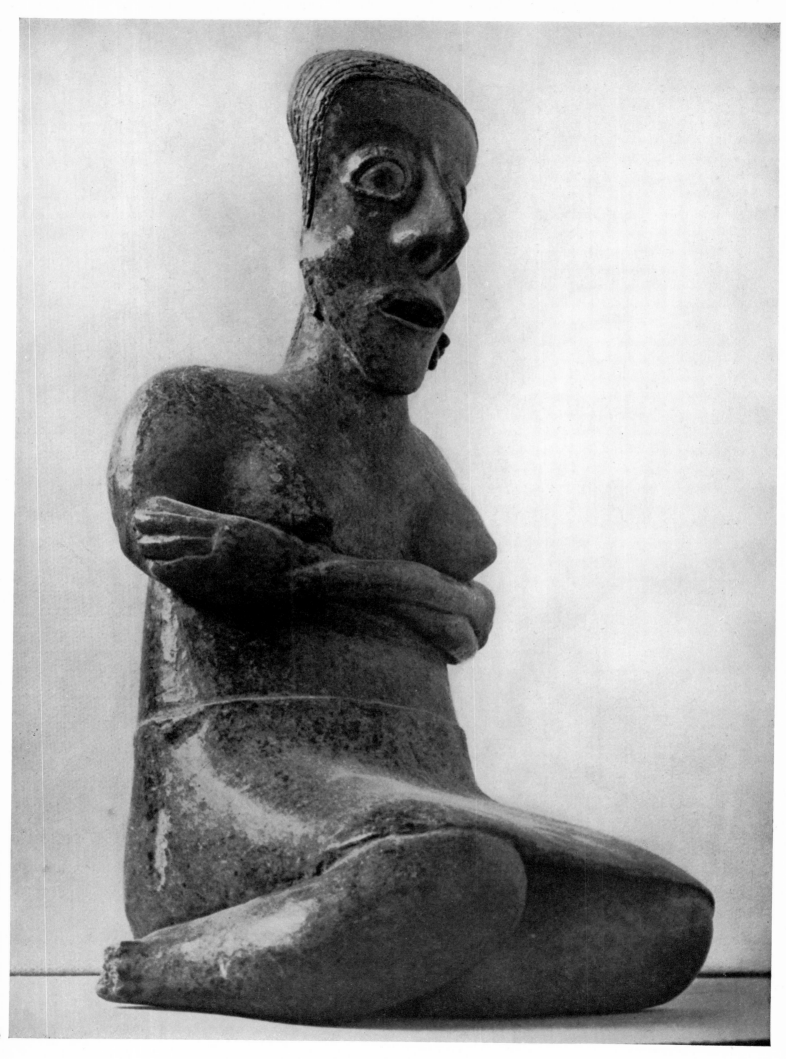

74

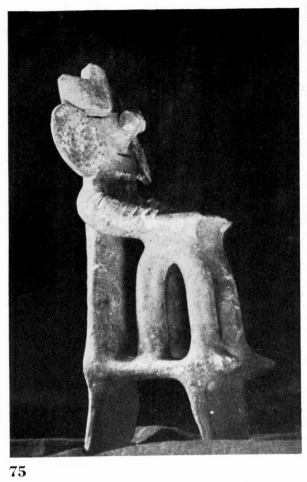

75

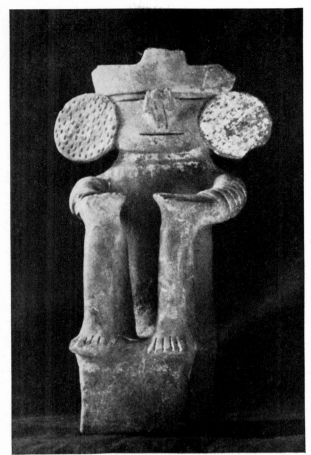

76

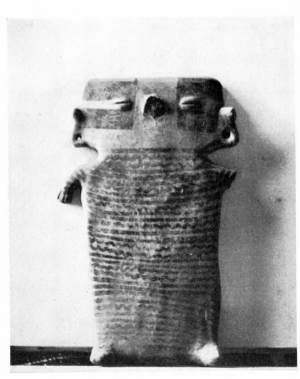

77

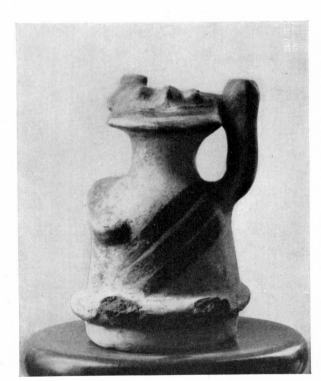

78

MIXE
(STATE OF OAXACA)

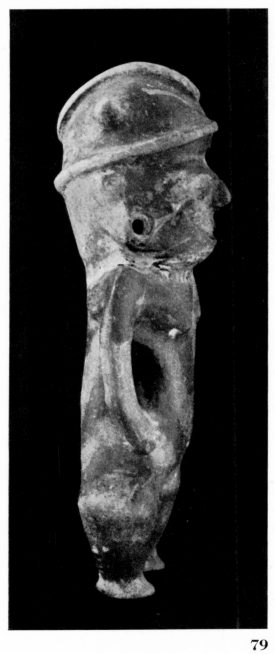

79

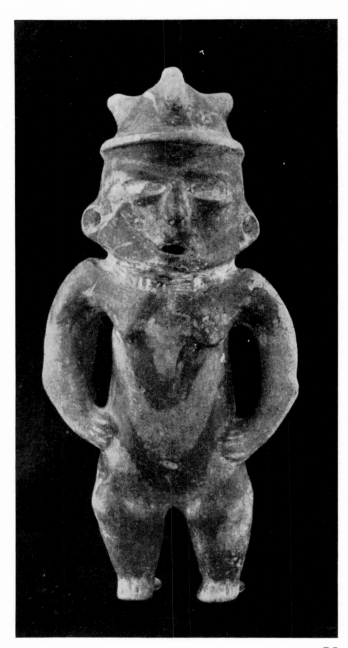

80

TARASCAN

FROM THE STATE OF COLIMA

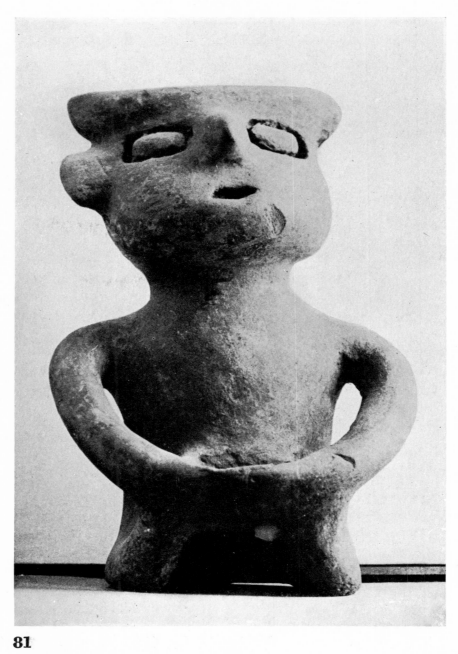

81

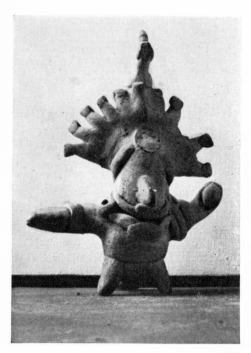
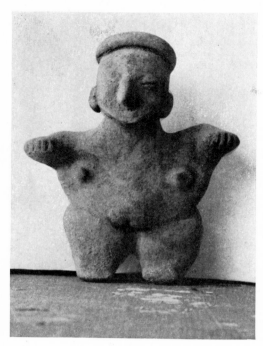
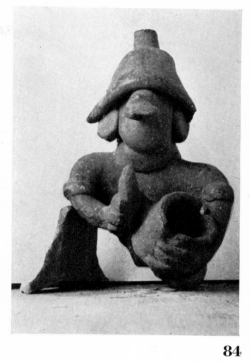

82

83

84

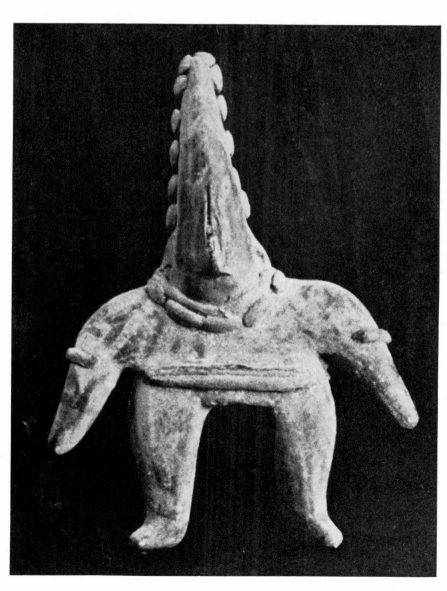

85

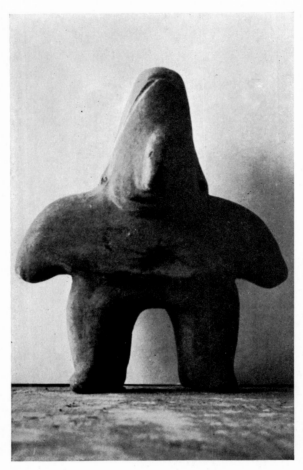

86

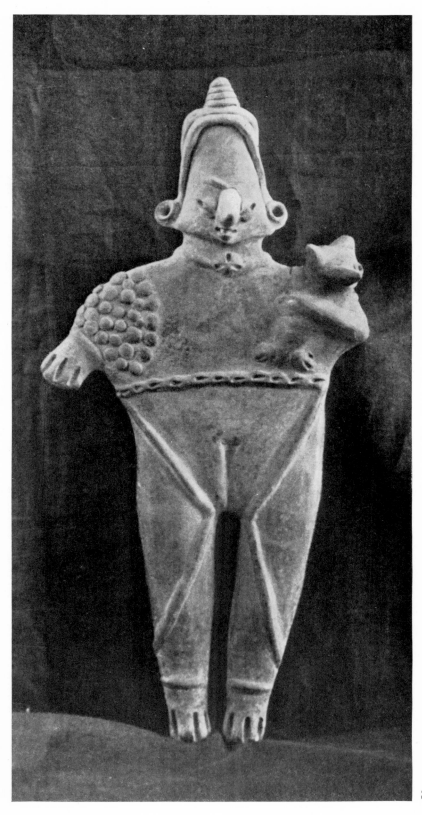

87

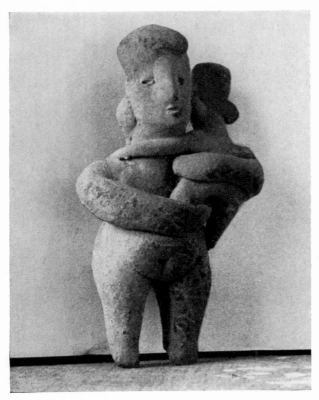

88

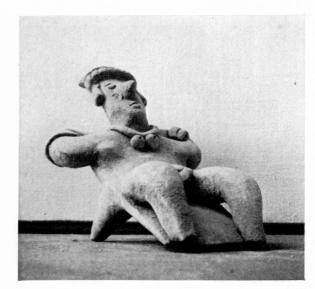

89

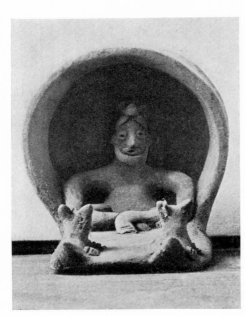

90

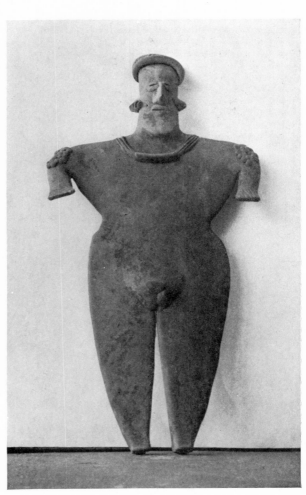

91

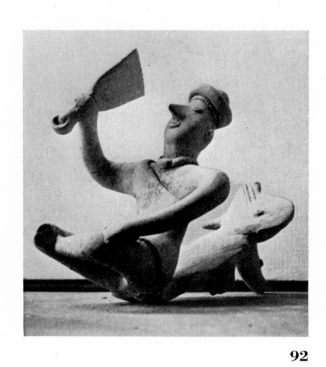

92

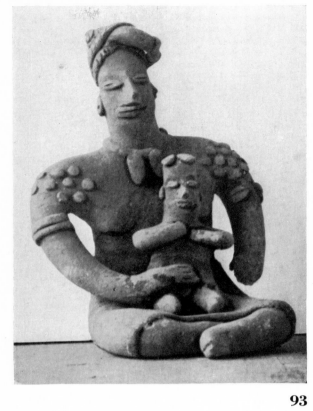

93

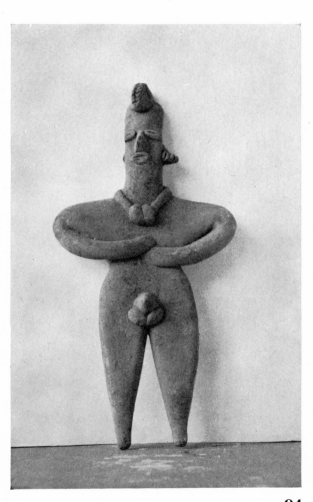

94

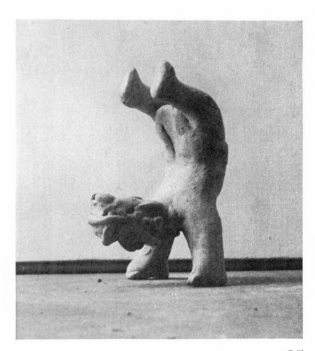

95

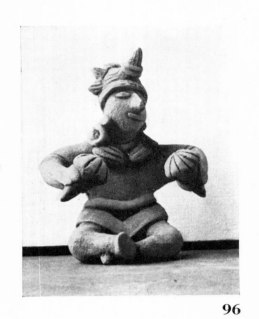

96

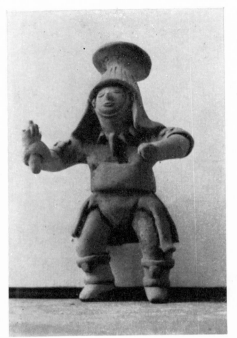

97

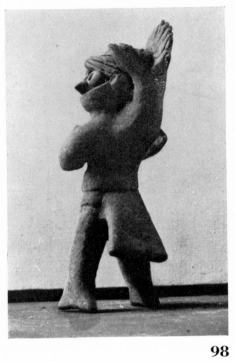

98

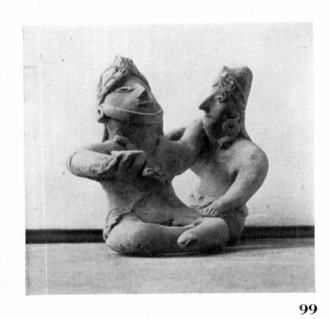

99

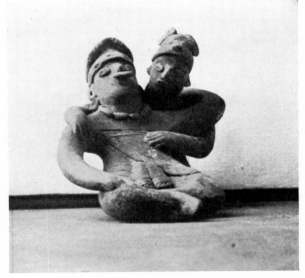

100

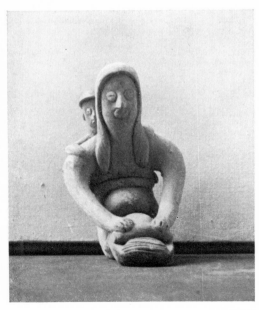

101

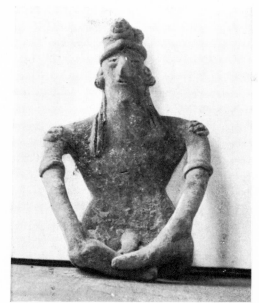

102

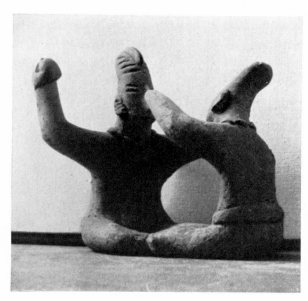

103

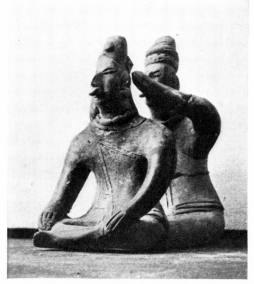

104

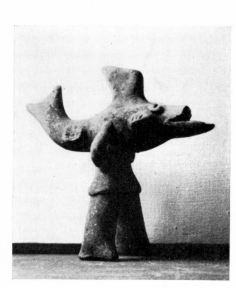

105

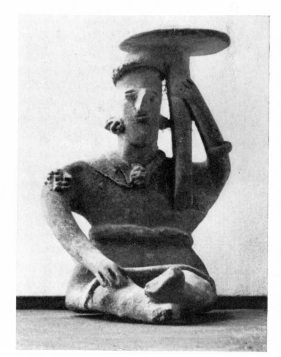

106

107

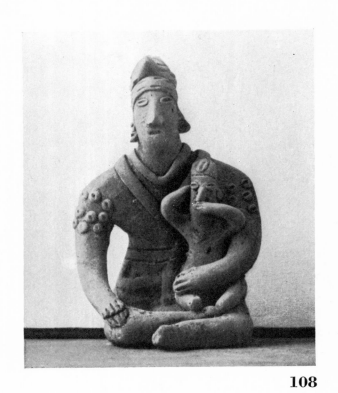

108

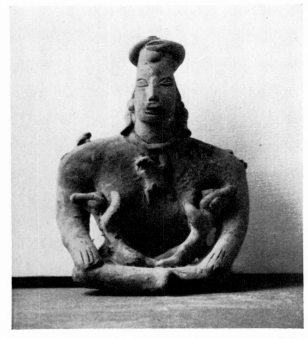

109

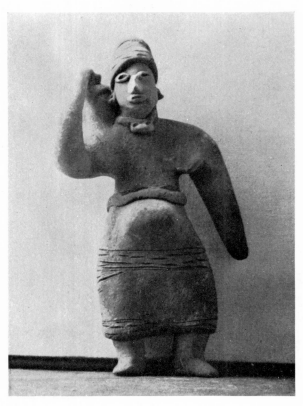

110

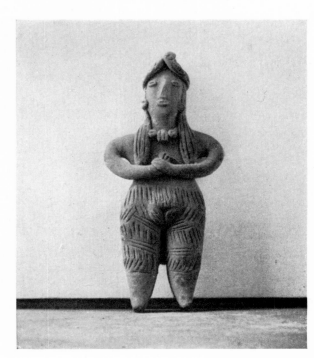

111

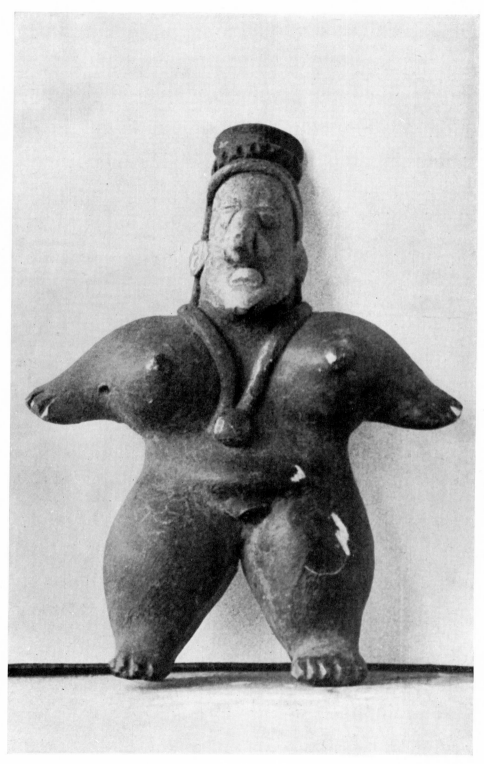

112

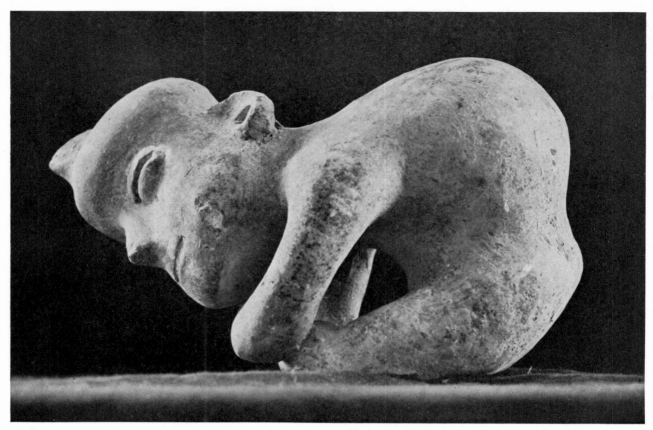

113

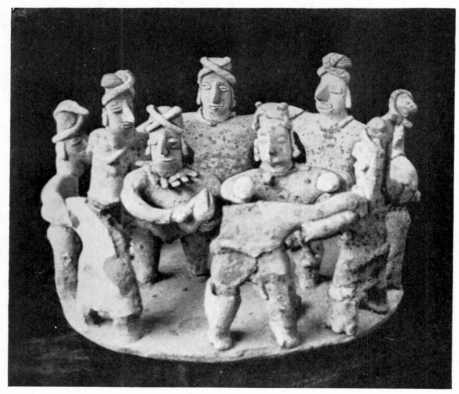

114

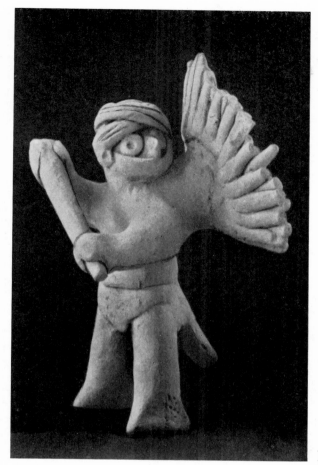

115

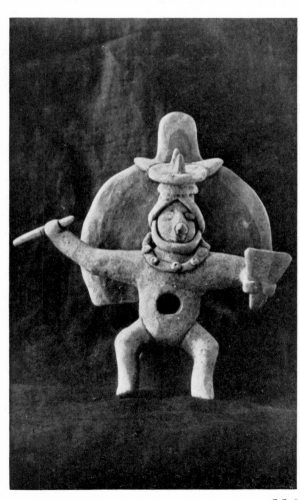

116

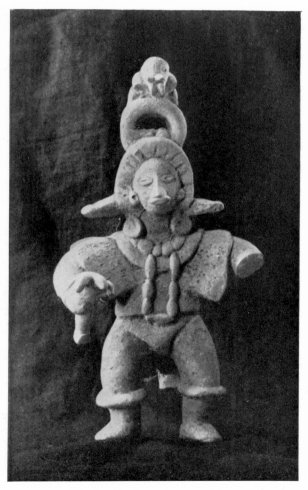

117

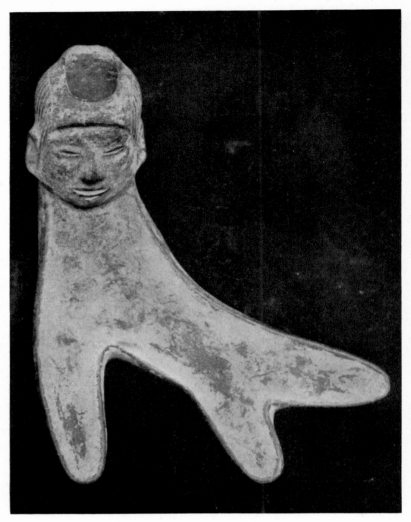

118

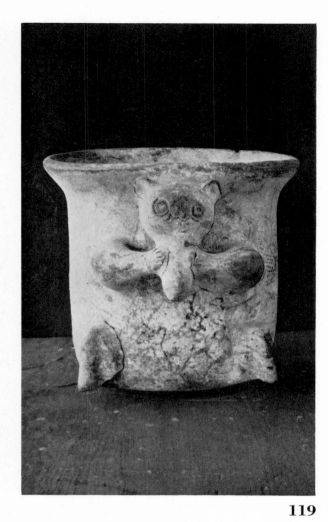

119

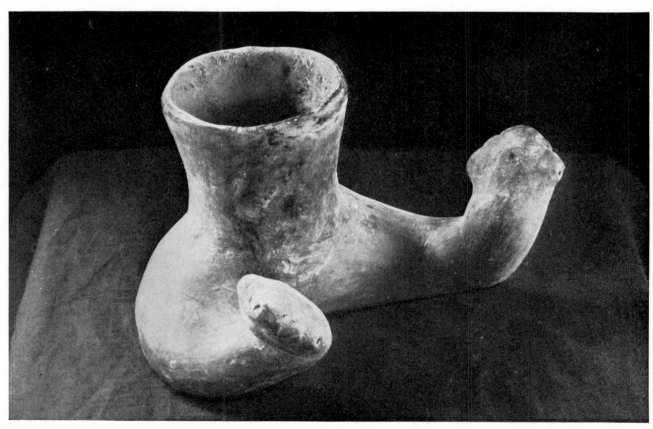

120

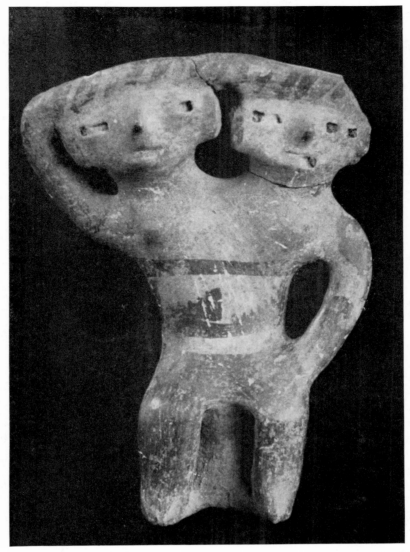

121

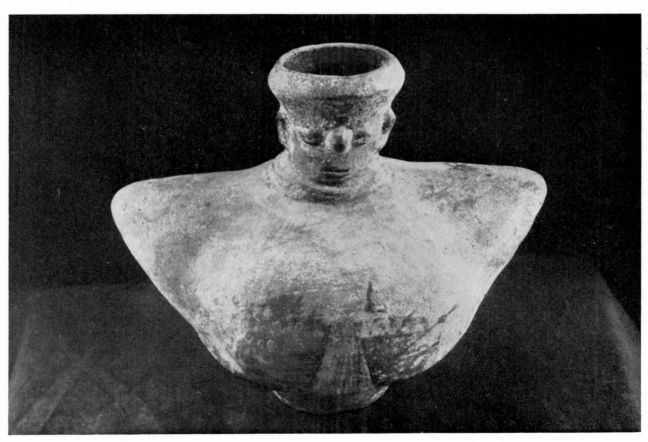

122

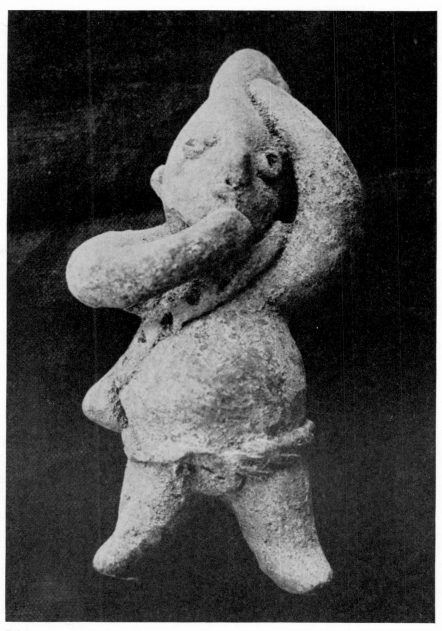

123

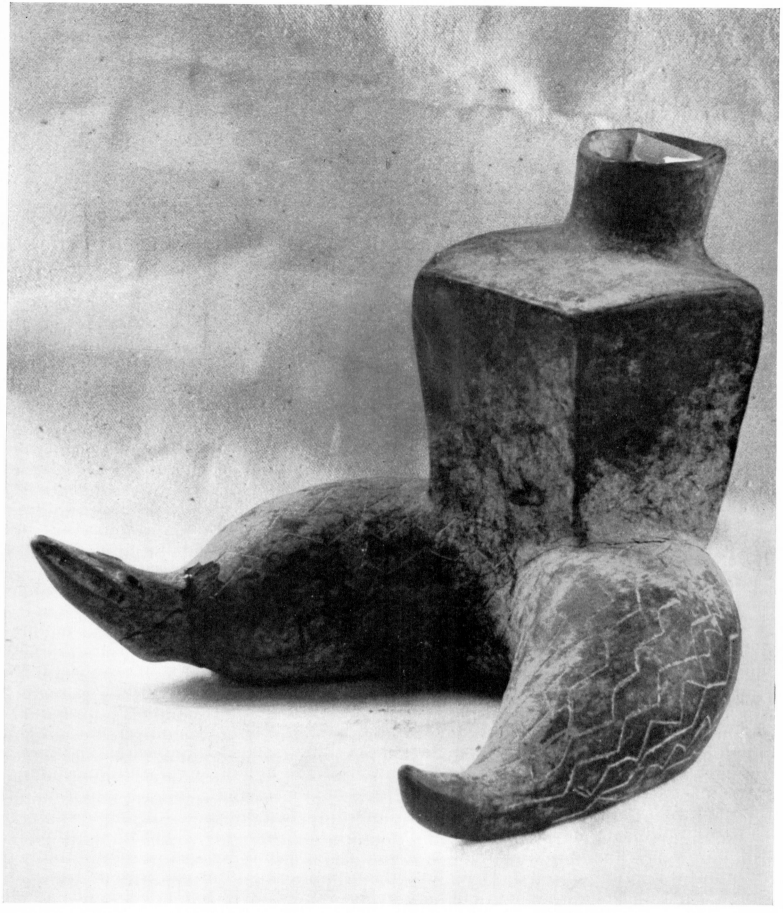

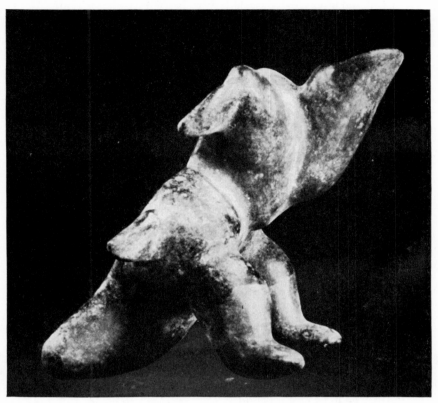

125

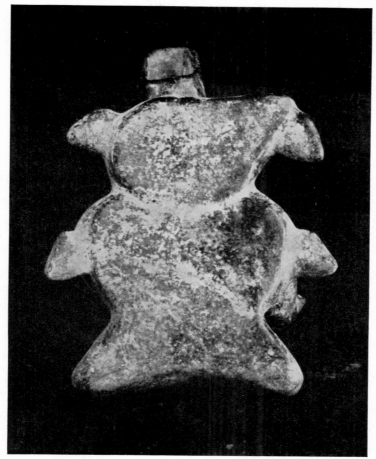

126

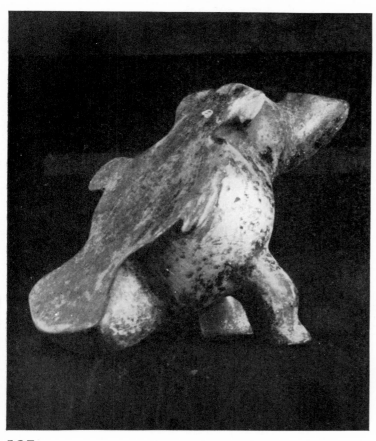

127

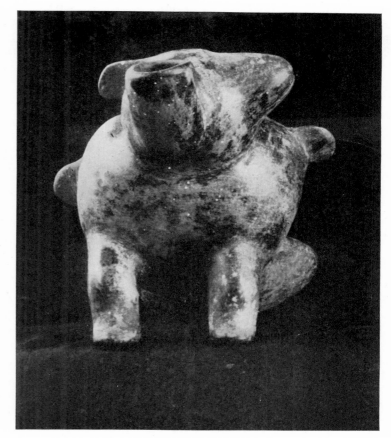

128

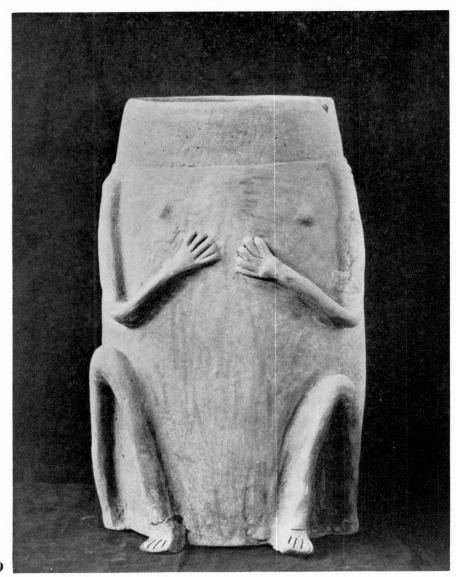

129

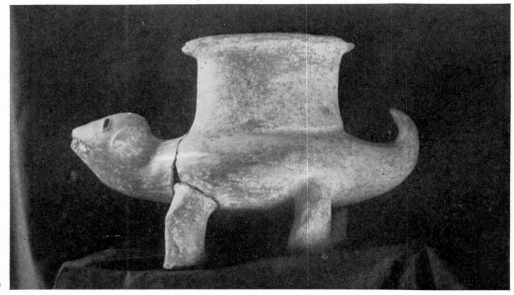

130

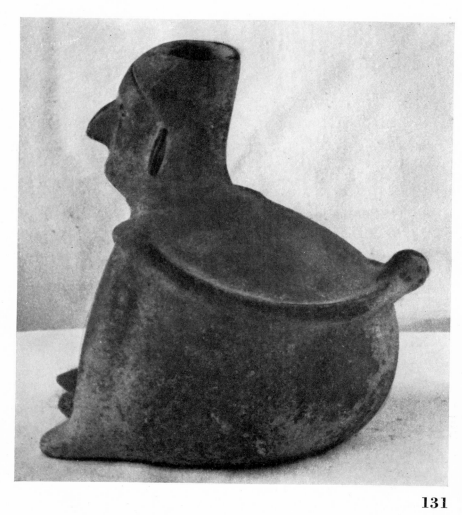

131

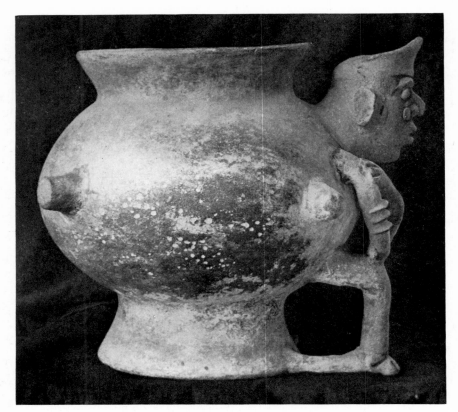

132

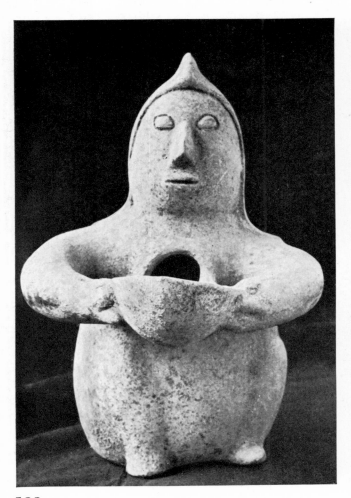

133

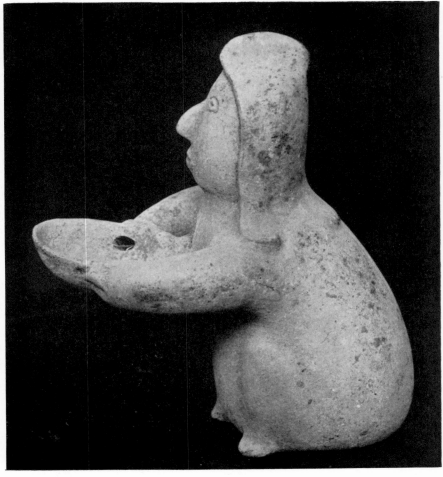

134

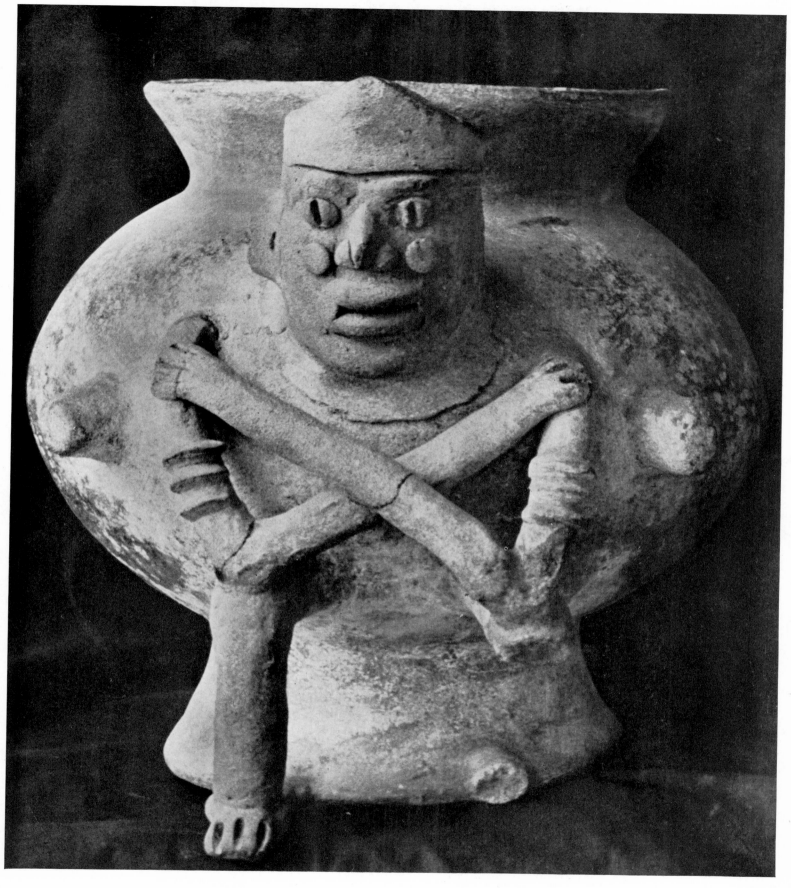

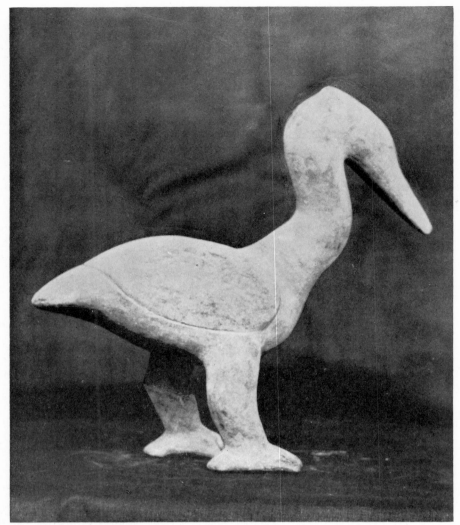

136

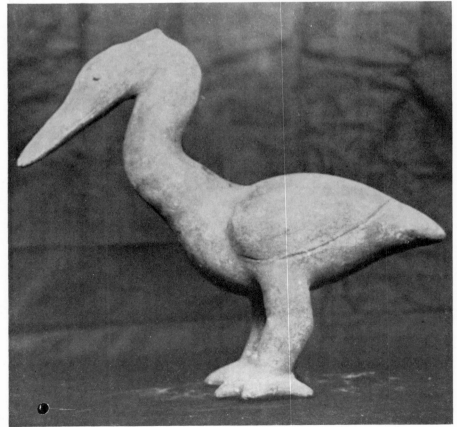

137

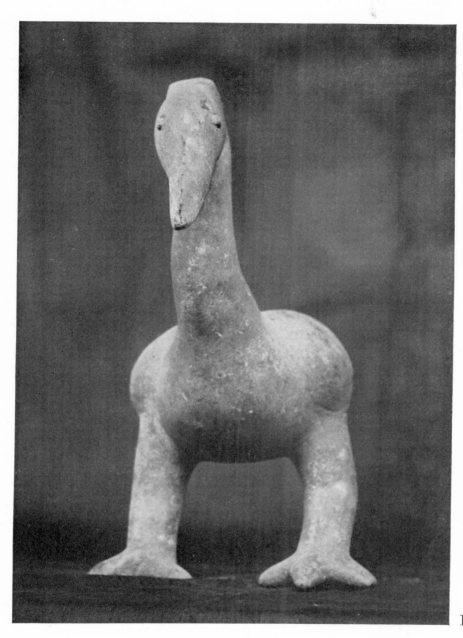

138

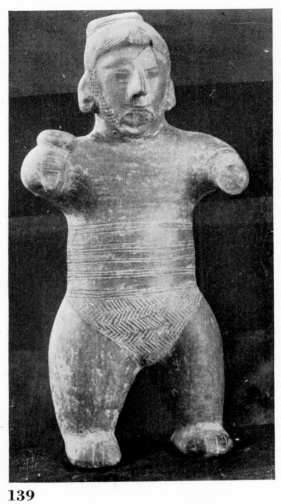

139

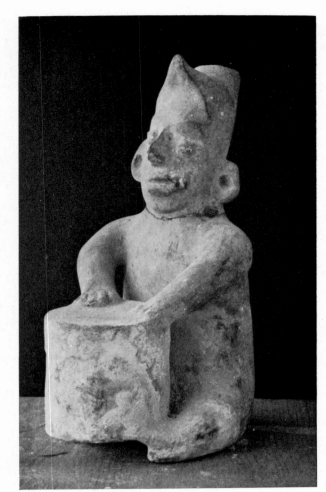

140

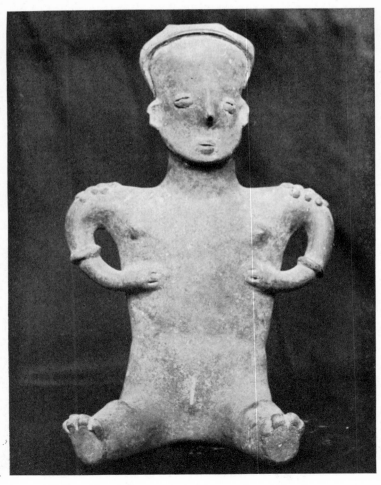

141

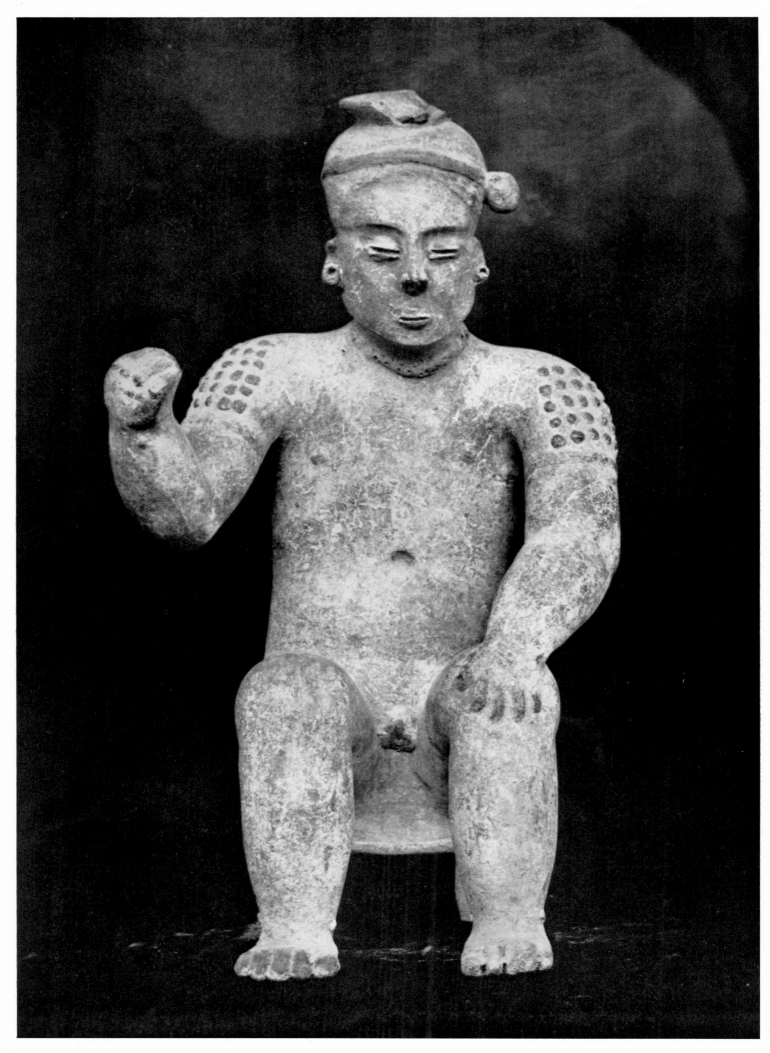

142

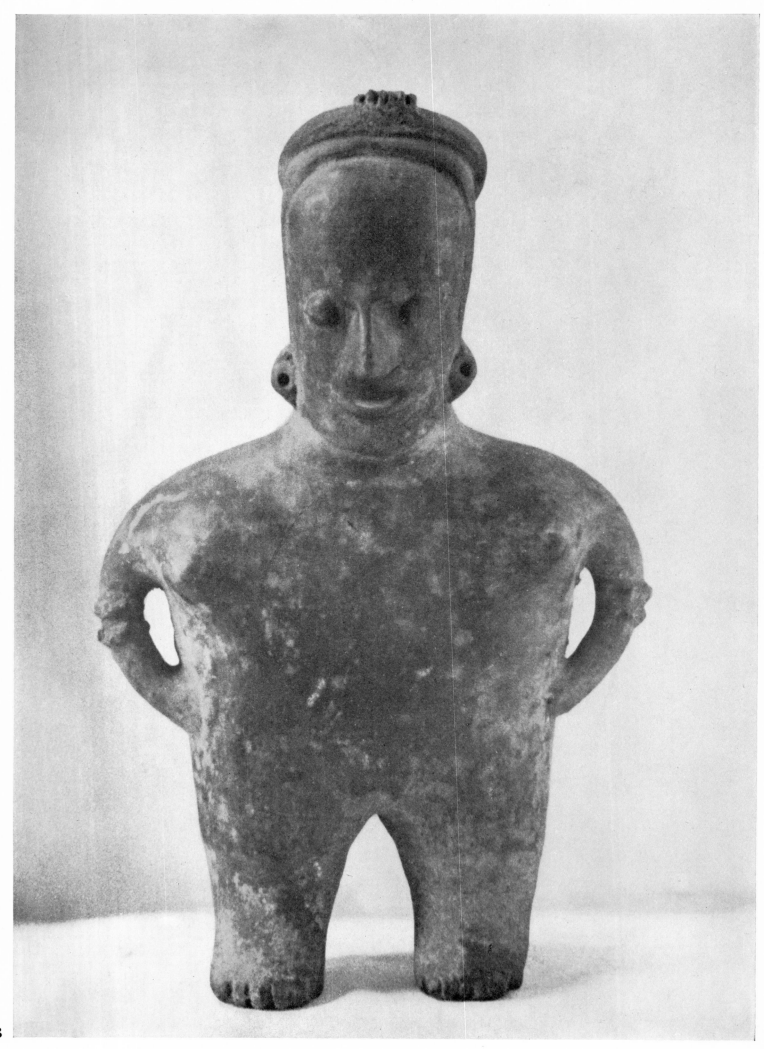

143

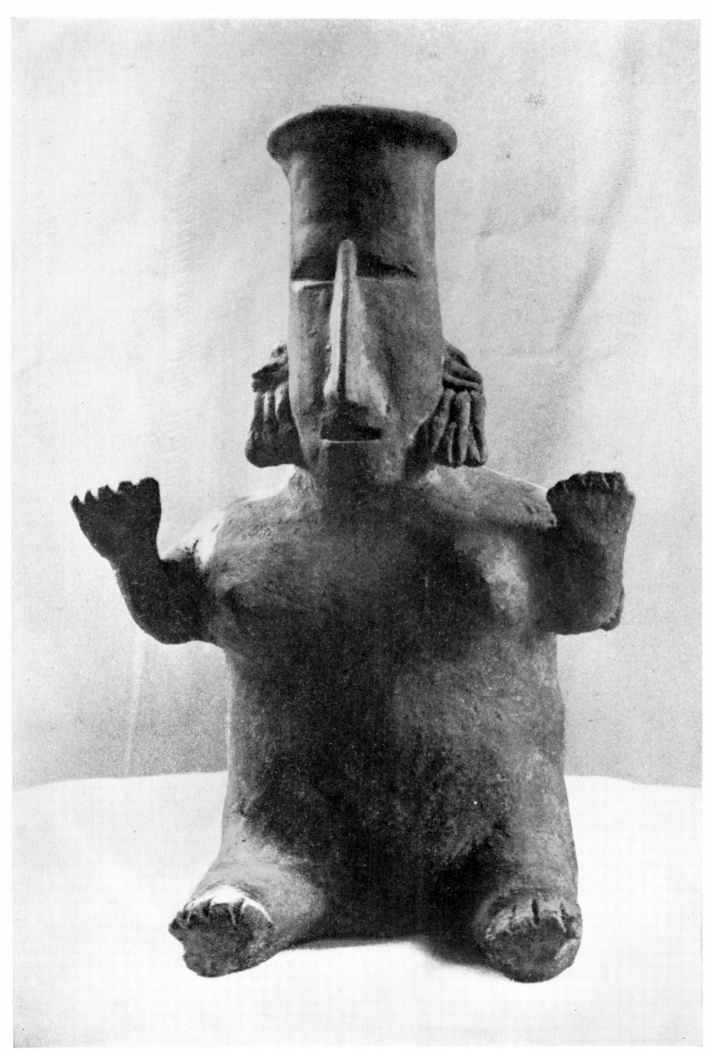

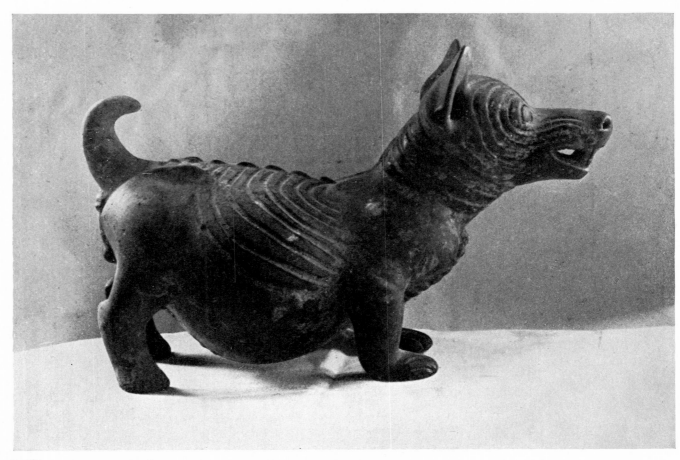

145

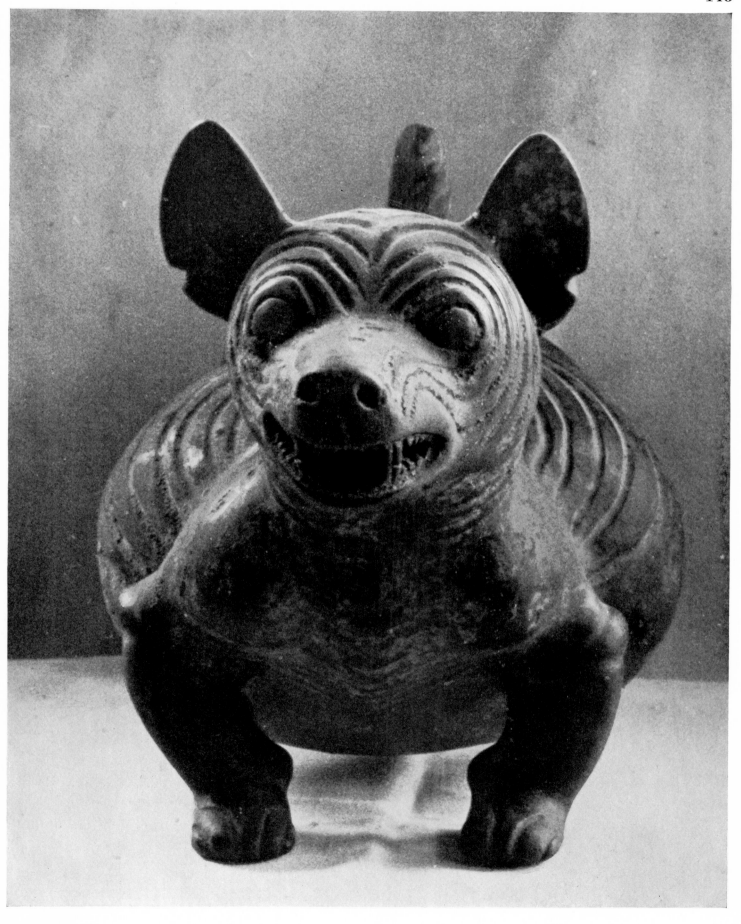

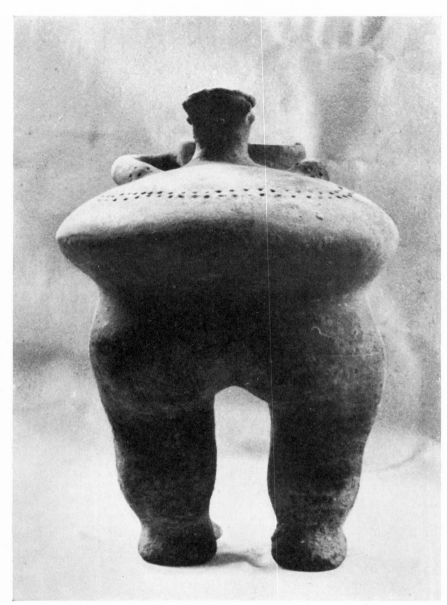

147

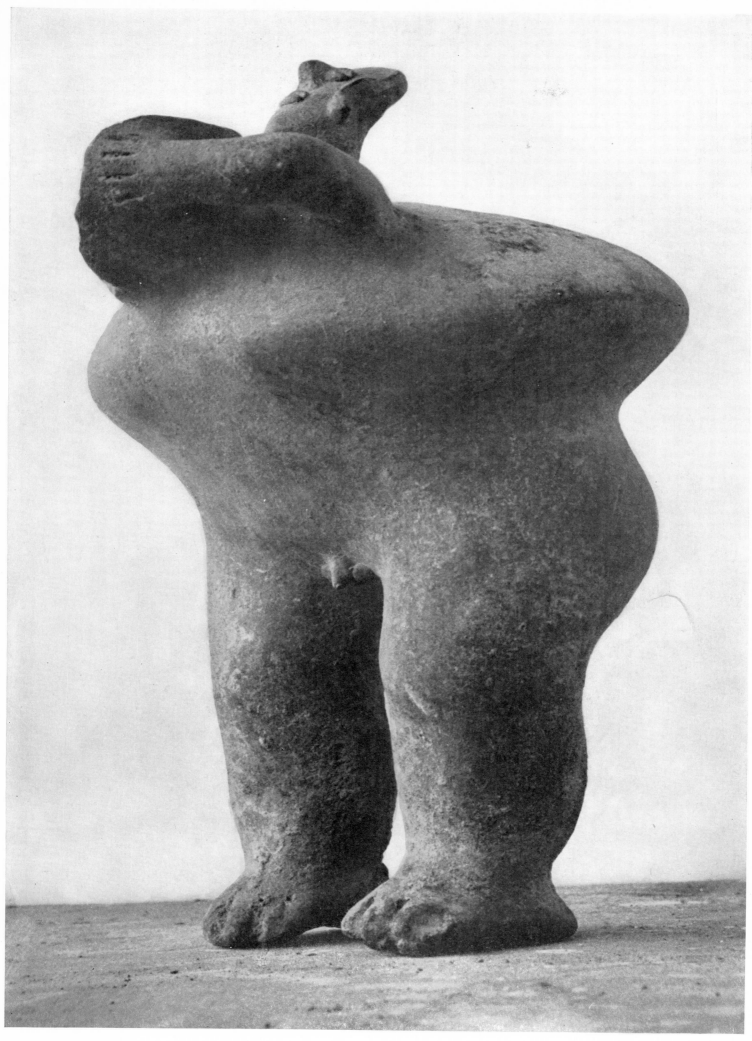

148

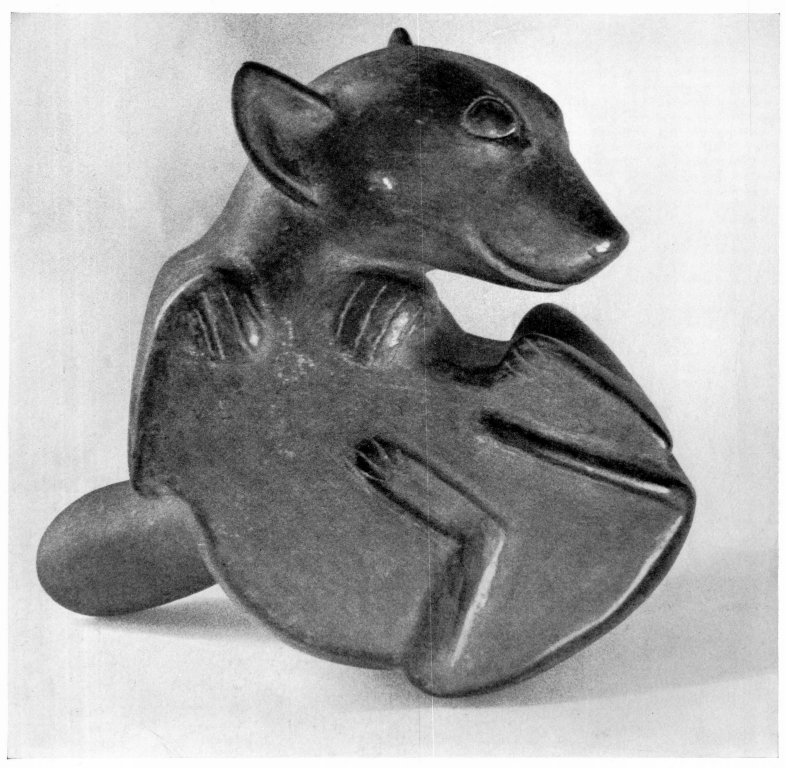

149

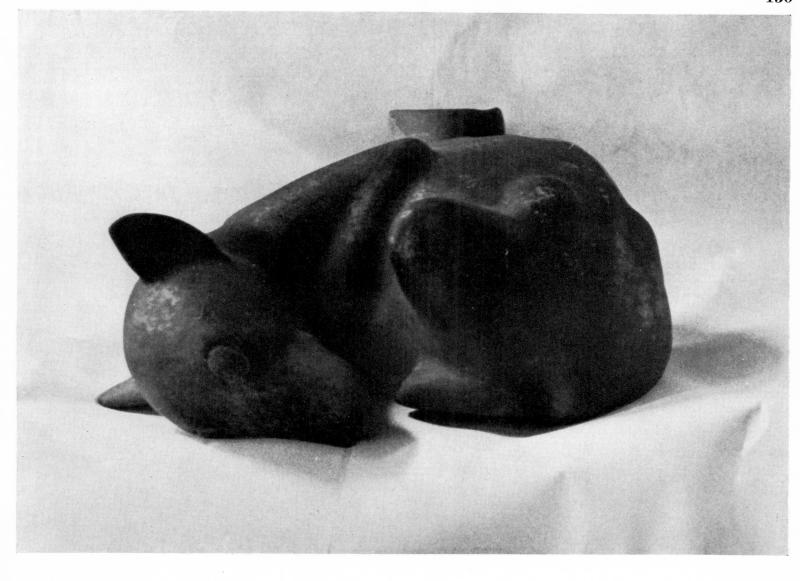

151

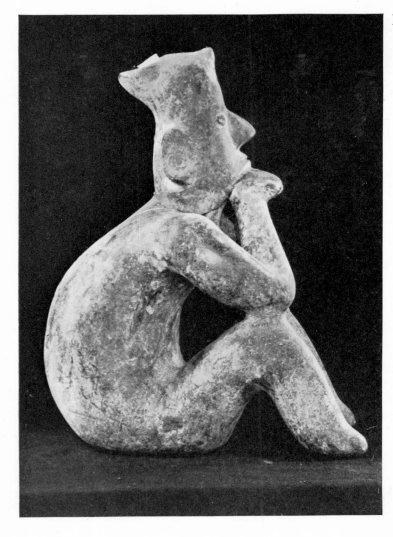

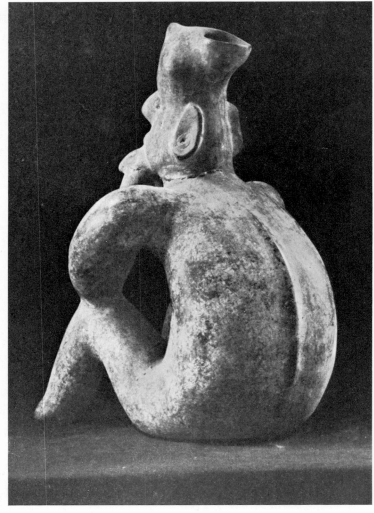

152

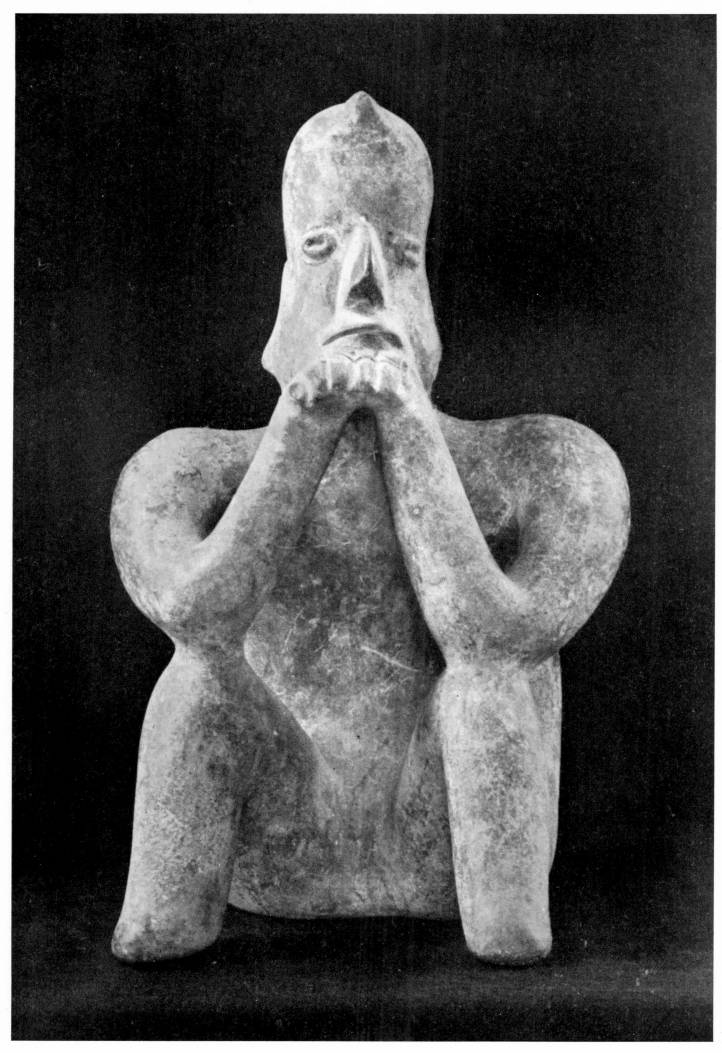

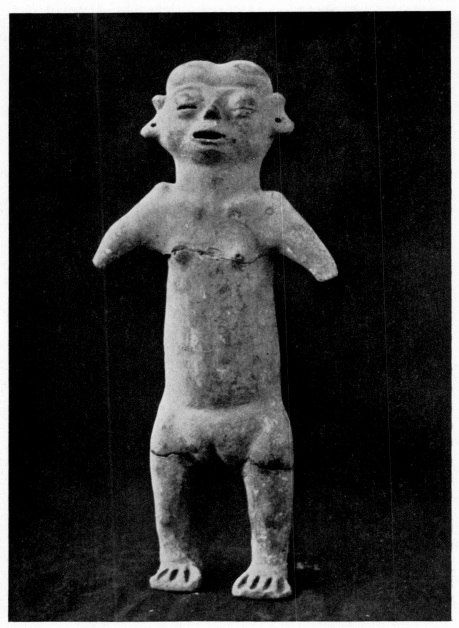

154

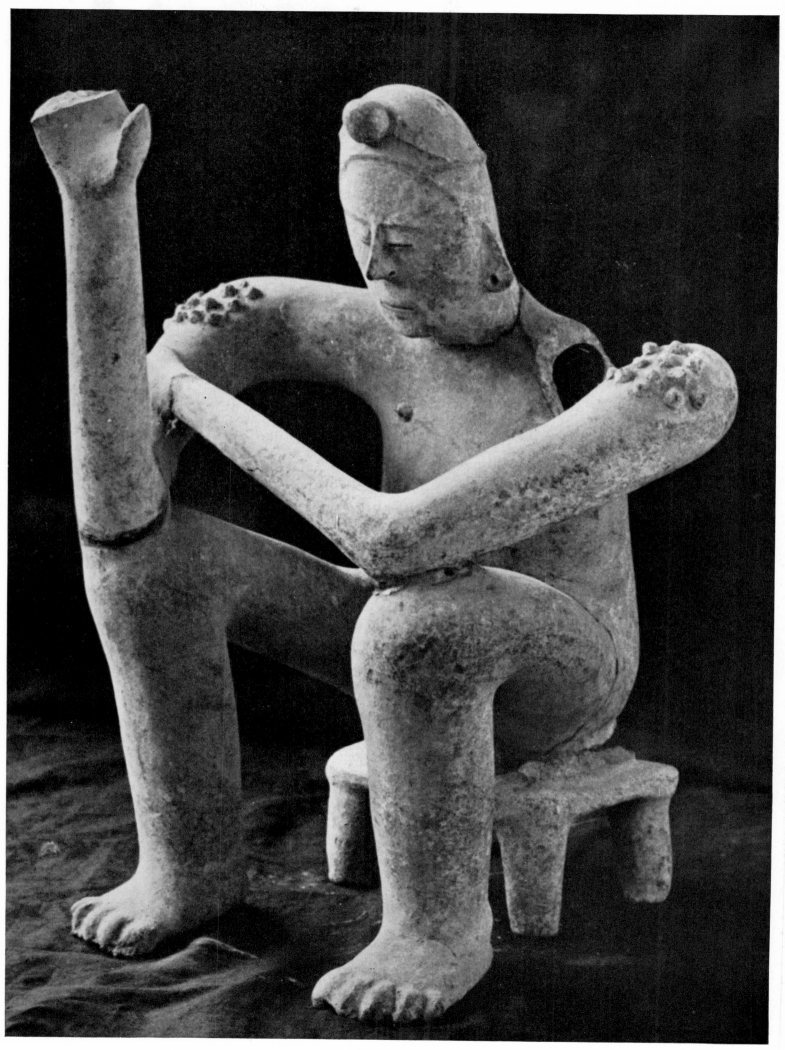

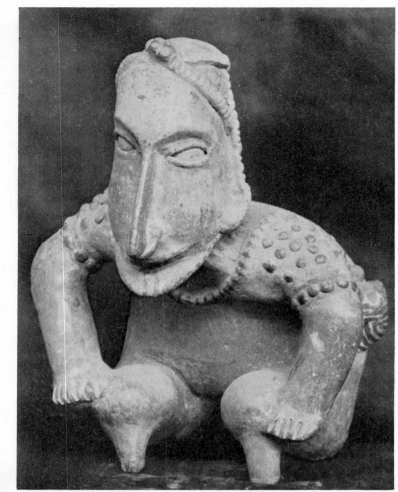

157

156

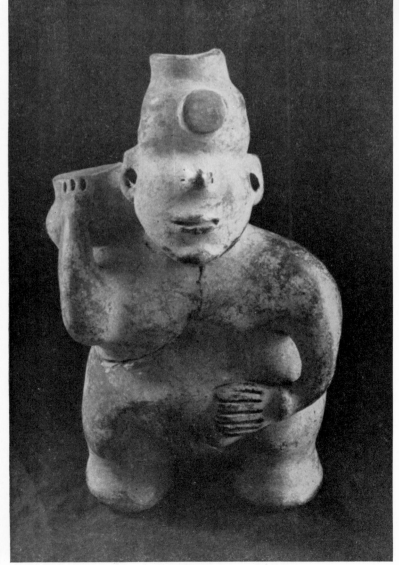

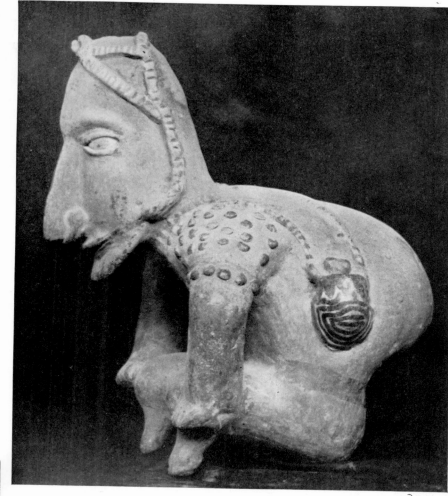

159

158

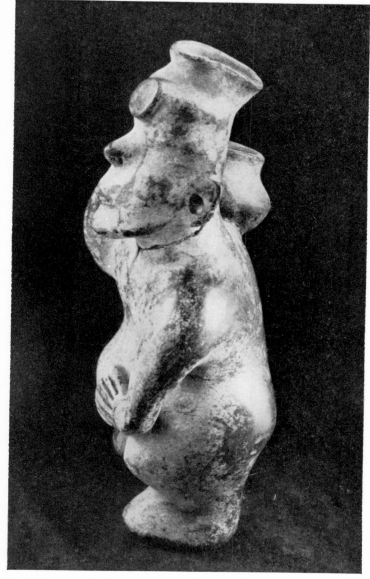

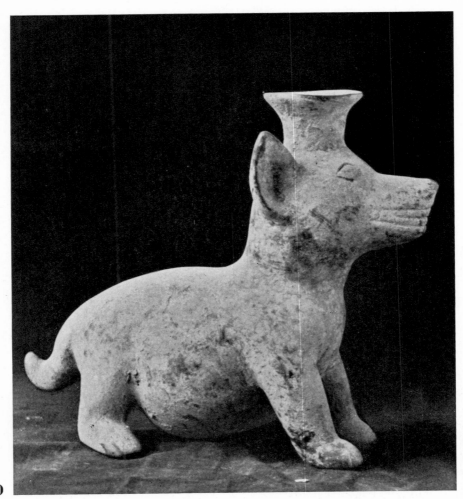

160

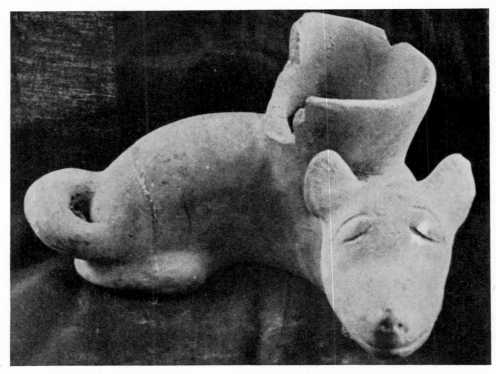

161

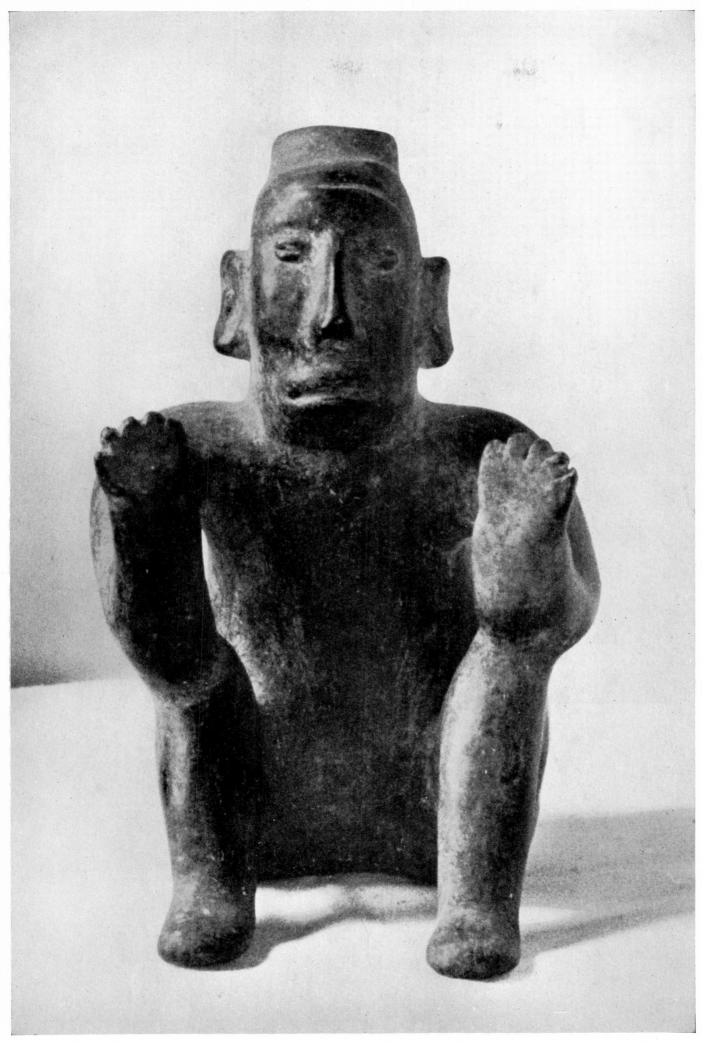

163

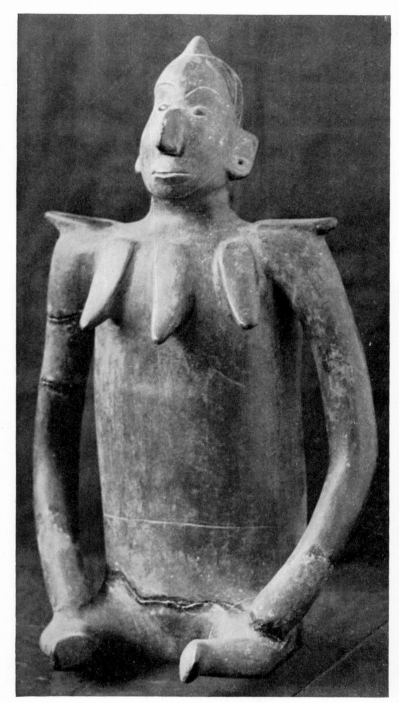

164

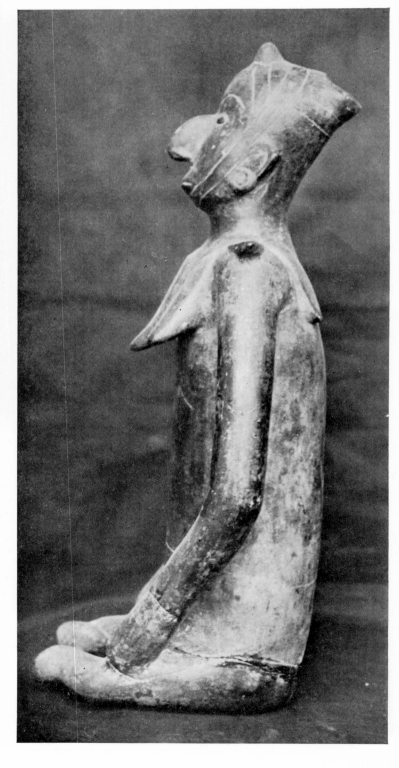

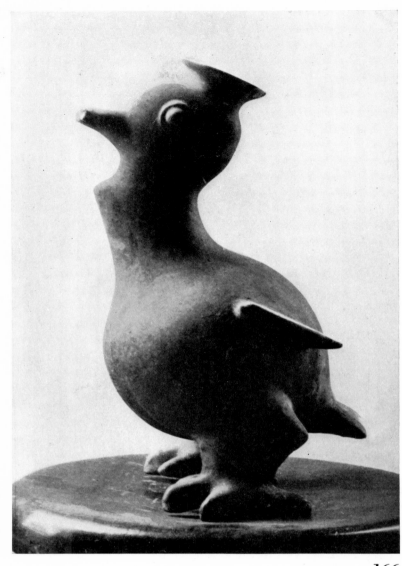

166

165

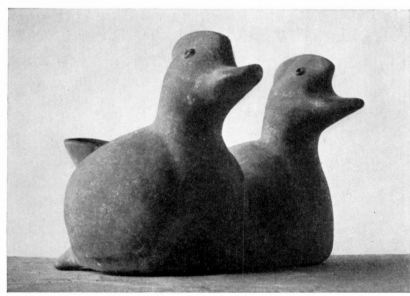

167

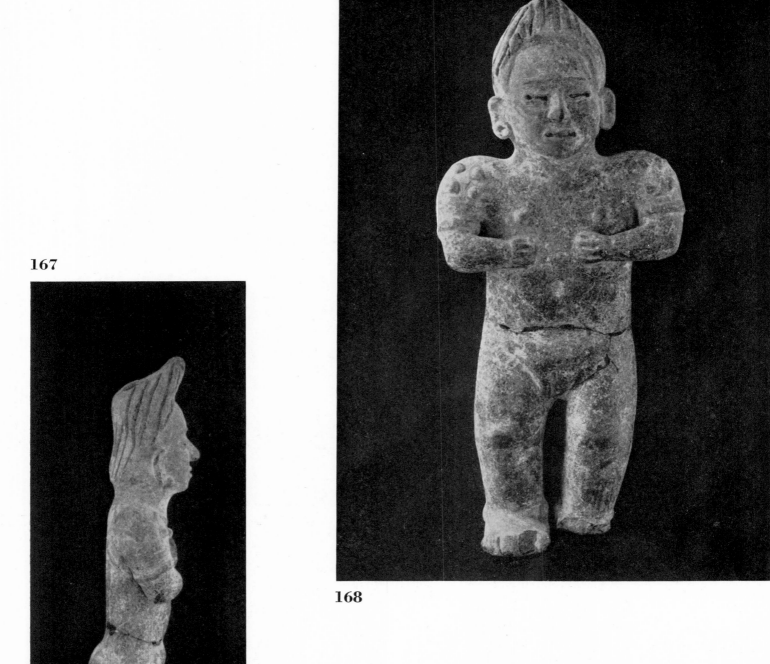

168

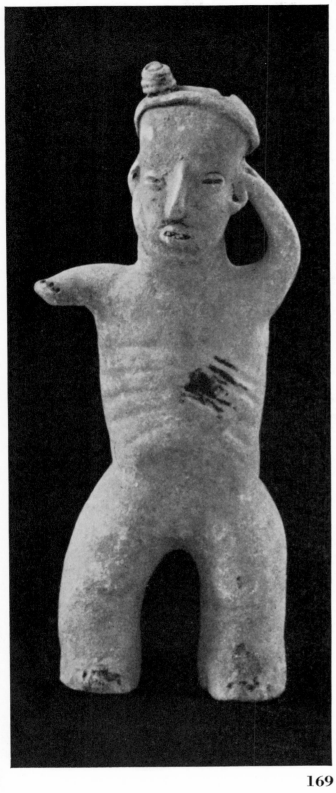

169

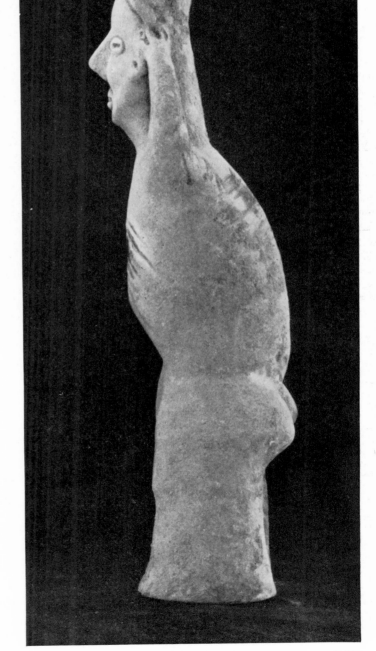

170

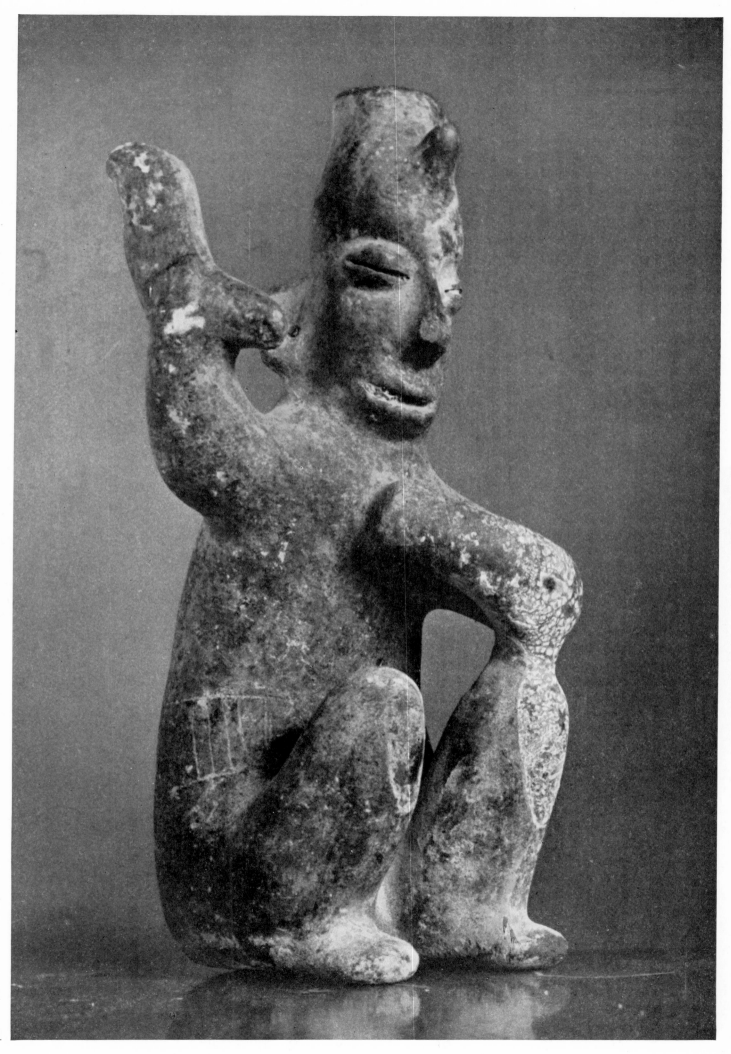

171

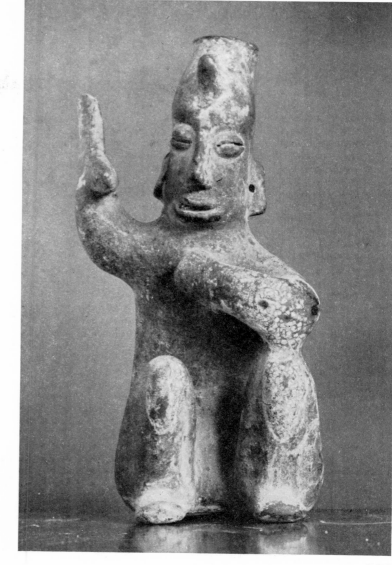

173

172

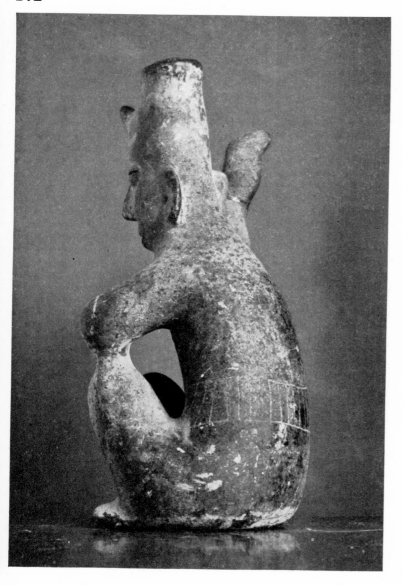

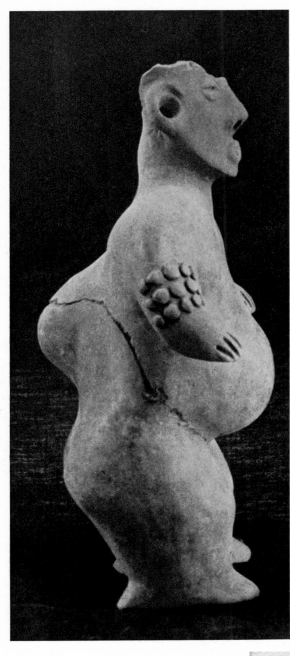

174

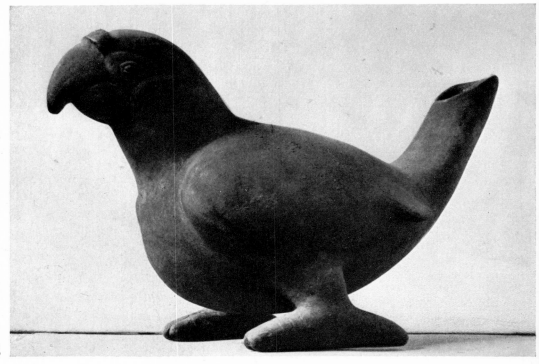

175

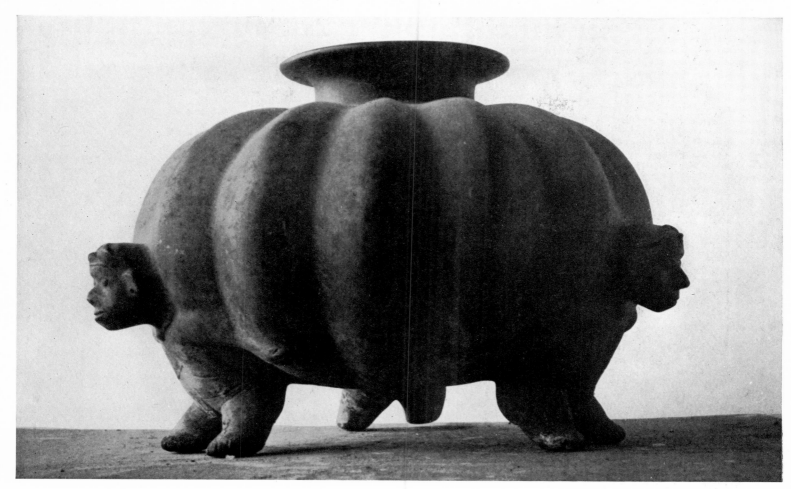

176

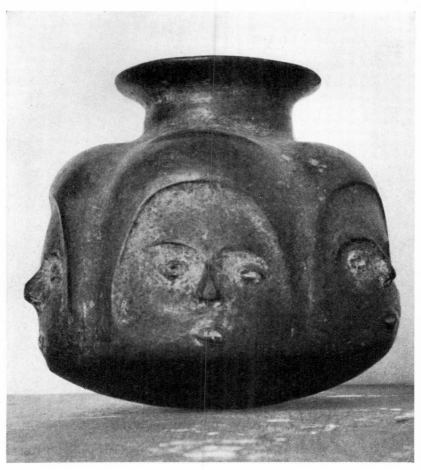

177

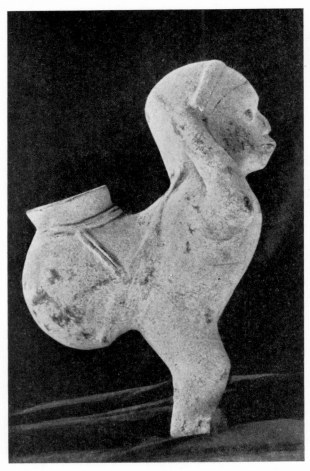

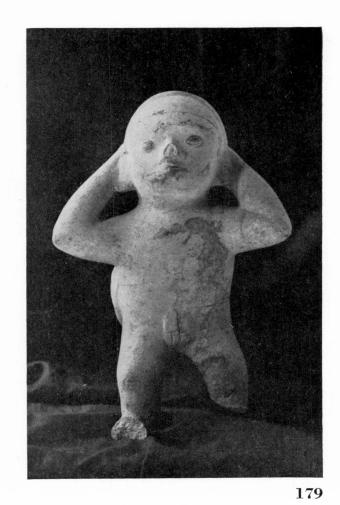

178

179

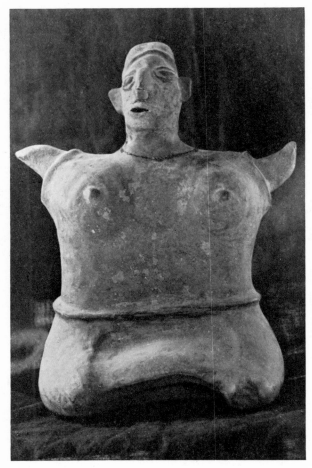

180

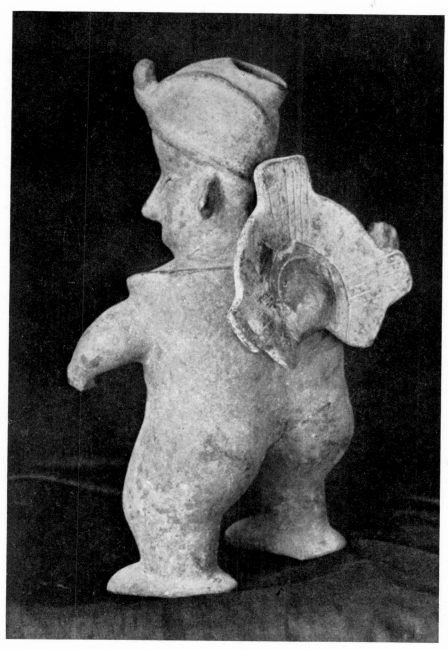

181

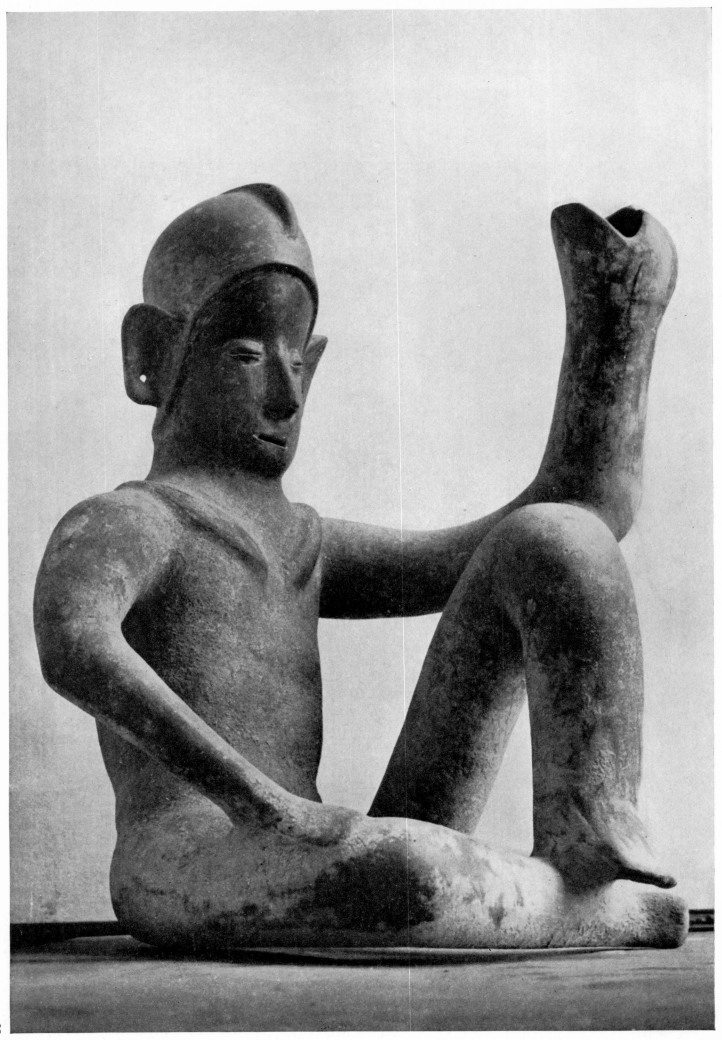

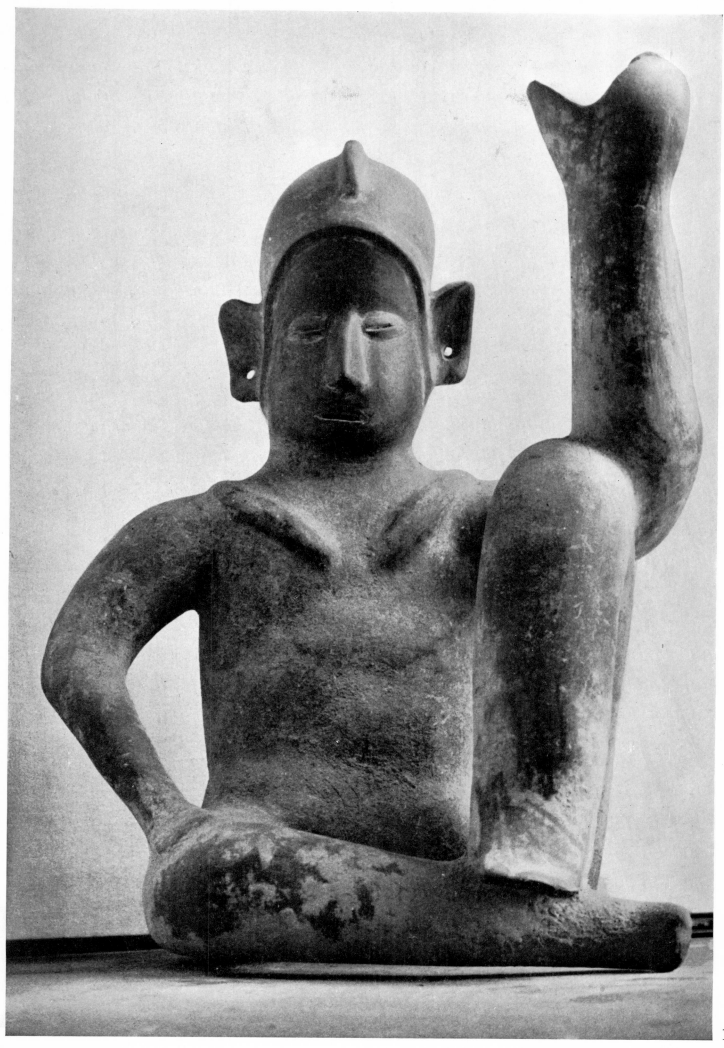

183

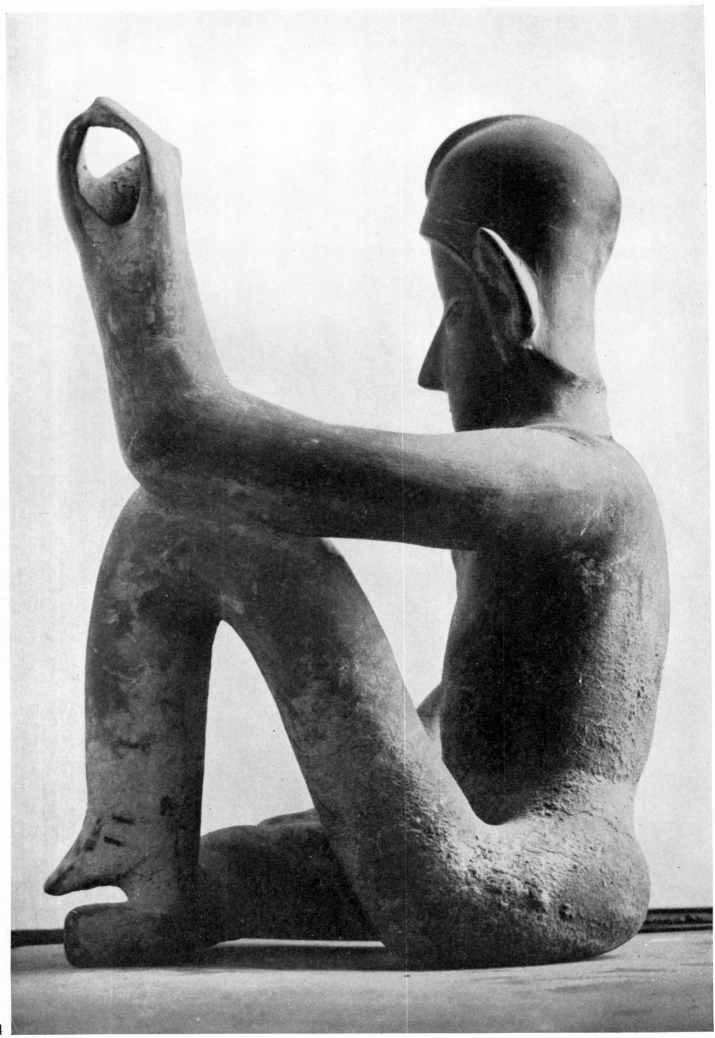

184

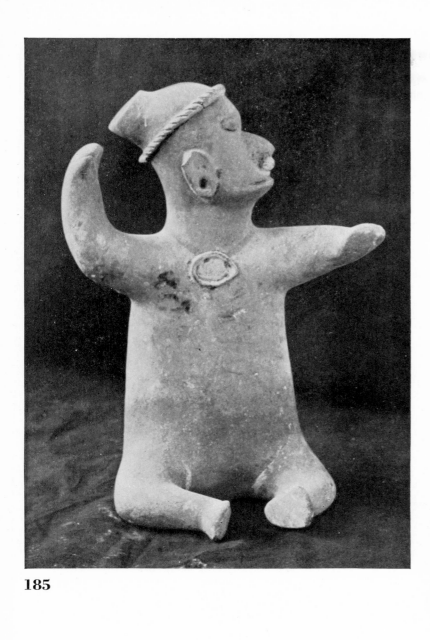

185

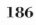

186

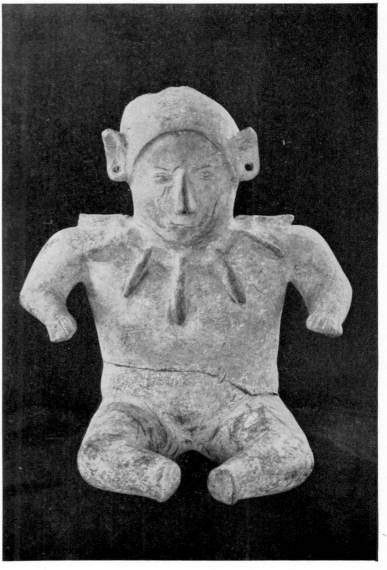

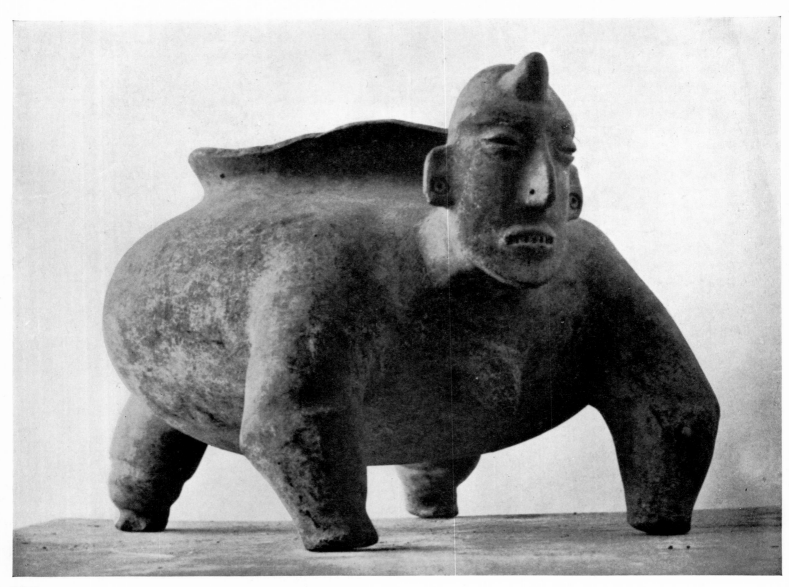

187

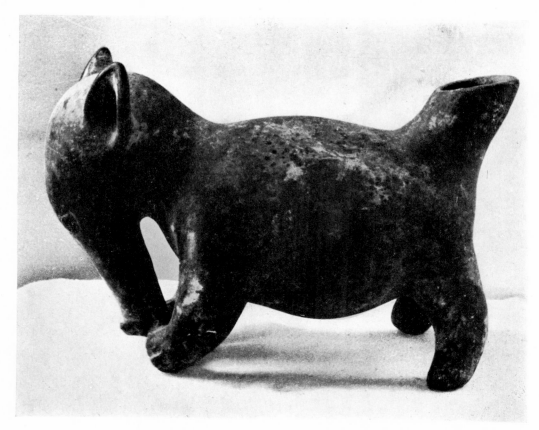

188

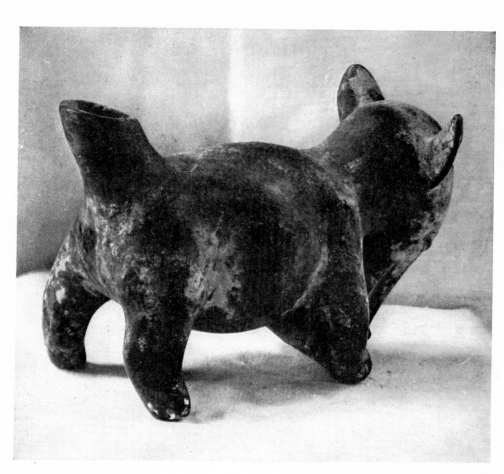

189

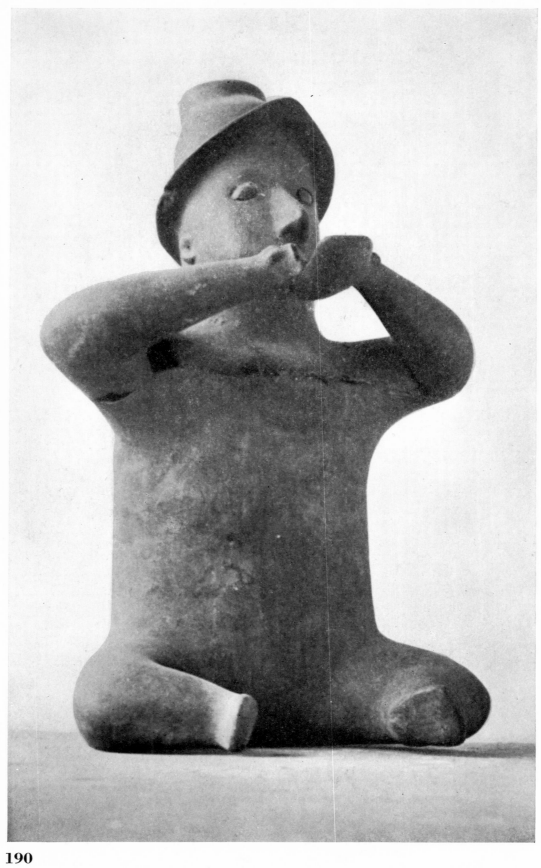

190

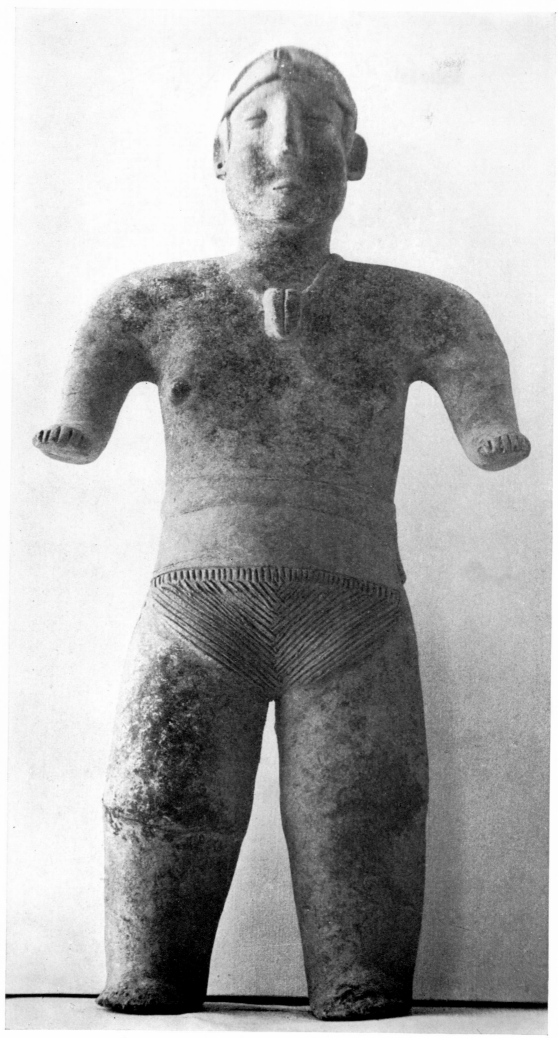

191

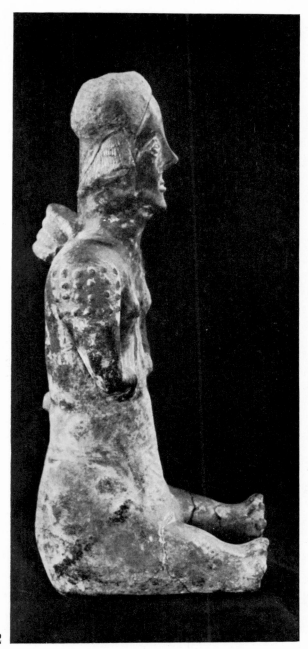

192

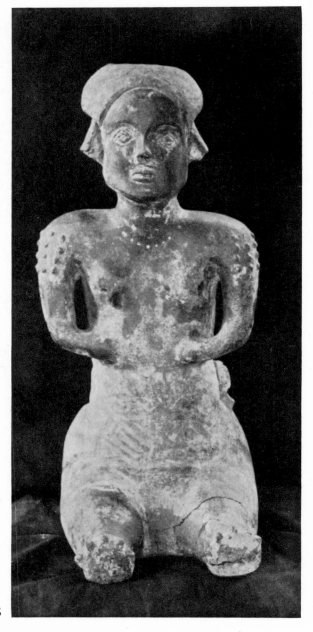

193

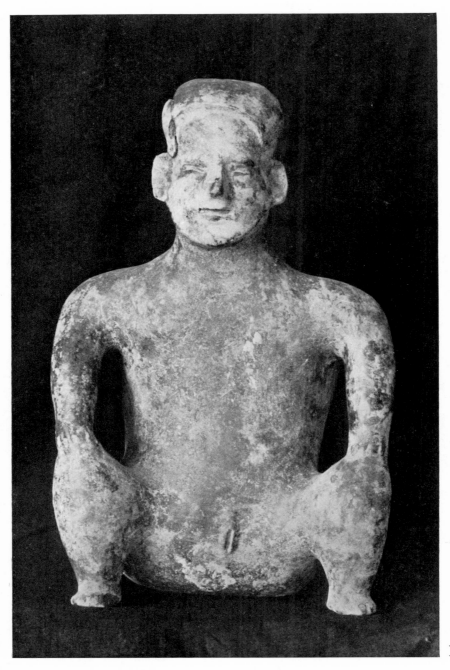

194

195

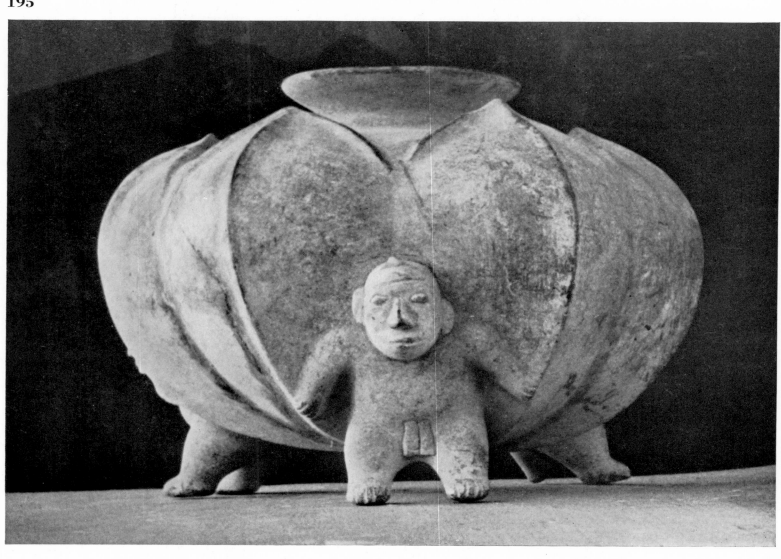

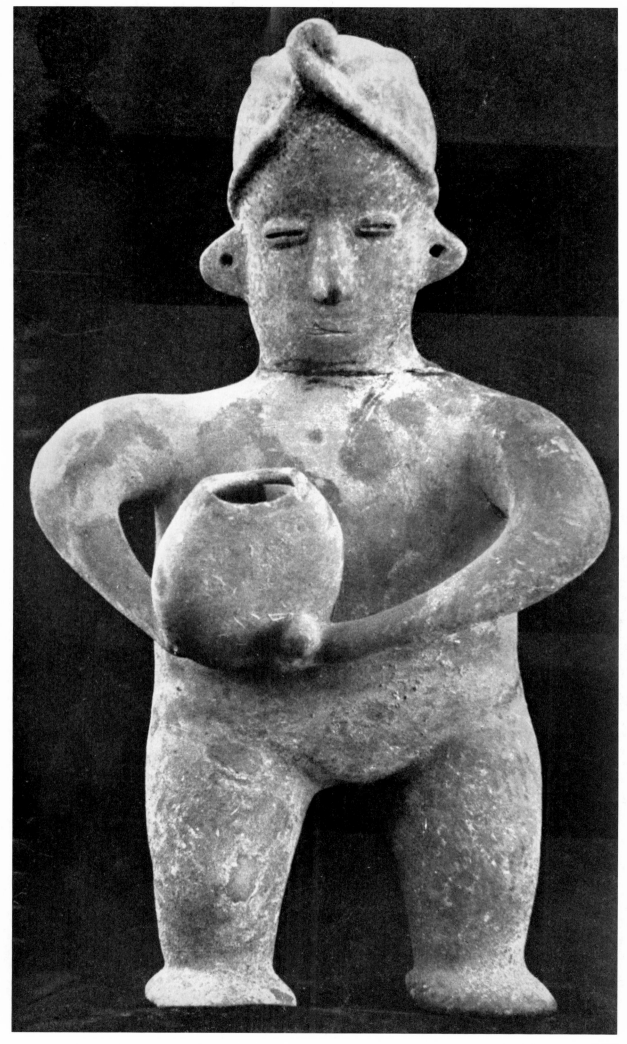

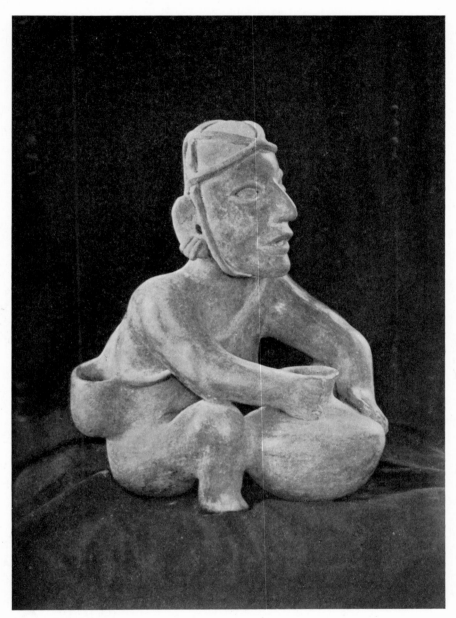

197

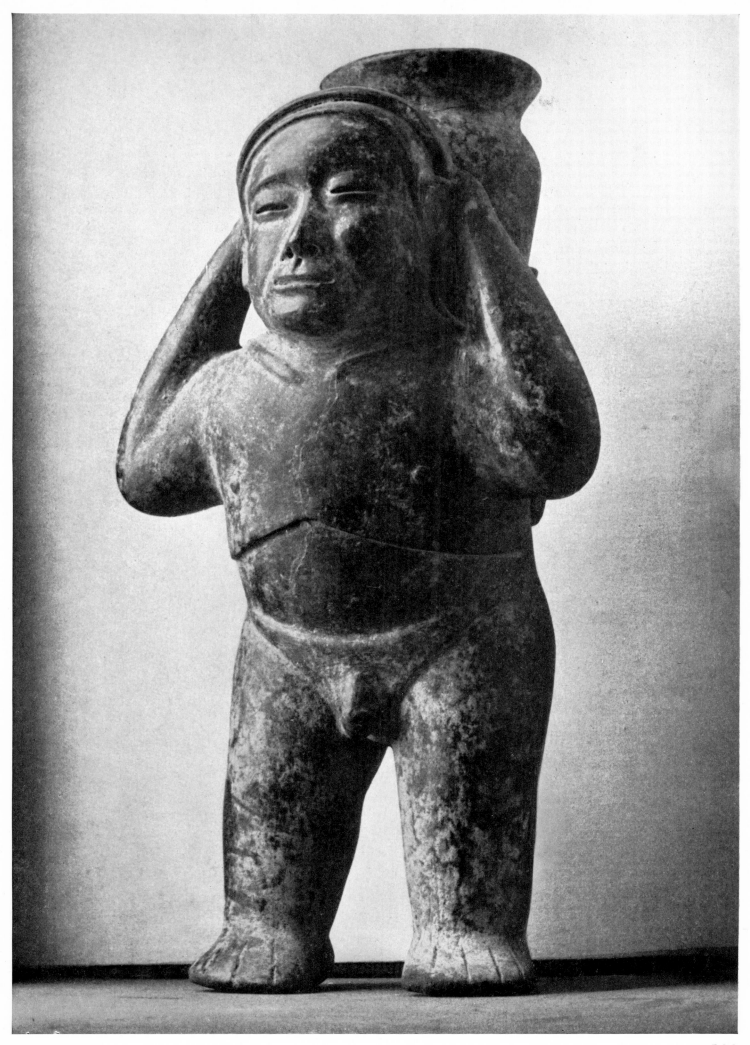

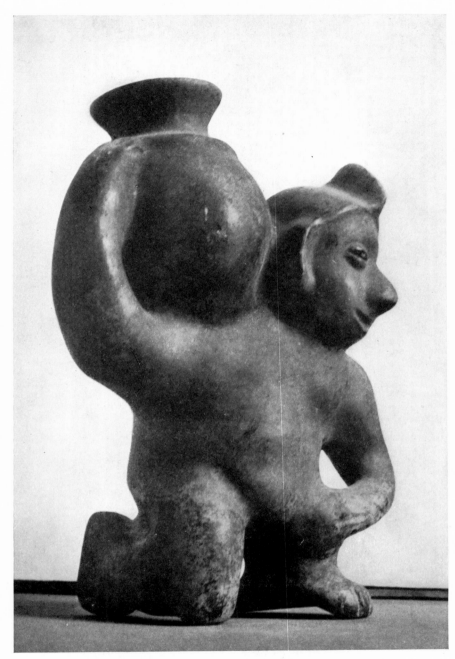

199

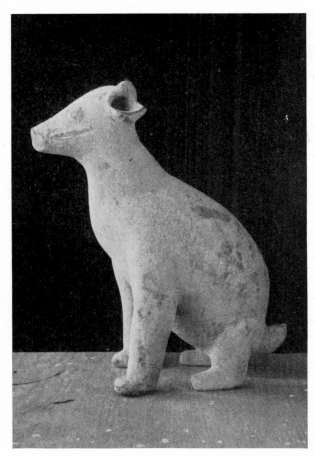

200

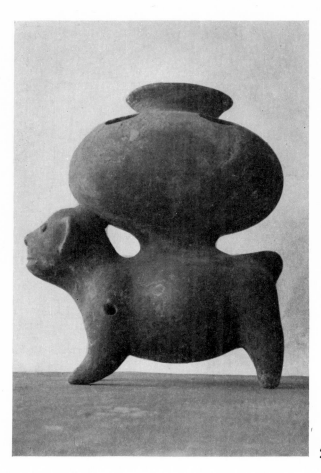

201

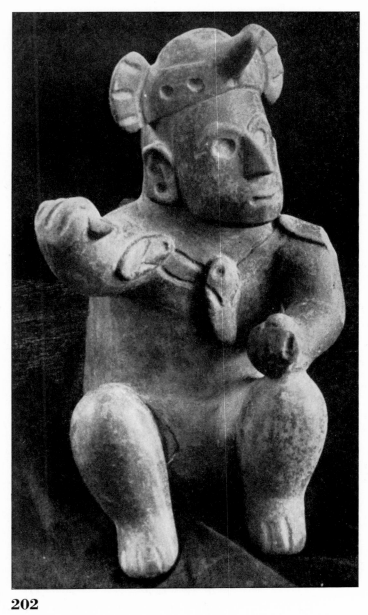

202

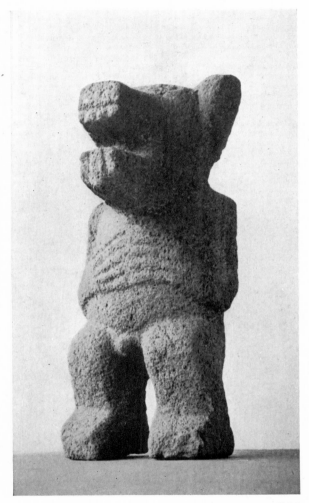

203

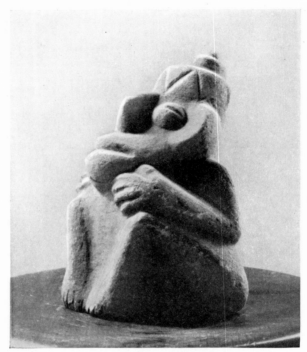

204

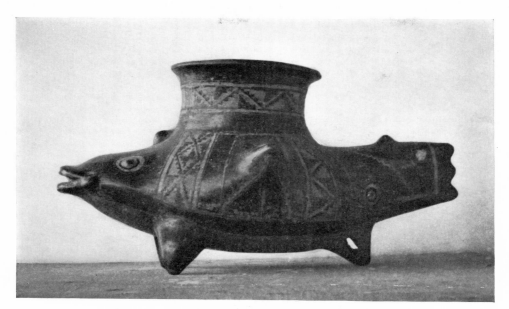

205

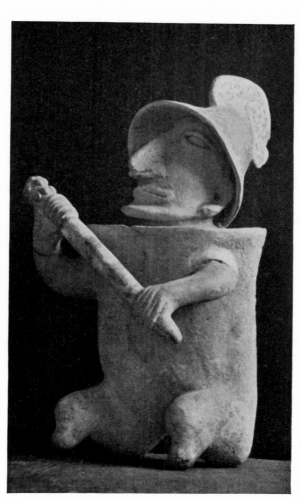

206

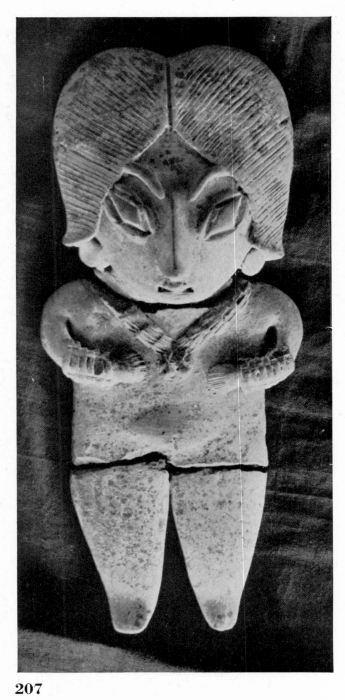

207

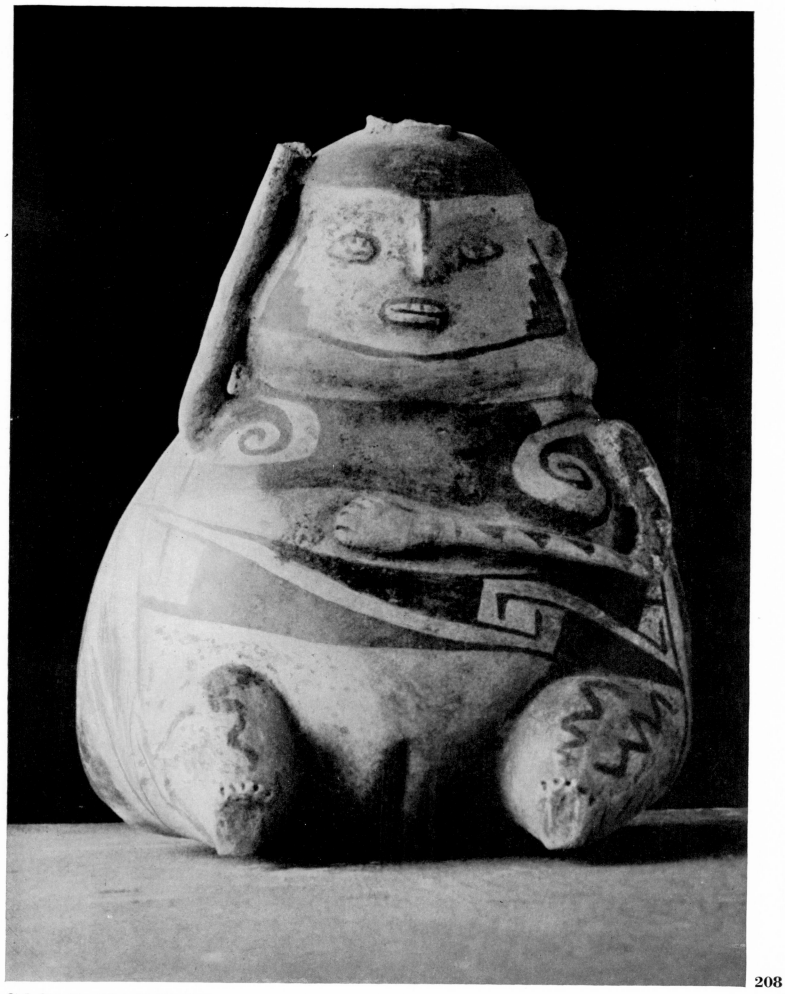

208

CASAS GRANDES

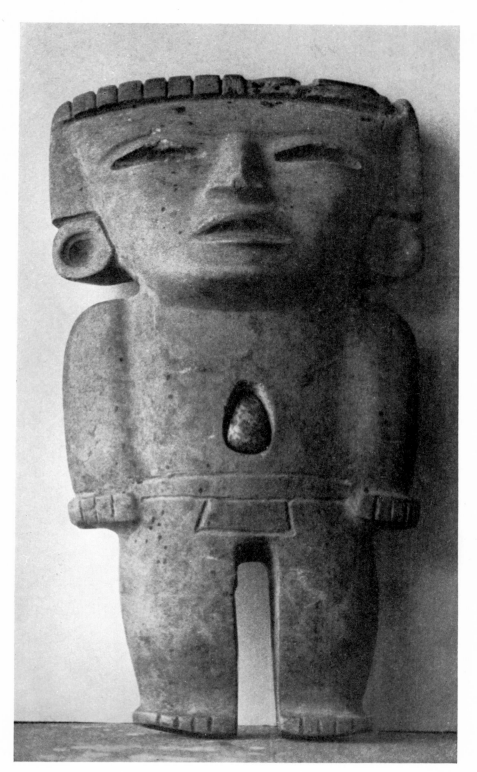

TOLTEC

209

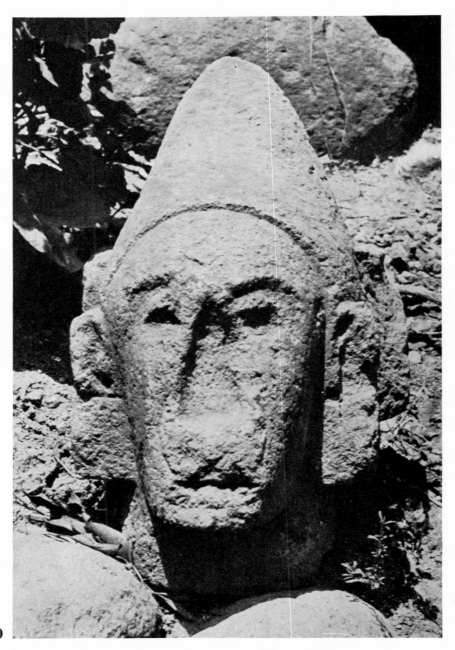

210

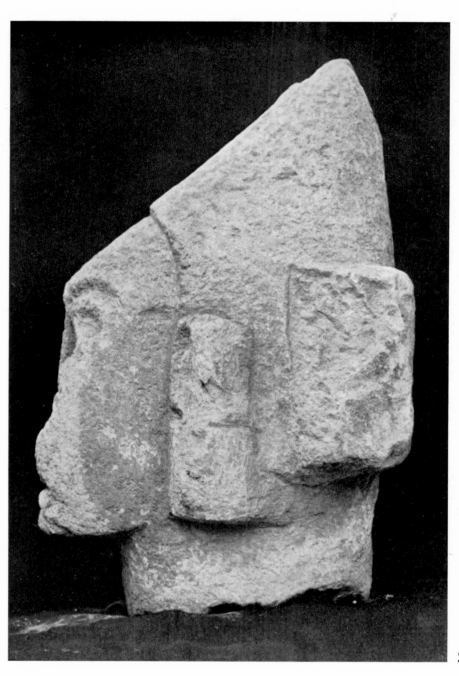

211

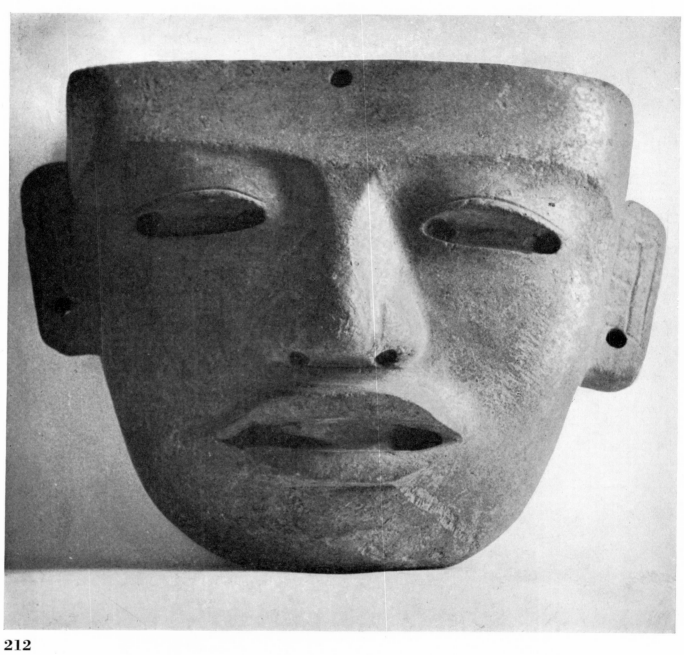

212

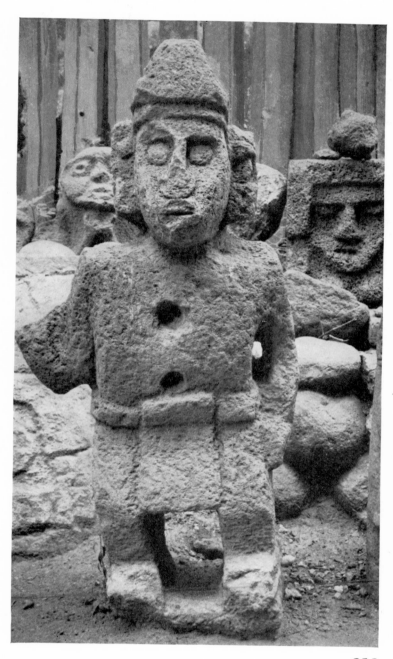

213

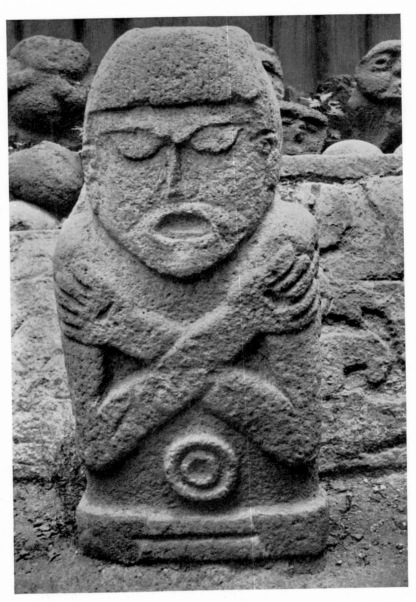

214

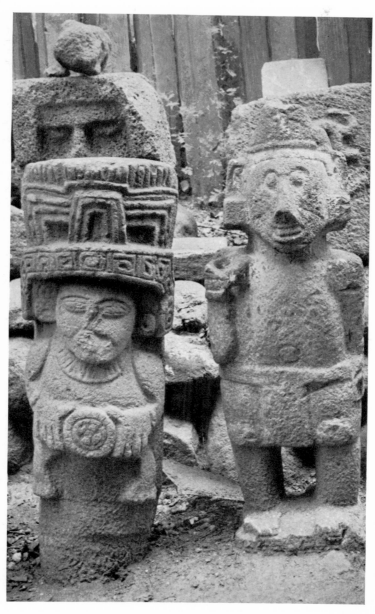

215

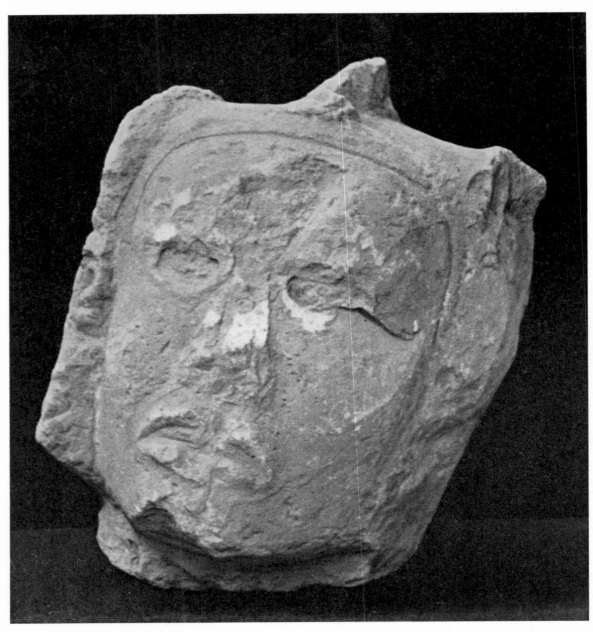

216

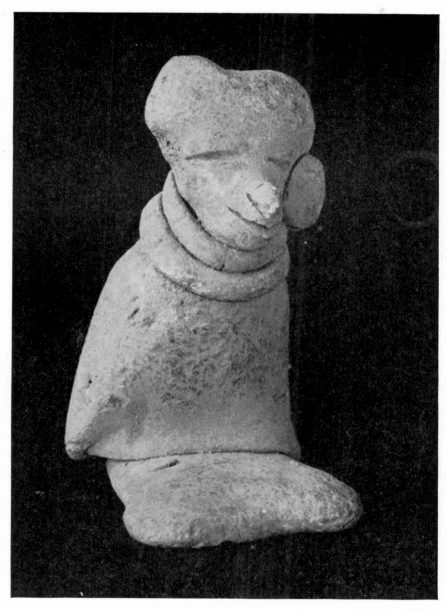

217

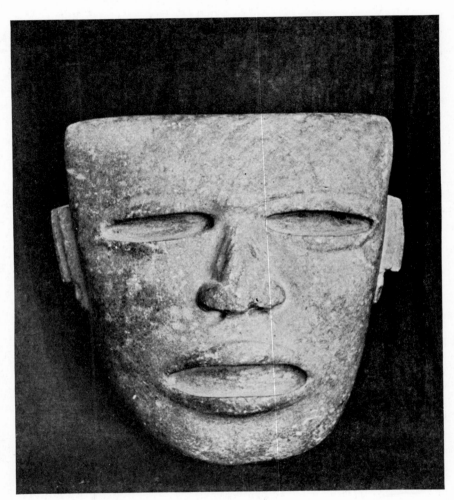

218

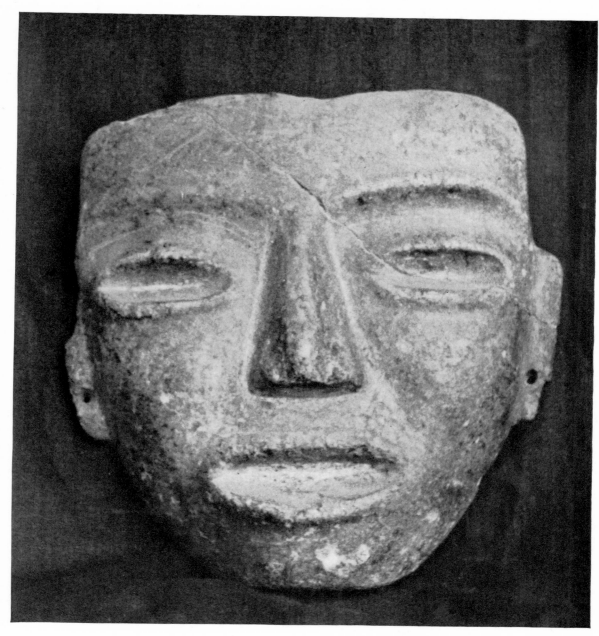

219

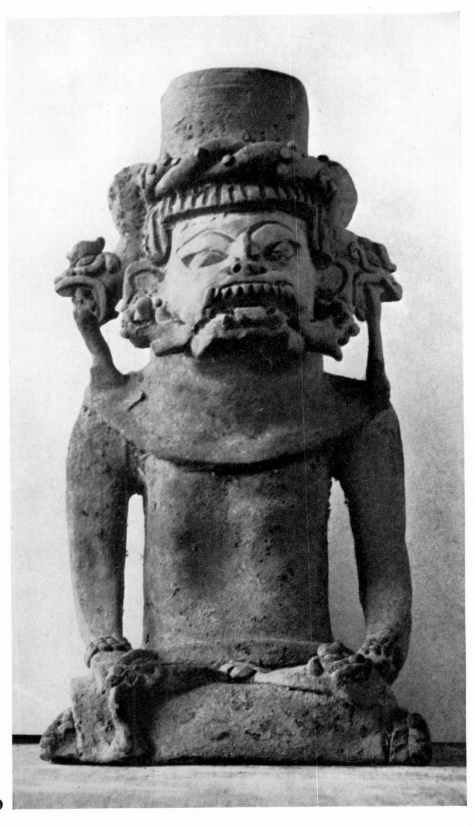

220

ZAPOTEC

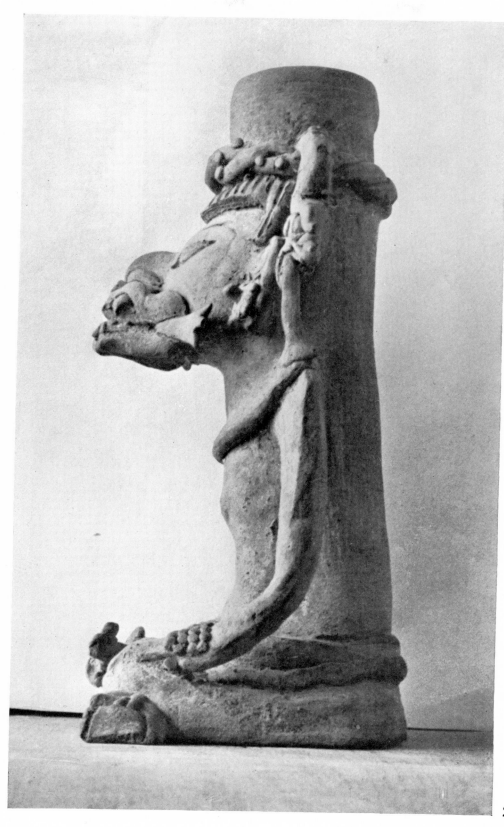

221

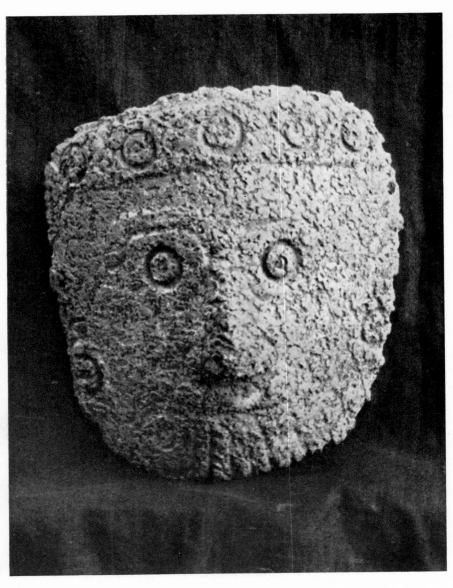

222

MIXTEC

AZTEC

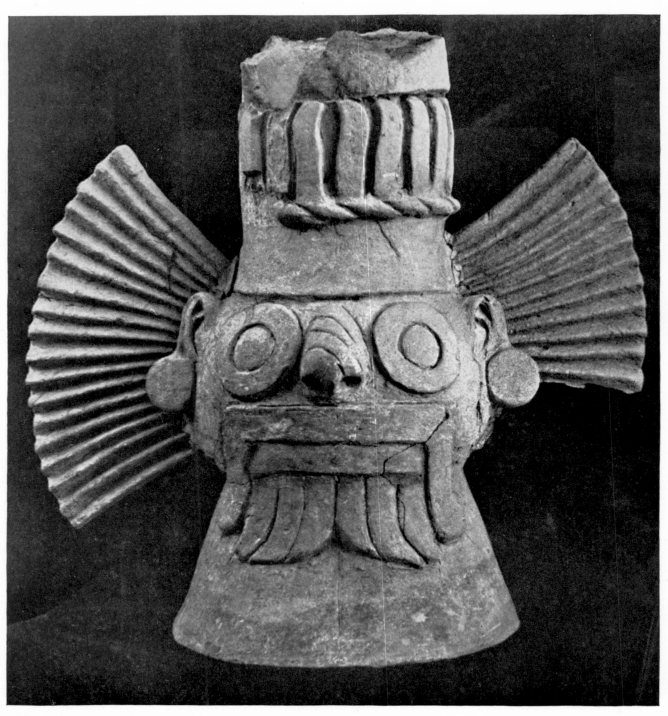

223

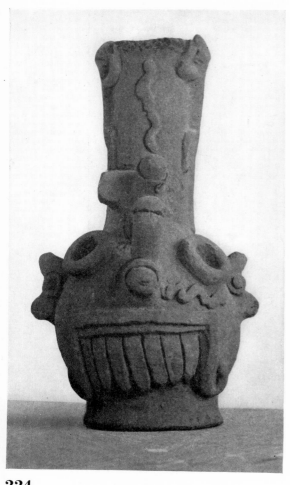

224

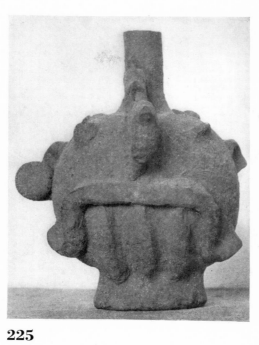

225

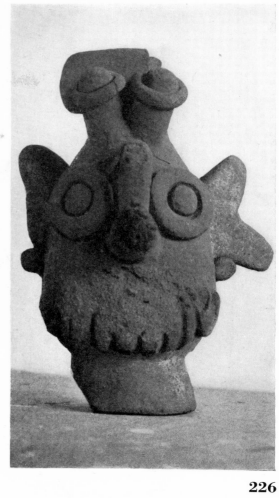

226

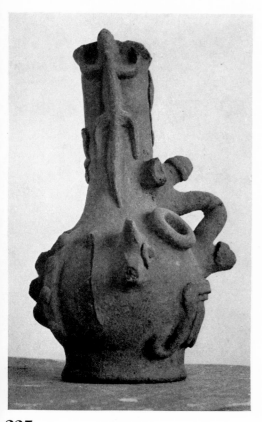

227

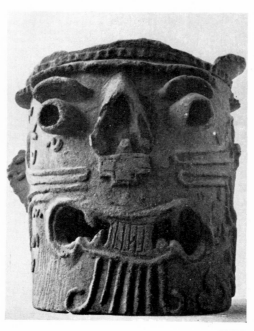

228

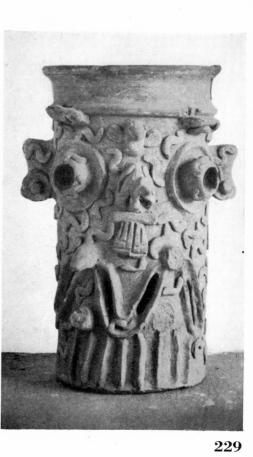

229

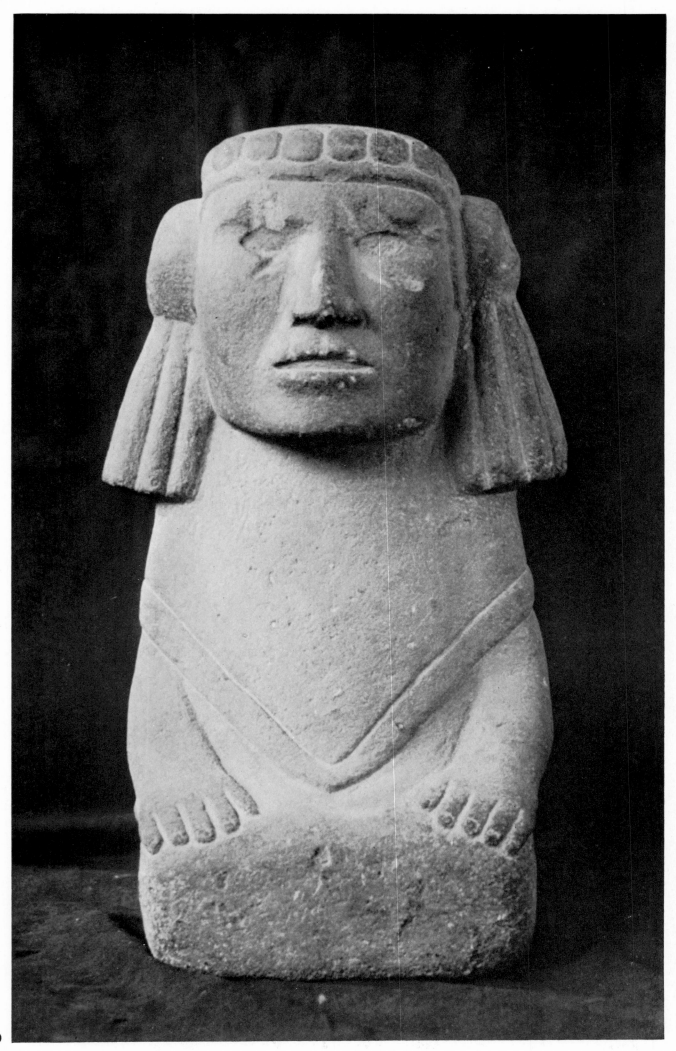

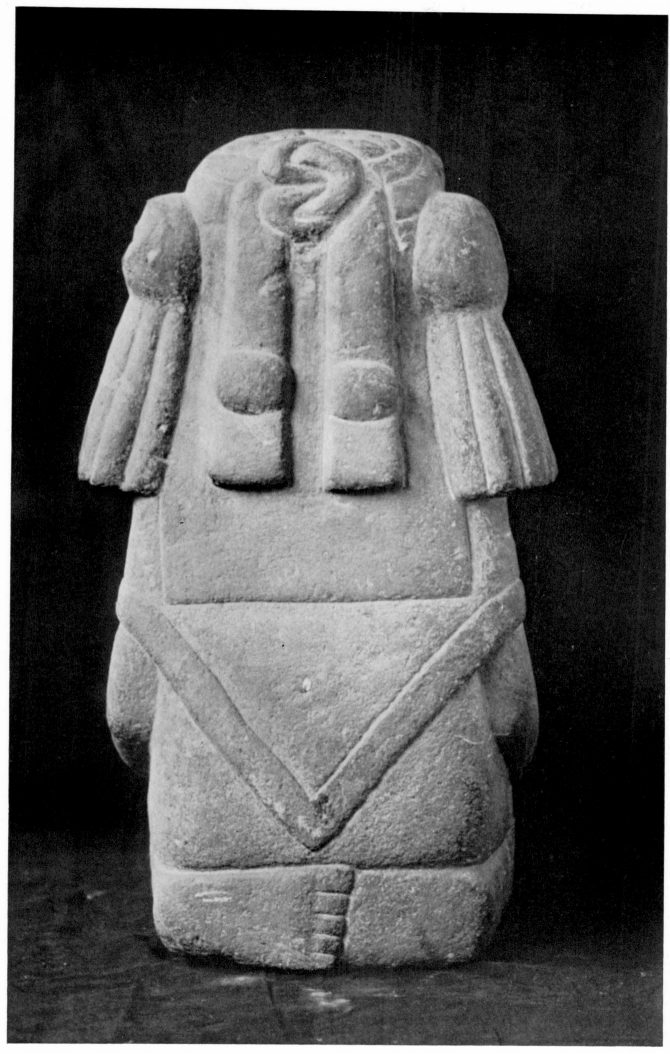

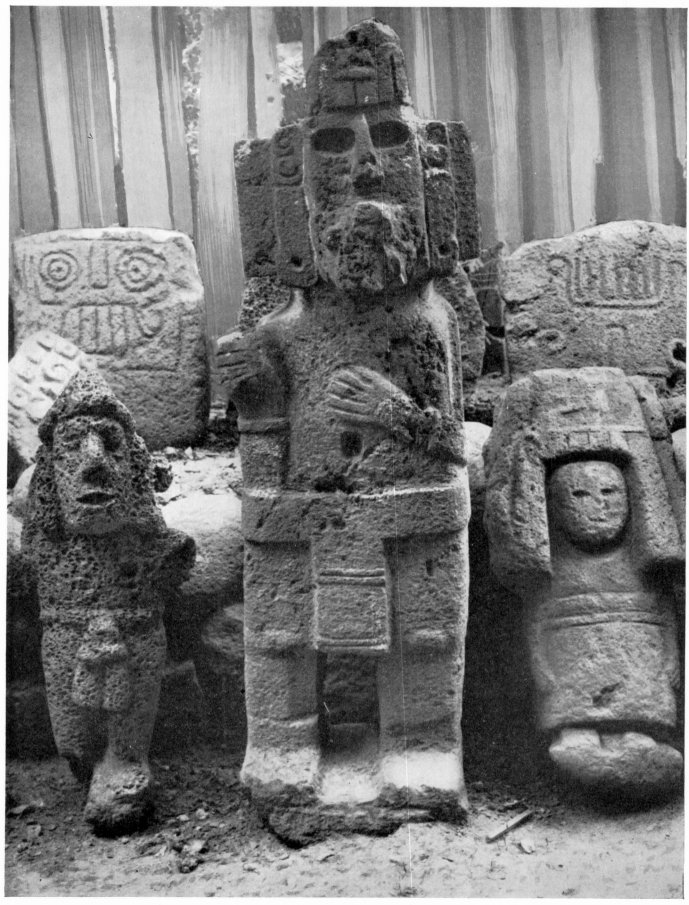

232

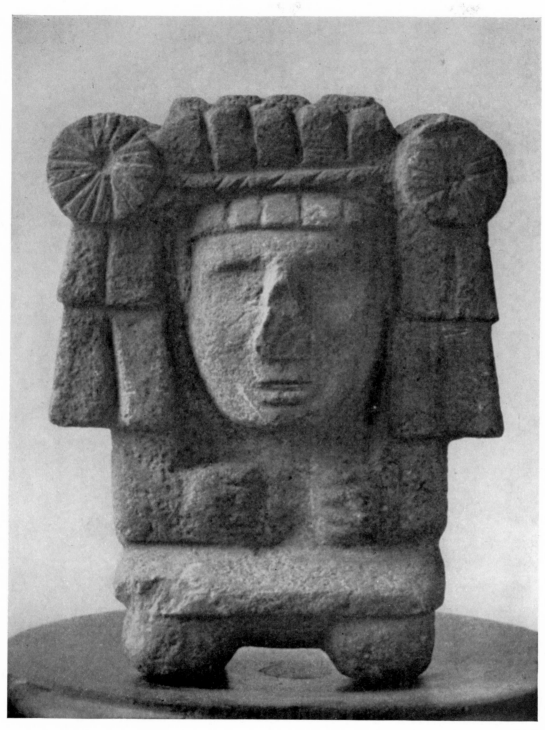

233

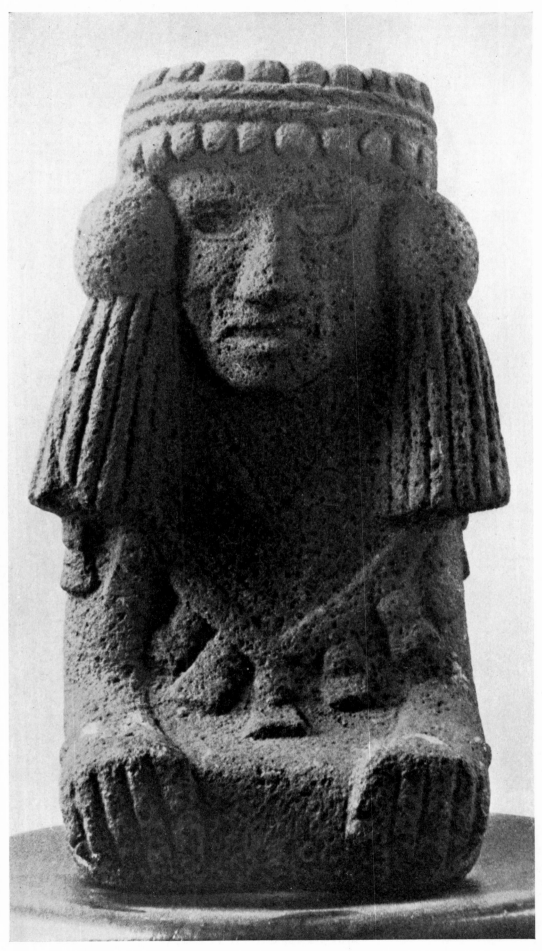

234

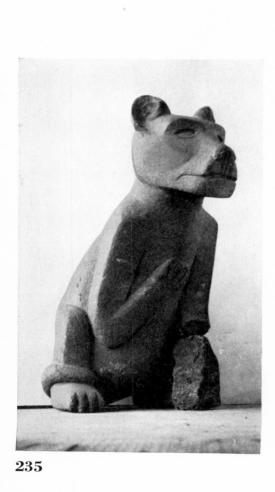

235

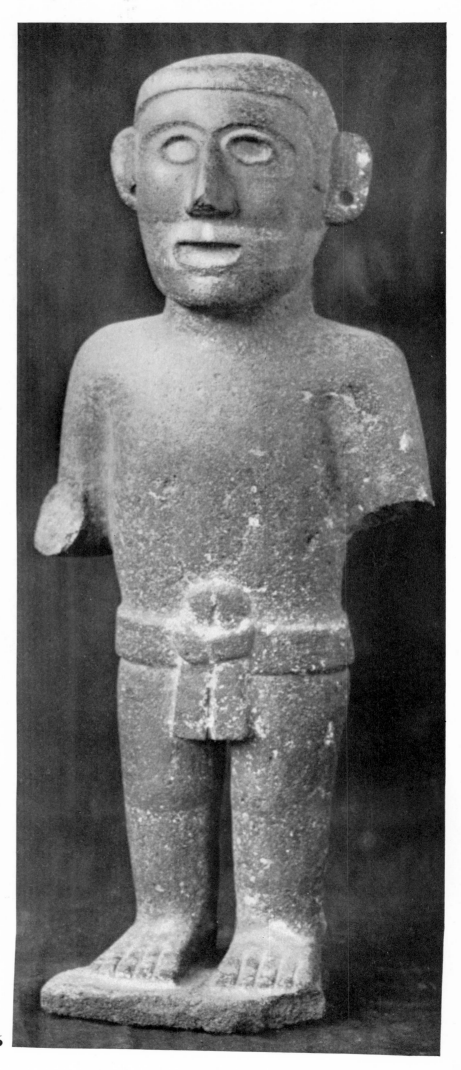

236

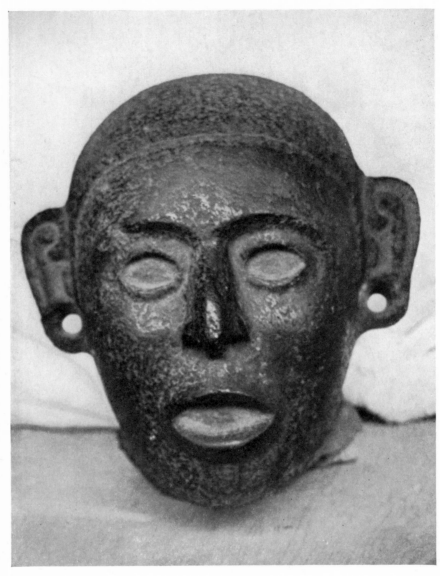

237

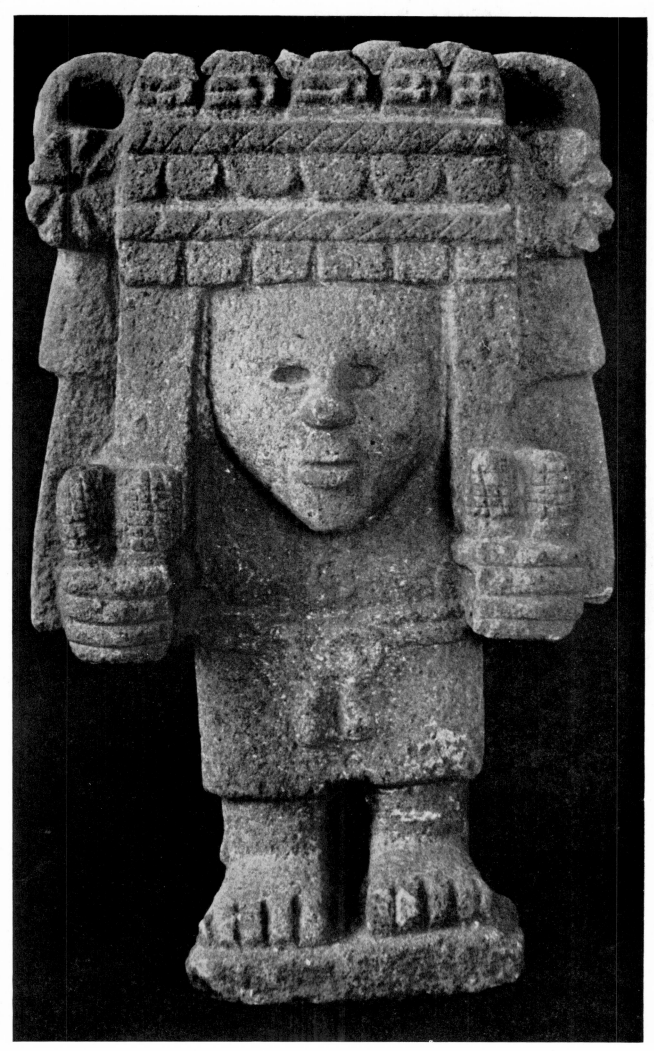

238

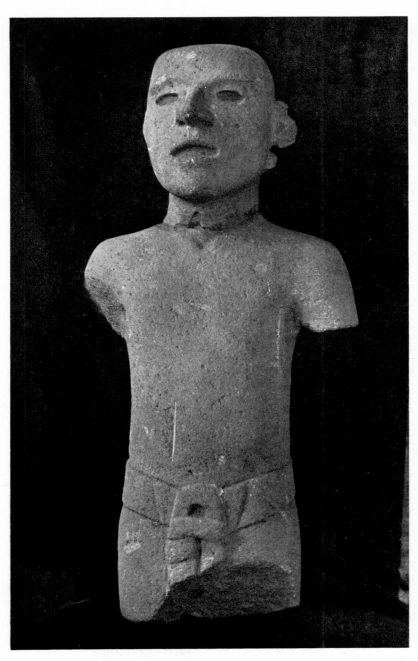

239

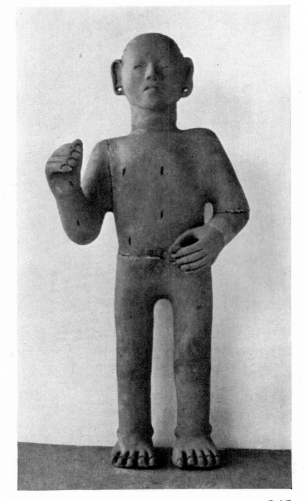

241

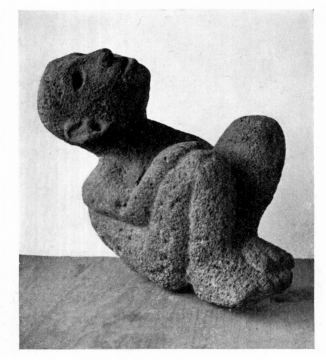

240

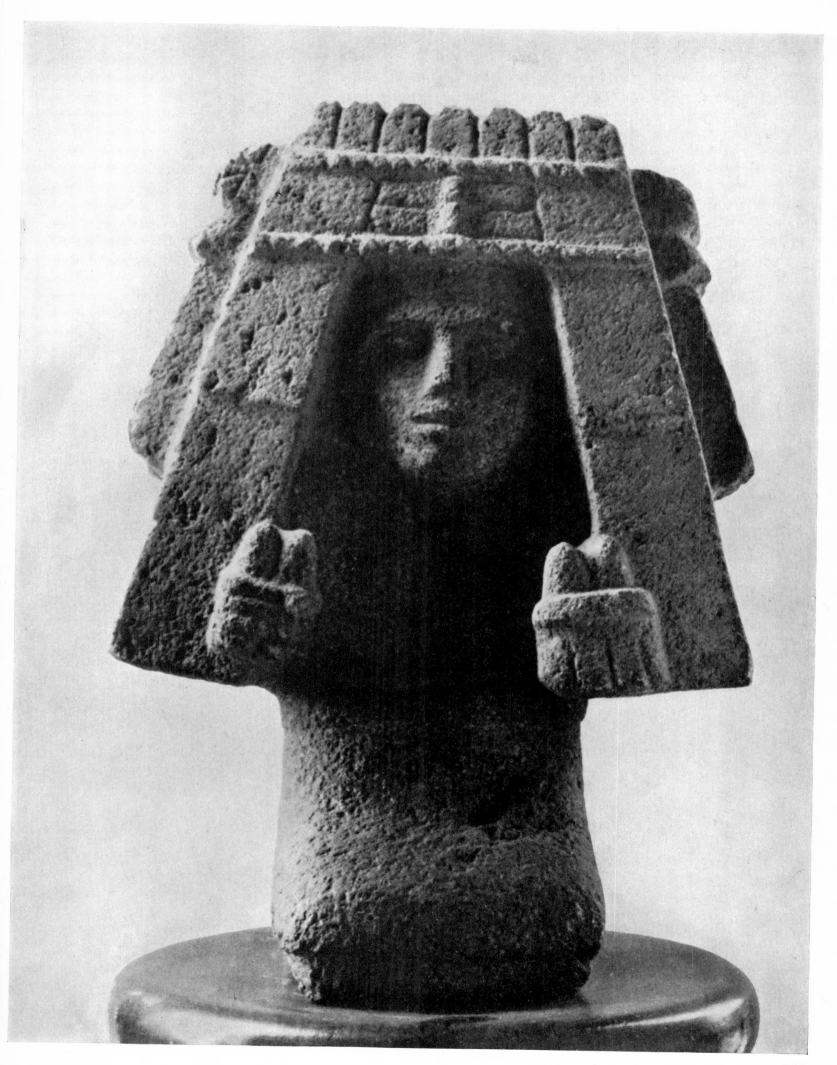

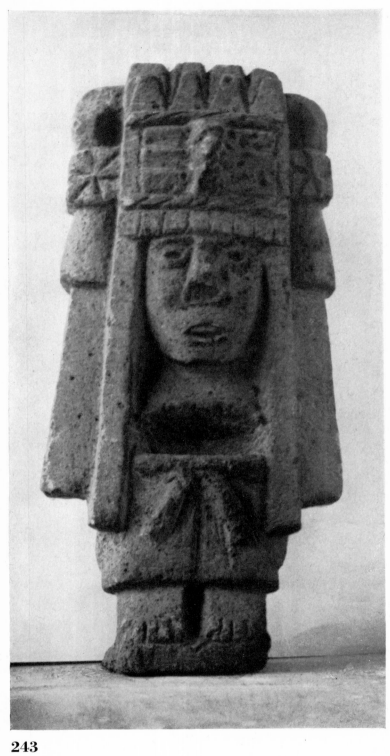

243

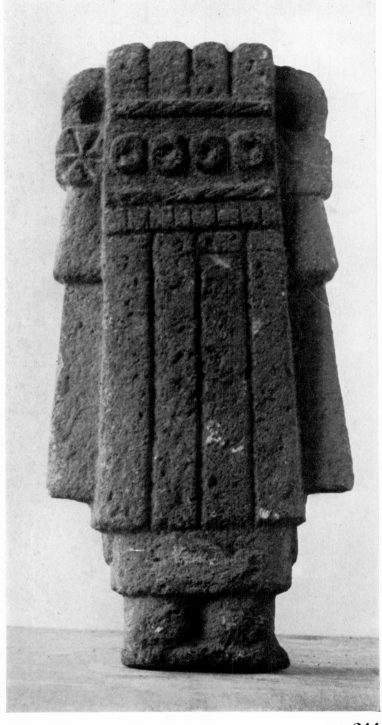

244

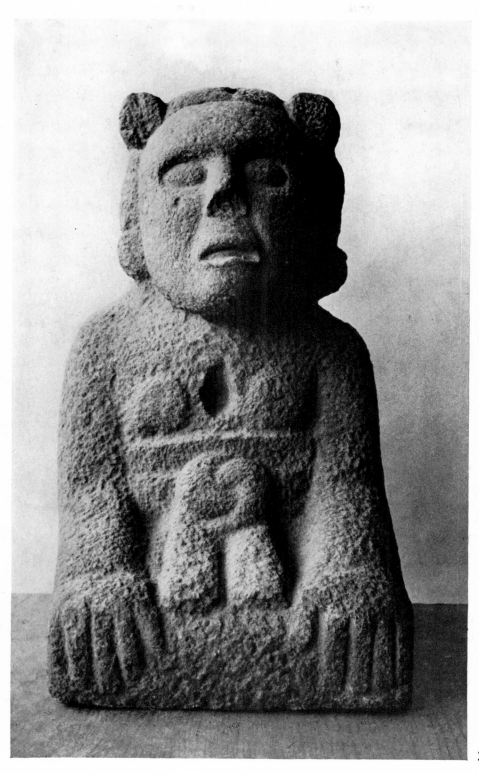

245

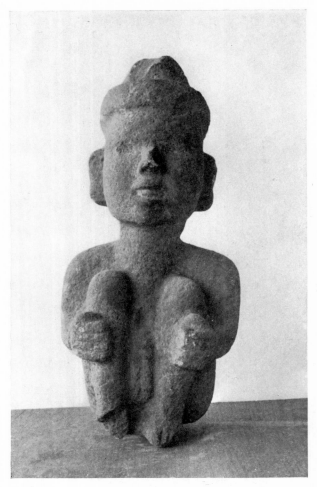

246

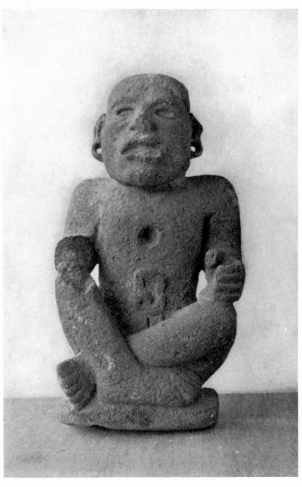

247

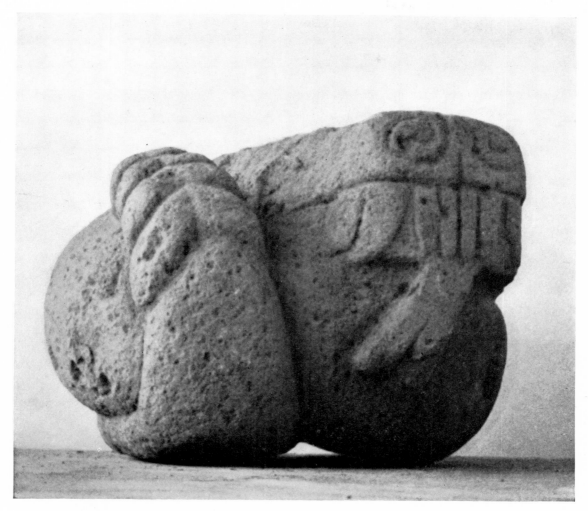

248

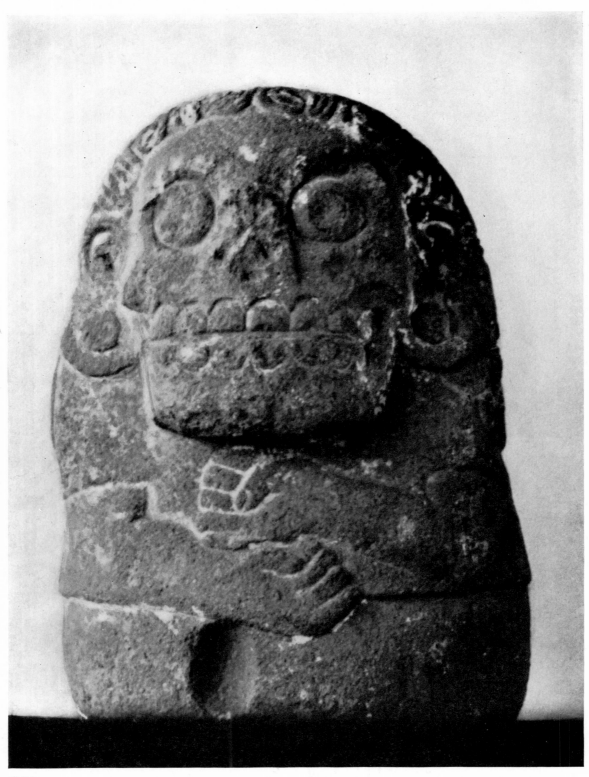

249

TOTONAC

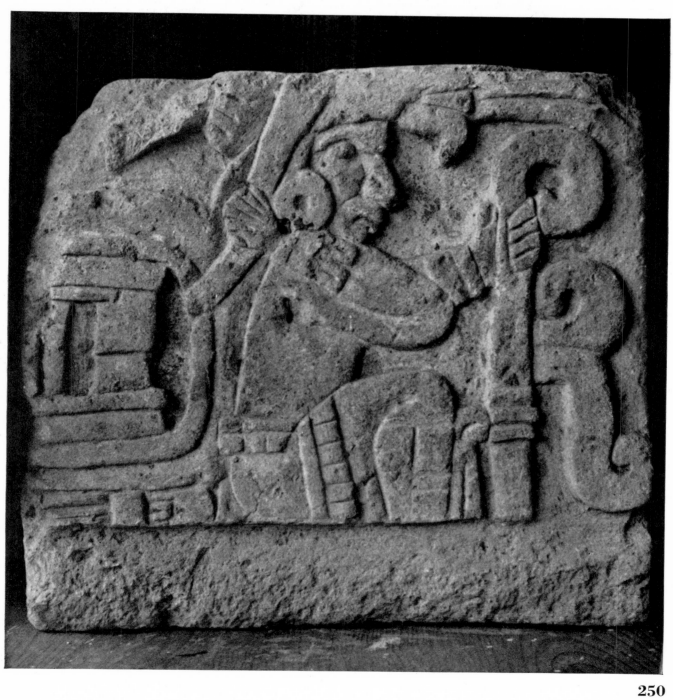

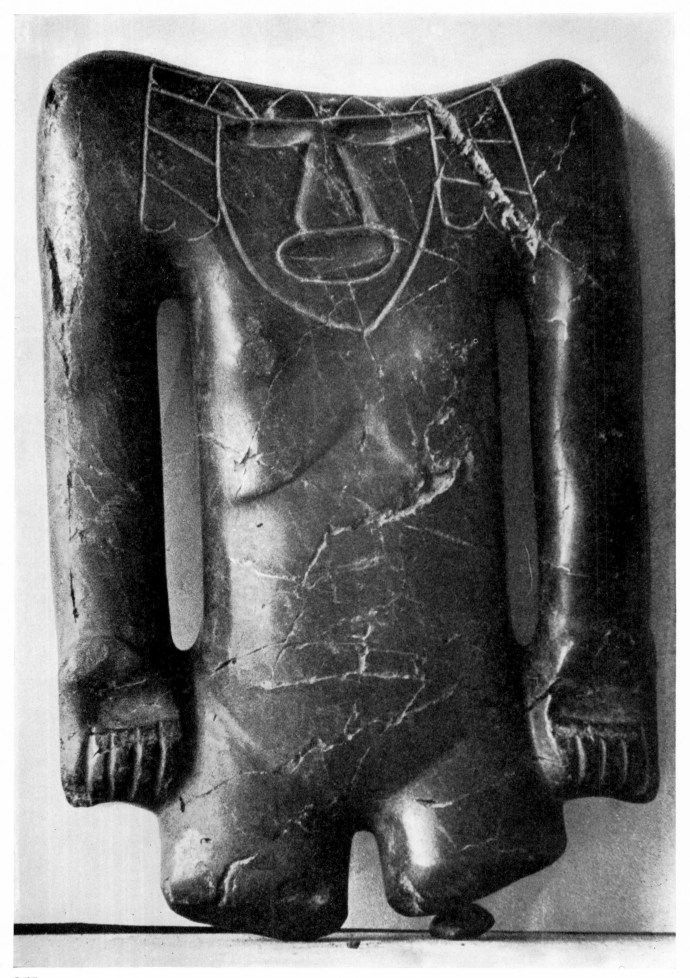

251

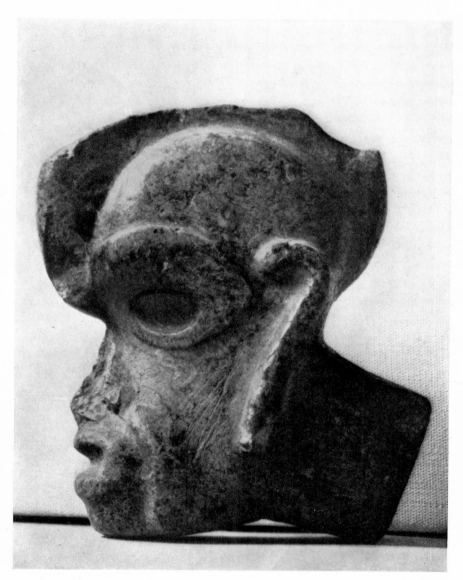

252

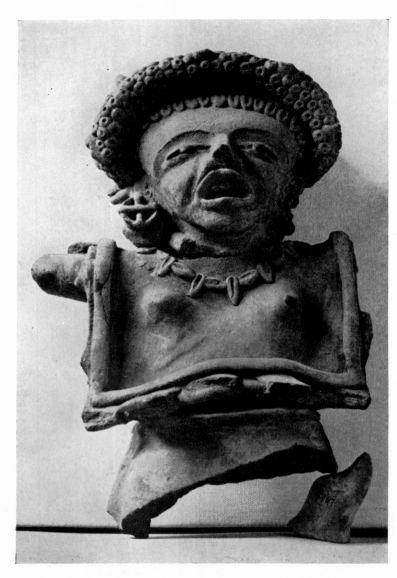

253

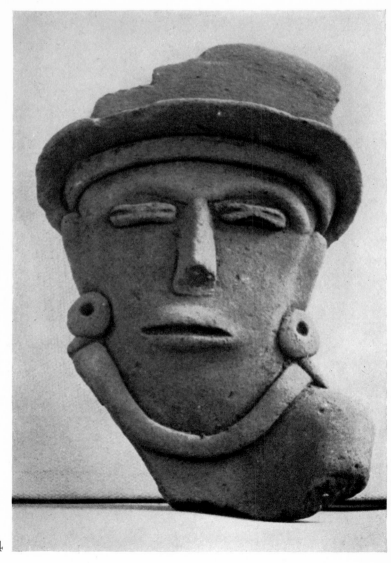

254

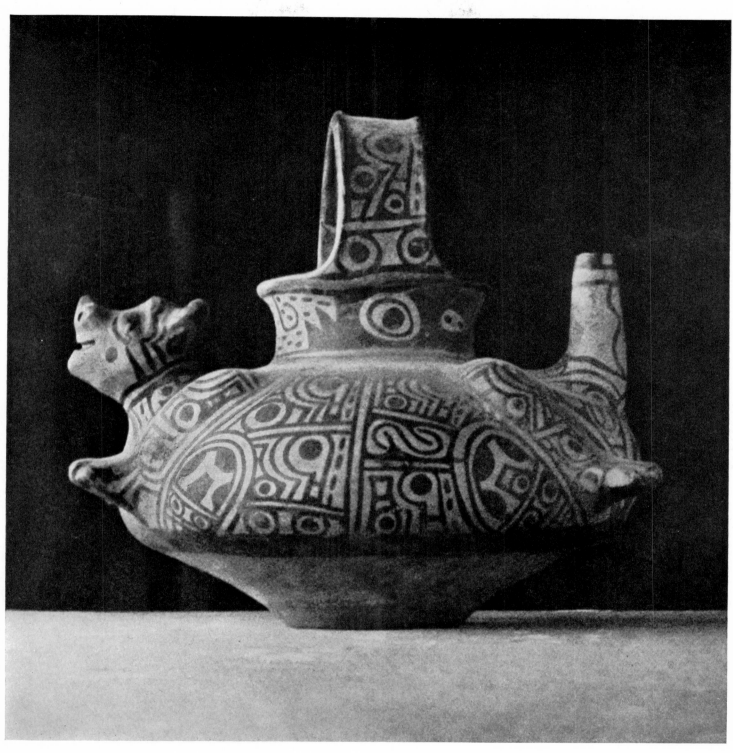

255

from VERACRUZ

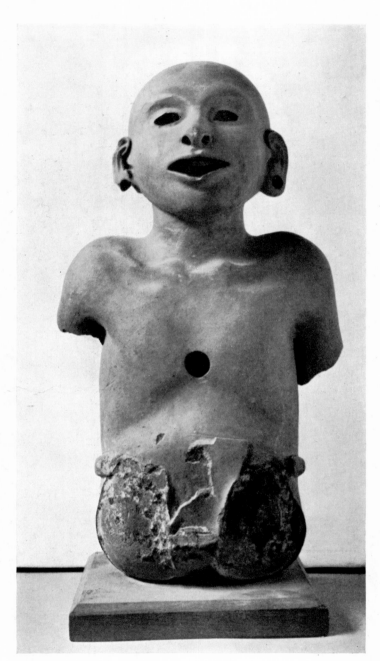

256

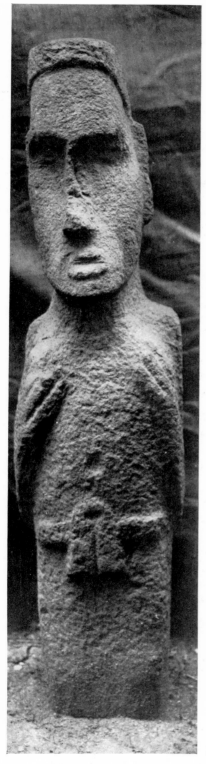

257

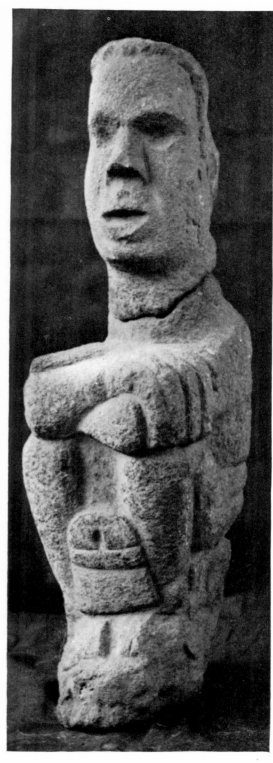

258

MATLAZINCAN

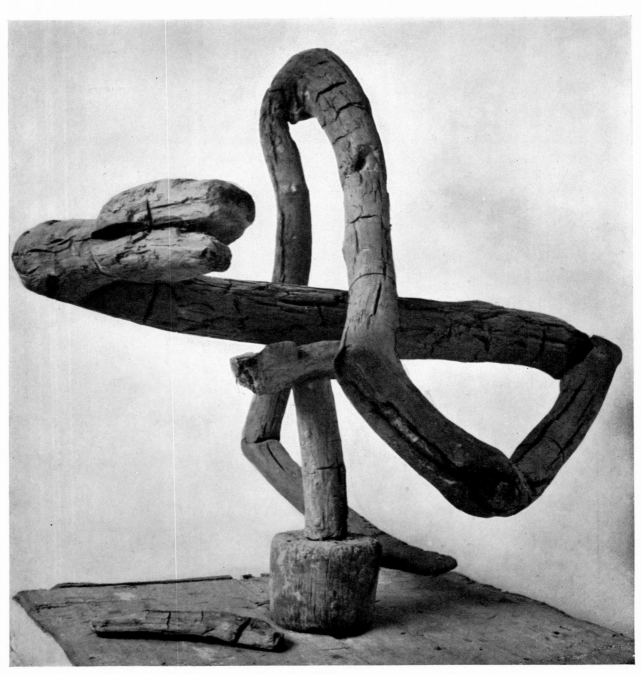

259